For Chandra, Genevieve and Lydia

ONE MORE LAP

ONE MORE

LAP

JIMMIE JOHNSON AND THE #48

WRITTEN BY ROBERT SULLIVAN
PRODUCED BY IVAN SHAW

RIZZOLI
NEW YORK

New York Paris London Milan

I've been a fan of Jimmie Johnson's for years.

People are surprised to learn that I love **NASCAR** and motorsports. My dad was a true fan, and I grew up going to races with my family all across the Southeast.

Jimmie caught my attention with his drive, leadership, and mental toughness. But to become a seven-time champion in your sport **AND** to win five titles in a row requires something extra—an intense passion for winning, and Jimmie's got it. He and I have talked on several occasions about what it takes to not only be a champion in your sport, but to be a repeat champion. Obviously, it's not something that comes easy, but it sure feels good.

I love that Jimmie challenged himself to compete in IndyCar. With his championship mindset and his relentless will to win, I have no doubt he'll find success.

-MICHAEL JORDAN, 2021

TABLE OF CONTENTS

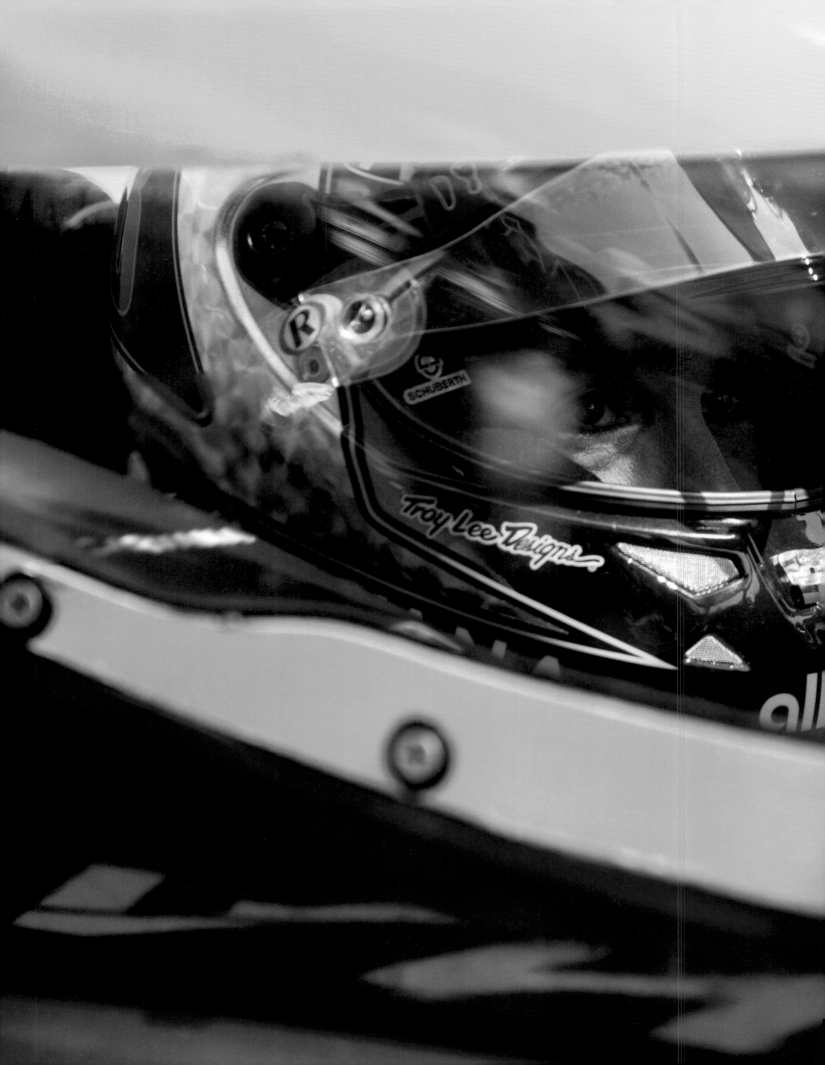

SEEING THE TURNS

BY ROBERT SULLIVAN

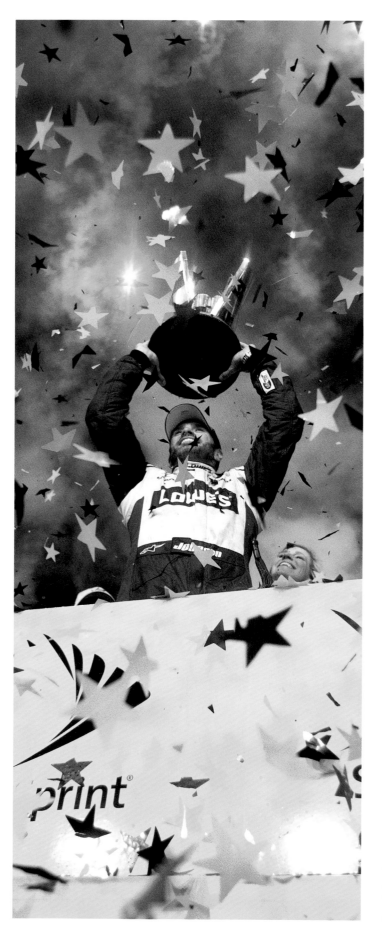

It was about four thirty in the morning in Portland, Oregon, and Jimmie Johnson, rookie IndyCar driver, was trying to get some sleep in his bus on the grounds of the Portland International Raceway, in those few wondrous overnight hours when the same cars that have spent all Saturday roaring through the course are momentarily still and silent, as if preparing for the next all-out day. For Johnson, the trip to Portland was like powering out of a turn, and you could feel the energy at the beginning of a three-race west coast swing that would wind up his very first season racing the IndyCar circuit. He felt more ready than he had all year to hold his own against twenty-seven other IndyCars, most of them driven by non-rookies, all managing average speeds of just over 100 mph, hitting close to 160 mph in the straightaway that passes the viewing stands and the occasional tall green Douglas fir. It had been a long, hard rookie season. "I'm not last!" he tweeted to his fans after his third-ever race. But now, things were about to shift to a higher gear, and this pre-dawn moment was theoretically a moment for his body to recharge—when suddenly, a freight train rolled by, ever so slowly crossing the Columbia River.

"It woke me up," he said, a few hours later, and he was telling me this as he prepared to suit up for the race. The seven-time NASCAR champion had managed to get to bed early after a long day of practice and qualifying laps. If you've ever tried it, you know practice involves several hours crunched inside a tiny cockpit—your body like a taught muscle, and your eyes and nerves looking ahead at a road that has already moved behind you as you contemplate it. And then come hours of sit-downs with strategists, engineers, and driver teammates. An IndyCar, when it is racing, is like a patient wired up in a diagnostic lab, generating enough racing data for a college statistics class. Johnson had planned on getting up early anyway; his teammates know him as the guy who texts earliest, with questions about turns as well as encouraging comments

that might just be annoying if they weren't heartfelt and coming from one of the most successful racers in the world. But being rumbled awake by slow-moving diesel-powered transport? Not ideal.

Why this was not a huge problem is, first, Johnson's bus is comfortable—spacious and well-stocked, with games for when his kids are there, and a big screen TV to watch races in which he is not racing. It's a long way from the hollowed-out camper van he had in the days when he was first racing off-road vehicles, trucks, and stock cars, an aluminum shell swaying in hot desert winds in California or cold mornings in the Midwest. But anybody who knows Jimmie Johnson knows he can't help but make a too early wake-up call anywhere into an opportunity. Thus, in Portland, train-awakened and not getting back to sleep, he proceeded to visualize each of the twelve turns that, in a few hours, he would navigate precisely 110 times, when the green flag waved on the first of his last three races in his IndyCar rookie year.

"You're seeing the turns," he tells me later, describing the mental race simulator that somehow connects his racing body and racing mind. With about three hours to go until the Grand Prix of Portland's green flag drops, he's walking from his bus to the giant transporters where his racing team meets and tunes the cars. But he pauses to expand the description. As he does so, you can almost see him replaying one of the turns in his mind's eye. "And well, you're feeling the turns, really. That's really what it is," Jimmie says.

The way you and I might feel the turns—in a car going 120 mph or even in our much slower mind's eye—is not the way Jimmie Johnson feels a turn. You and I feel the turn as if we are being swung around by an amusement park ride that threatens not only to amuse but to leave the earth, or maybe, given the G-forces involved, press us down deep into it. If the turn feels different to other rookie IndyCar drivers, it's only because Jimmie

Johnson is not like other IndyCar rookies. Johnson is the best-known name in motorsports and among the winningest of all time. He is a NASCAR champion among NASCAR champions. When it seemed as if three and then four times winning the storied trophy was nearly impossible, he won three times more. He's a seasoned veteran with close to a thousand races under his belt. Although dressed for the Portland race in his bright blue racing suit, the forty-six-year-old with a tinge of silver in his beard really does move like a rookie. He's on schedule but he's rushing to the track, as if it might get him a little faster to the finish line. "I just love racing," he says.

You don't have to spend ten minutes with Jimmie Johnson in the pit and around his car, or maybe even outside the technical debriefing room (data!), to see that racing charges Johnson, who in turn seems to charge those around him. Outside the trailers for Chip Ganassi Racing, fans are doing double takes on seeing the banner announcing Johnson, and drivers are excited by a guy who has won the number of races he has won and yet is confident enough to come in and, yes, maybe lose. More than most people, Johnson's driving compatriots understand what the retired NASCAR driver is attempting: a shift to a whole other kind of car that makes for a completely different kind of racing. To someone who has never raced cars, IndyCars might seem like more of the same, but to anybody who has, Johnson is switching sports entirely, as if moving from winning seven World Series in baseball to trying out for an NFL team. It's like switching from pole vaulting to the luge, or tennis to golf.

"This is a completely different discipline," says Eric Cowdin, the engineer on Johnson's team. "You have to completely rethink and relearn from the ground up your skillset. And to me, what he's accomplishing—well, yeah, I understand that they're both motorsports, but the two disciplines could not be further apart."

When Johnson walks out on to the Portland speedway to look for No. 48, he is no longer looking for the car he made famous. In NASCAR, he drove what might be described as a souped-up sedan that was vaguely street legal. With its wheels tucked below the body and inside fenders, it was a muscle car on steroids—lots of steroids. When he walks to the pits at Portland International Raceway, he will squeeze into a seat that feels less like the front seat of a Corvette and more like an experimental jet fighter, or a supercar with wheels that come off it like wings. It is wind-tunnel designed, with tires that are well outside its body and aero foils that keep it from flying, or attempt to. In terms of how it feels to be behind the wheel, switching from NASCAR to IndyCar is like switching from a 3,000-pound, 200-mile-an-hour jeep to a half-as-heavy, 240-mile-an-hour jet fighter that is sleek and slippery, turbocharged, and ready to fly. An Indianapolis-based Indy-Car technician I know likes to tell people that if they want to experience what driving an IndyCar is like, they should drive the freeway in Indianapolis on a winter day when the interstate is covered with ice, and they should do it at 100 mph. "It's so fast, it's slippery," he says.

A question that doesn't distract Johnson, either while mind-racing at dawn in his bus or when he will hit the throttle on the No. 48 IndyCar later in the day, is: why bother, especially after twenty good years of checkered flags? Why make the shift from one kind of racing to something entirely different—to a kind of driving that is like apples to oranges, in terms of, for example, brakes and hitting the gas? Here are a few possible answers: Jimmie Johnson is hardwired to race and has been competing since he was five. If a gazelle got in front of him, he would pass it, or try to. Jimmie Johnson's idea of relaxing doesn't have to do with sitting still but with speed on a bike in an Ironman competition, backcountry skiing, or finishing the Boston Marathon in just over three hours, and finishing it, furthermore, thirty-six hours

after a NASCAR race at Richmond Raceway. Note that in 2009 Johnson was the only race car driver ever to be named Associated Press Male Athlete of the Year. Note too that in 2020 the honor went to LeBron James.

If you are looking to pinpoint a moment when Johnson got the idea to make the shift, you could either look at his childhood, when he first visualized himself making the turns at the Indianapolis 500, like many speed-obsessed young kids. It is, after all, probably the most famous race in the world—no offense to European road races. Or you could go back to that day in 2018, when pretty much everything in his racing life changed. At the time, he was still racing NASCAR, but for the first time in his life, he found himself behind the (comparatively tiny) wheel of a Formula One car, which is like an IndyCar in that it is also open wheel. Automotively speaking, IndyCar is little brother to Formula One. Just getting into the car and just beginning to feel what an open wheel car can do meant that, for Johnson, the game was suddenly changed. Then he hit the pedal, which proceeded to take him toward 200 mph, or about as close as you can get to flying without a pilot's license. Although come to think of it, when it was over, he described feeling aloft: "I'm on Cloud Nine," he said. When he remembers the day even now, he speaks slowly and clearly, and smiles big time. "It was the most epic experience I've ever had in motor sports," he says. "So much fun."

———————————————————

To be clear, Jimmie Johnson is not the first driver to shift from NASCAR to IndyCar. A handful of people have done it, and a few more have tried and failed. (The switch from Formula One to IndyCars is somewhat more common.) Switching and then winning is what's hard. The also-legendary Mario Andretti acoomplished it too. After winning the Daytona 500 in a stock car in 1967, Andretti won the Indianapolis 500 in an open wheel car two years later. A few other drivers from earlier generations did the same. When Johnson looks back at this kind of a feat, he

is both inspired and amazed. "Those guys could drive anything," he says. The technical hurdles are mind-boggling, requiring a driver to do nothing less than relearn racing, in terms of not just braking and accelerating but even handling the cars. And while IndyCars are far from fragile, it is true that in some ways stock cars are rougher, just in terms of bulk. A host on ABC's "Good Morning America" got at this while interviewing Johnson recently. "In NASCAR, you're bumping and rubbing round the corners," the host said, inquiring tentatively, "but with IndyCar, you don't do that, right?"

"You can," Johnson said. "But . . ."

Here we must pause to explain that if, for better or worse, stock car drivers have a reputation that's part outlaw, then Johnson is an anomaly. He is a clean cut, good-natured sportsman who is generous to a fault. He is rough in a car, but in person he possesses an innate courteousness. Over the course of his career he has been faulted for it, as if the job description for NASCAR driver required breaking up a bar. Thus, while being interviewed on morning TV, and questioned about IndyCars bumping and rubbing–and if you've watched them race, you know that neither rubbing or bumping is ideal–Johnson smiled warmly at the host, a motorsports novice, and gently explained. "You can…" he said, "but your success rate is pretty low. With the open wheels and the very fragile nature of the cars, touching is not something you want to do with an IndyCar."

And this is putting it mildly. Earlier in this 2021 season, a month before Portland, when IndyCar raced in the streets of Nashville for the very first time for the Music City Grand Prix, Johnson's car touched the wall after hitting what looked a lot like a pothole coming off a bridge during practice. And then during the race itself, there was a lot of touching at Turn 11. When he thought he avoided hitting the car in front of him, Johnson got his transmission taken out from behind. But at that point

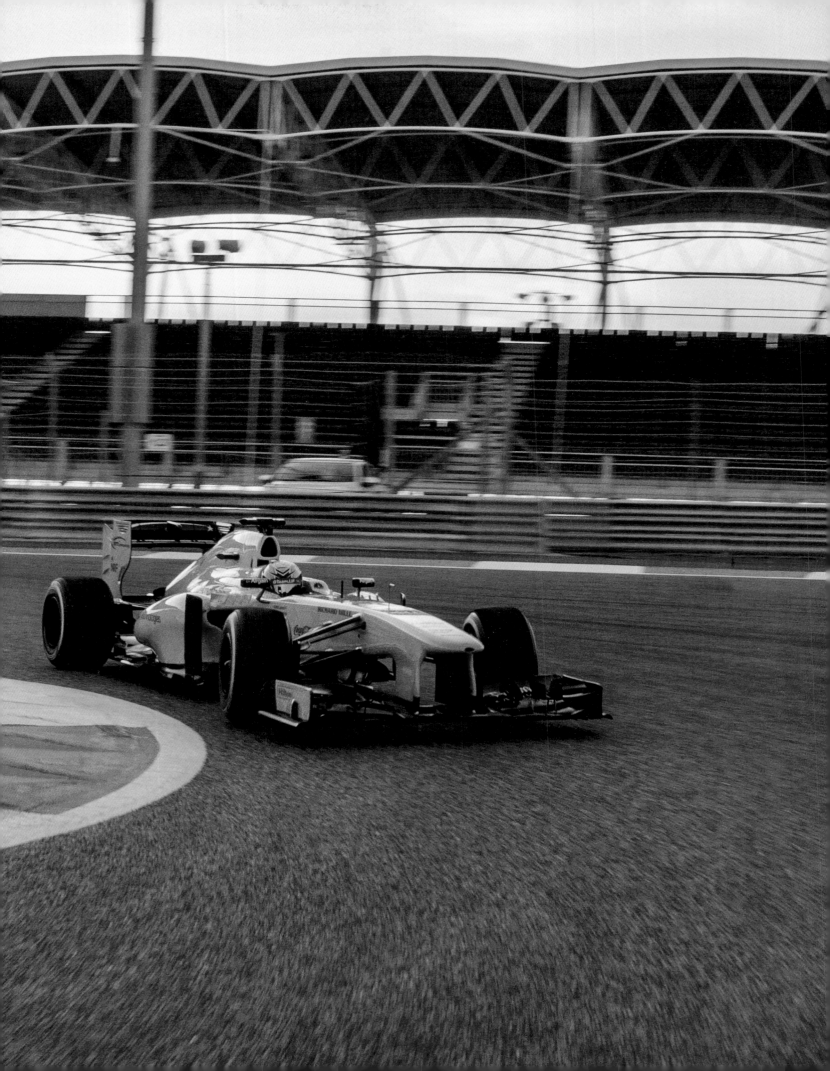

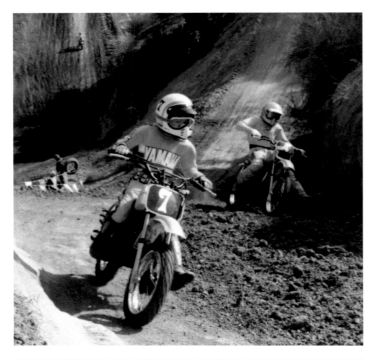

in the season, he was finishing quite a way back in the pack. Now, on this gorgeous late summer afternoon in Portland, he is almost a different driver. He is heading to the starting line after having a great day before, one of the best-ever qualifying times in his IndyCar career (i.e., his entire six-month-long IndyCar driving life).

Then again, he had been feeling very good about Portland since he arrived on Friday night, in part because he'd been to the Rose City before, for a day of practice earlier in the summer. He'd spent time there with his team, learning the turns and testing out configurations of the car. In that time, he had managed to find that rhythm that drivers talk about and dream of. There's nothing like a mishap to focus you, and especially after picking up his pace post-Nashville, he was visualizing better finishes—ones that got him closer to the top ten. The press was, of course, interested in Johnson as a rookie, for his skills and his fan base, but racing coverage was focused for the most part on the IndyCar drivers competing for the top slots—drivers like Johnson's teammates, Álex Palou and Scott Dixon, as well as the likes of Josef Newgarden, Pato O'Ward, Simon Pagenaud, Alexander Rossi, Colton Herta and Marcus Ericsson. What was becoming clearer to analysts and race fans as they arrived in Portland was that Johnson was racing his own race, quietly making headway, closing the gap between his car and the winners, which was an extraordinary goal for any rookie.

"Portland was awesome," Johnson tells me when the season is over and he is back at his home in Charlotte. "Portland was the start of me being competitive."

But as he prepares for the green flag back at Portland today, he is mostly just thinking about the two hours of driving ahead of him, and maybe a little bit about how amazing the other IndyCar racers are, given his new vantage from an IndyCar cockpit. "I had no idea," he told Leigh Diffey, the NBC IndyCar commentator. "I'm just amazed at how they drove so many different cars

so well," he told me, as he headed to his No. 48 Indy-Car being primed and primped at Chip Ganassi Racing's trackside traveling garage and command center.

As the car gets towed to the track, the weather is warm but not too hot, and the sky dry and clear. It is a perfect day. The race strategist and engineers take their seats in their computer screened-filled booth alongside the track and adjacent to the No. 48's pit. The car's technical data has been digested, and Johnson has downloaded his early morning track visualizations as muscle memory: seeing the turns, feeling them, taking in the trial run from the day before, and loading another set of experiences into the data bank that is his racing body. "Over all these decades, I'm still learning," he says.

At this point, as the twin-turbocharged 2.2-liter V-6 Honda engine roars up some of its 12,000 rpms, the only thing standing between Johnson and a good race is maybe Portland's very first turn—what amounts to a dangerous kink in the track. Less than a quarter mile into the 1.96–mile course, it has confounded rookies and veterans alike over the past three seasons, causing multi-car wipeouts and crashes. He has planned on it being a mess. He knows that if he tries to avoid what will most likely be a crash or two in front of him by momentarily driving off the course, he will be forced to move to the back of the pack. All of which means that about six seconds after Jimmie Johnson hits the gas to begin the final stretch of his first season in a new life as a race car driver, he will have to hit the brakes as hard as he possibly can.

For most people, retirement is a word that translates as a kind of strategic withdrawal, or at least a slowing down, but, for Jimmie Johnson, it translates to diving further in, even though during his NASCAR years, he was about as deep into racing as any human could possibly be. When Jimmie Kenneth Johnson was starting out, racing motorcycles on dirt tracks in southern California as a kid,

NASCAR was a faraway dream. Off-road racing was the thing; he was driving a Super Lite buggy in the Mickey Thompson Off-Road series, touring dirt tracks in stadiums. By the time he was in high school, he was moving up the ranks, driving trucks in stadiums and off road, and winning more. At sixteen, he was spotted by Herb Fishel, who convinced the young Californian that NASCAR was his future. (Fishel was the legendary head of racing at General Motors Motorsports. He was the man who, at a time when GM was in the economic dumps, kept the car manufacturer winning at the races, with V-8s and Corvettes winning more than any other car.) Cut to the Greased Lightning 200 on June 12, 1999, when Johnson raced on Memphis Motorsports Park's paved oval, a 240-mile race. The former dirt racer led on asphalt for 156 laps.

Racing for Herzog Motorsports, Johnson was a star in no time. Just out of the gate, he earned, six top ten finishes in the Busch Series, athough he was chastened early by a harrowing crash in July 2000, at the racetrack in Watkins Glen, New York. When the brakes went on his No. 92 Xfinity car in the forty-sixth lap, the pedal suddenly hit the floor and the car left the track on the first turn. As he hurdled down a grass embankment and then launched toward the track's wall, Johnson contemplated the end of his career just as it was beginning. He was certain the wall ahead was concrete. Onlookers were certain too. In fact, it was layers of Styrofoam. When he climbed from the car and walked away, the crowd erupted, as amazed as he was that he was still alive. "We're lucky for the way it worked out," he told a reporter at the time.

"It was a pretty frightening day—one of the very few times in a race car I thought it was over," Johnson said years later.

Shortly thereafter, in 2001, several colleagues died in racing accidents, including Blaise Alexander, a close friend he had come up with through the ranks and whose car he raced just after Alexander died. (Alexander

died as a result of a basilar skull fracture sustained in the impact. Six other racers died from similar injuries over the course of two years, such that NASCAR was forced to mandate head restraints in their cars.)

The No. 48 Chevrolet that would become Johnson's trademark rolled out full-time in 2002, when he signed full-time with Hendrick Motorsports. It was less like signing with a racing team and more like joining a family. Hendrick's headquarters, just down the street from the Charlotte Motor Speedway, is a cross between NASA and Dollywood, where engineers work furiously on newer, faster cars on a campus that celebrates Rick Hendrick's history in automobiles-a history preserved in the cars he owned, sold, repaired, collected, and raced. Mr. H., as he is known, is the winningest team owner in the history of NASCAR. When he spotted Johnson, he was impressed with the unpretentious young kid who was sleeping on a couch and trying furiously to break into stock car racing–though the first time they met, Johnson kept Hendrick waiting. He had raced in Saint Louis with Hendrick's son, Ricky, who had dropped out of the race early and had offered his friend a ride home. This later gave the elder Hendrick an excuse to tease Johnson: "I had to wait two or three hours for you, and then I had to feed you cheeseburgers!" But Hendrick quickly felt close to Johnson, who in turn felt close to the Hendrick family. "He told me that he was about to sign a contract with somebody else," Hendrick recalled recently, "and I just said, 'No, don't do that. We want you.'"

Though Johnson was a star from the start, he had some high-speed assists with Hendrick's not insignificant resources (then as now, a lot of rookies can't even afford to race through a full year) and with Jeff Gordon as a mentor. Gordon, a road-tested superstar then nearing the peak of his NASCAR career, encouraged Hendrick to sign Johnson on. The finishing touch was Hendrick's likewise young and enthusiastic crew chief,

Chad Knaus. It was a match made in racing heaven: two guys from racing families who had the confidence of their boss. With Knaus in his pit, and with Hendrick and Gordon on his side, Johnson quickly won the pole at the Daytona 500, and then his first race at Southern California's Auto Club Speedway.

"With their experience and success, I had a road map to learn the racing industry," Johnson told me one day as we drove around Charlotte, remembering his start. "I had two mentors who had really achieved the highest of highest, who truly cared for me. So it was fast-paced. There was a lot being thrown at us." (And by "us," he means him and Knaus.) "I was," he continues, "in the perfect environment to thrive."

Johnson thriving turned out to be a way for NASCAR itself to thrive. His No. 48 was co-owned by Gordon, who made his name not just winning NASCAR races but building NASCAR's popularity—a wave that would only take Johnson higher. "Back then, there was kind of a perfect storm of a rivalry between Jeff Gordon and Dale Earnhardt," Johnson remembers. "NASCAR was very regional, but it finally became national and had a national TV package. You had Jeff Gordon racing to dethrone the icon of the southern man and, as that played out on TV, it grew the sport."

It was more growth than NASCAR had ever seen, and it had created the kind of fanbase that made sponsors hungry for more drivers. Enter the kid from Southern California—the Desert Rat, as the press called him—who was eager to do whatever it took to win, who saw a life as a racer ahead of him, and who was taken in by the Hendrick family and worked conscientiously to hold his place. And he listened to Gordon, who opened all kinds of doors for Johnson in the world of NASCAR, and who, in his competition with Earnhardt, opened the sport for America's fastest stock car racers. "That rivalry really nationalized the sport in big ways, and my career

benefited from that," Johnson says.

At which point in the Johnson story, Johnson offers the Jimmie Johnson mantra: "I was very fortunate."

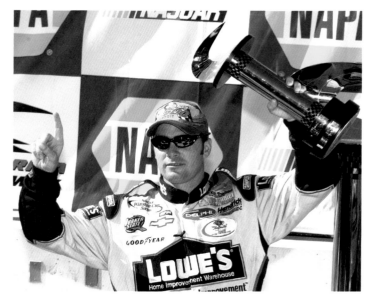

Like all families, the Hendrick Motorsports team could get a little complicated. As a kid, the one die-cast race car that Johnson kept in his bedroom was Jeff Gordon's No. 24, Chevrolet but as a racer, he eventually had to worry about Gordon crowding him on the turns. They were teammates and, eventually, competitors. "Forty-eight is testing my patience, I'll tell you that," Jeff Gordon, said after the two battled each other at the Texas Motor Speedway.

When reporters pressed him, Johnson kept his response curt. "It's an awkward, interesting dynamic," the mentee said of his increasingly confounding mentor. Awkward not in the least because Gordon was a co-owner of Johnson's car. Still, it was a dynamic that propelled the younger driver to rack up the wins in 2003, and then again in 2004, when he finished second in the standings, with what would end up being the second-most victories in a single season in NASCAR's modern era. Sadly, tragedy marred a huge win at Martinsville Speedway that fall—a tragedy that only brought the family closer. When the race was over, Johnson and his team were informed that a Hendrick Motorsports plane carrying ten people headed for the Virginia race had crashed near the track, killing Ricky Hendrick, Hendrick's son, among others. It was a deep cut for Johnson's racing family and for Johnson himself. "Jimmie's going to be a superstar," the elder Hendrick quoted his late son as saying. "He's going to be one of the greatest."

As if to fulfill his late friend's wish, Johnson's first NASCAR Cup Series championship came in 2006, after five wins, thirteen top five, and twenty-four top-ten finishes. (He also won the first of two Daytona 500s and the first of four Brickyard 400 victories.) Wins followed wins. In 2007, Johnson won his second NASCAR cup

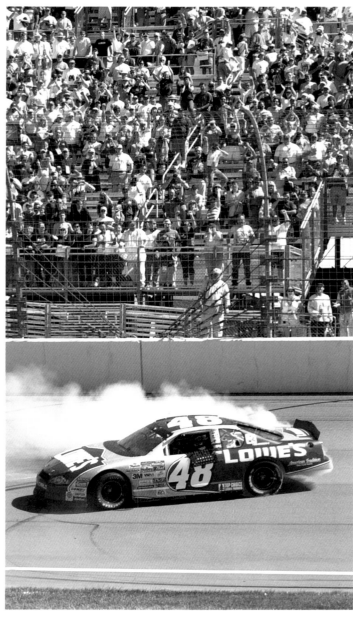

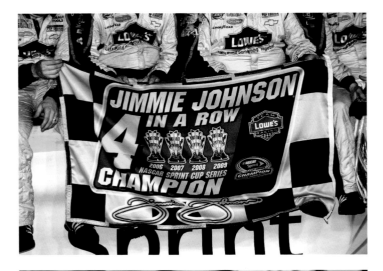

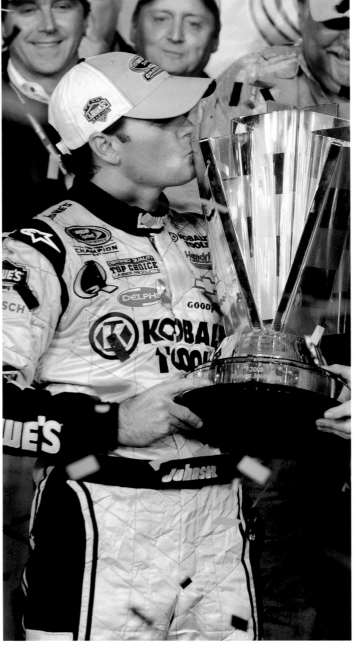

championship. Then, in 2008, he won his third. That third win was a career-changer in itself, a shift from star to legend. To put it in NASCAR perspective, with two consecutive wins, he tied legendary drivers like Dale Earnhardt and Richard Petty, not to mention Jeff Gordon, but with three wins, he tied Cale Yarborough, the star of the 1970s. It was, thus, not surprising that when he was mere laps away from winning his fourth at Homestead Miami Speedway, a track where he'd never been able to take the checkered flag, he would get a little rattled—so rattled in fact that suddenly, his forward progress was in doubt. Chad Knaus—his crew chief and, at this point, his Hendrick family brother—could read the tone of Johnson's voice like nobody else. He knew that he had to talk him through it while, lest we forget, Johnson was driving 200 mph or so. "I had to talk to him and kind of reel him back in," Knaus would later tell a reporter.

Suffice it to say, the mid-race counseling worked big time, and No. 48 took another checkered flag. As Johnson took his victory lap, Knaus radioed, "Jimmie, you are a rock star, my friend."

It was an amazing win—a feat for all sports. At the time, Bill Center, the veteran San Diego Union-Tribune sportswriter, summed it up for NASCAR fans and non-fans alike: "You might not be into NASCAR, but this is a dynasty that can match its achievements against the likes of the Yankees and Lakers. And Johnson is the four-wheel version of Tiger Woods and Lance Armstrong. A better comparison might be Michael Jordan and the Chicago Bulls—a great talent lifting the entire team."

"Jimmie is an incredible talent," Knaus told a newscaster after the race in Miami. "He is still the most underrated driver here. He's underappreciated by the fans, by everyone. He can do things no other driver can do."

When he won his fifth, in 2010, Johnson radioed in ahead to the pit crew to say he would need a minute to

figure out what to say. "I don't even know what it means!"

"Green! Green! Green!"

So goes the call through the drivers' headphones at 1:30 P.M., on Sunday in Portland, as the green flag is waved at the start line. The twenty-seven cars break from their two-by-two grid and power up through the opening straightaway, racing toward the first terrifying turn or, in the language of race cars, the chicane—a word related to trickery, which, in Portland, distinctly applies. Within ten seconds, cars are crashing and spinning through the turn that's really three turns in quick succession: a 90-degree right, with a 120-degree left, and a mercifully gentle right again onto another straightway. It is a melee as cars collide: Felix Rosenqvist's car hits the car of Álex Palou, and then Scott Dixon (Palou and Johnson's Ganassi teammate) is muscled off the track as a half dozen or so collide behind them: eight of the twenty-seven cars would have to head to their respective pits. But notice just behind the melee: the blue and yellow No. 48, moving quickly but patiently—staying cool, driving clear of the wreckage, Jimmie Johnson is driving his own race and will, after surviving the opening fracas, begin to enter the fray for real.

"Did you have any contact, Jimmie?"

"Negative," Johnson says. "I did not."

Scott Pruett is radioing Johnson the questions, sitting in No. 48's command center behind the pit box, alongside Eric Cowdin, the team race engineer, and five other technical specialists, who are all analyzing diagnostic data from the car, along with Johnson's on-track performance and the location and performance of the other cars. In the tent, video feeds of the track and its turns are considered along with reports radioed in from the No. 48 team's spotters, positioned at strategic points on the raceway. Pruett is Team 48's race strategist, and he is a kind of dream strategist from Johnson's standpoint. A former Ganassi driver, Pruett has won races in IndyCars cars and stock cars (and is a brand ambassador for Lexus). Additionaly, he's a five-time International Motor Sports Association, or IMSA, overall champion. He retired in 2018 to manage his winery but was lured from the vineyards to coach Johnson, who counted himself among Pruett's fans. "I've been around a lot of drivers and some of them talk the talk, but Jimmie walks the walk," he says. In a real way, Pruett knows where Johnson is coming from and what he's going through. "Knowing what that transition is like going from IndyCar to NASCAR or vice versa, the challenges are the same," Pruett told NBC Sports. "Great drivers will figure out how to drive any car fast. It's just a matter of time and a very steep learning curve."

"Jimmie," Pruett told me, "is his own toughest critic. Nobody's harder on Jimmie than Jimmie is."

Above all, Pruett is calm, cool and positive, as he was when he sat with Johnson before the race to work out the strategy for Portland's first turn. "I said, 'Hey, Jimmie. Turn 1 is going to be a disaster," Pruett recalled, "and you cannot cut through or you will be put at the back of the pack. So we went through all that before the race, and he really did beautifully. After it all happened, he went from twenty-something to fifteen."

There is a lot of translation involved: translating the car's mechanics and, translating the driver's body as it works to operate those mechanics. Pruett helps translate the car for Johnson. Then, with Eric Cowdin, the team engineer, he translates what Johnson is feeling and describing for the crew, tuning up the car with Johnson's driving and with the rookie's learning curve in mind. Pruett's goal is to give Johnson the car that feels like a car he can push. "Jimmie gets it," Pruett says. "He understands it. His muscle memory is changing. The thing that makes Jimmie a champion is that he listens, and then he applies what he learns." What most excites Pruett is this particular rookie's passion. "You see this guy in his late forties," Pruett says, "and his peers are in their late twenties. He does not have to do this. He wants to do this.

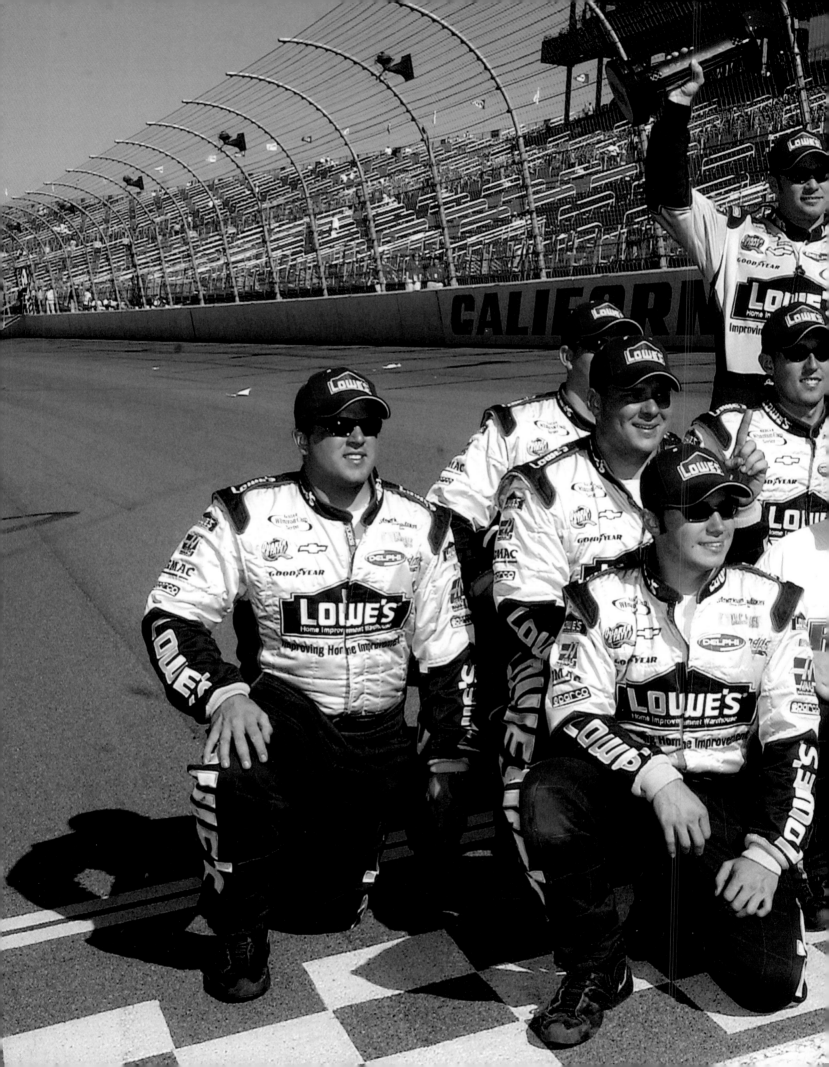

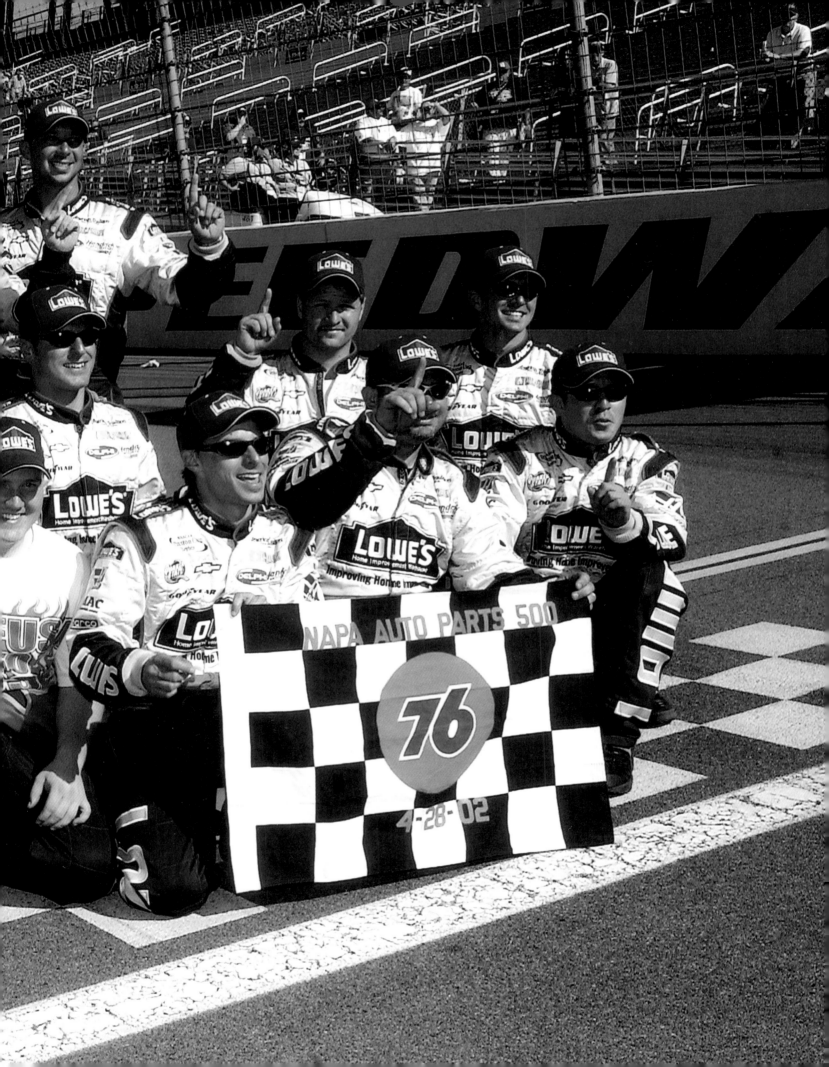

And he's passionate about it. When you're passionate about doing something, you can go beyond the normal. That's what I see happening with Jimmie."

The new Ganassi team has worked great so far. In Detroit, Johnson's practice was nothing to write home about—i.e., reasonable for a mortal but not for the rookie Johnson wanted to be. But hours of conversation and data analysis with Pruett and Cowdin made for changes that shaved nearly five seconds off his pace the next day. In a sport where the winners win by fractions of a second, five seconds is like a day at the DMV. Even Alexander Rossi, the 2016 Indy 500 winner, noticed. Rossi, No. 27 for Andretti Autosport, told a racing podcast host that he was struggling to get beyond No. 48, who had apparently mastered the IndyCar brake, as well as the gas pedal.

"Quite honestly, I couldn't pass him," Rossi said. "I was really impressed with his progression. He was driving his ass off and using up all the track, breaking late."

The mess from Turn 1 at Portland is cleared; a few cars head to the pits for inspection and repair. On Pruett's call, Johnson doesn't pit. During the yellow flag, he drives carefully, saves up some gas, and takes his place higher up the field when the yellow flag is lifted. As the race stars back up, Johnson stays with his game plan: to lay down laps, to increase his lap time, and to find the rhythm that moves him ahead, maybe to pass, all while working the high-tech steering wheel that, by the way, is another big adjustment from NASCAR. In NASCAR, the steering wheel resembles a steering wheel. The IndyCar steering wheel looks a little like something your kids play video games with—with paddles for shifting, buttons for everything from radio communication to pressing through the screen displays that (while you are racing!) give you data on your cars and the other cars around you. And then there's the button to overtake, a booster, which is referred to as push-to-pass. This sounds like magic, but is really just a matter of turbocharge.

"Should I be using the overtake?" Johnson radios in, early on.

"Absolutely, if you need it," advises Pruett.

Johnson is moving up from starting in the twentieth slot. He is pumping his brake hard but not too early, as he might try to, coming from a NASCAR experience that valued gentle braking, which called for maintaining a momentum around the track. To reiterate: all that experience is out the window—or much of it. Now, he must hit the brake harder than he ever hit a NASCAR or any brake before. He must hit it late in the turn, even if millions of years of evolution and survival gives us the very human inclination to hit it early like, now!

Meanwhile, in a kind of cruel irony, his NASCAR Chevrolet had power steering, whereas the Honda IndyCar does not. With G-forces, you can feel as if you are controlling all the weight of the car with your forearms. On certain courses at certain speeds, that weight can knock the wind out of you—strapped in tight like Chuck Yeager in an X-15. "It's a beast of a car," Johnson told another driver recently. "I'm so impressed."

Today, in Portland, it's his teammates who are impressed with him. He is driving confidently. At twenty-two laps, or about a half hour in, he is nudging up, maybe even getting a little more competitive than his team would want at that particular lap.

"Focus on the laps," radios Pruett. "Let's save our overtakes."

Among (many) other things, practicing for a few days earlier in the year is paying off.

"Find the pace. You're doing a great job," Pruett radios. "Keep doing what you're doing. You're doing a great job. Just keep ripping off these laps."

On a break a few days later, being asked by a reporter for the millionth time about the difference between NASCAR and IndyCar, he will try to sum it up in a

soundbite: "A NASCAR vehicle, you really need to be kind of just be very gentle with the car. It's a big vehicle, a lot of mass, and very small tires. These cars have so much potential that you have to drive like a crazy person every single lap."

Pruett is pushing Johnson a little more now, understanding that what is happening here is that Johnson is trying to discover for himself what he knew intimately in NASCAR but is still reaching for in Indy: where the edge is. Where is that place that, once he finds it, he drives near then pushes past when the situation calls for it? "Car in front of you just came out of the pits," Pruett says now. "If you can get by him in the back straights using push to pass, do it!"

"Tell us about the car. How are the brakes?"

"Pretty good but …" Johnson replies.

There's talk of adjustment on the pit stop. Remember, these conversations are happening between 40 and 160 mph, with the engines roaring through the Pacific Northwest afternoon. "Alright. Let's get some good laps going here," Pruett says.

"Keep the pace. You're catching the guy in front of you! . . . Go get him . . . Doing a good job, man! … You are hitting your marks. Be smooth…doing a great job!… That's it, stay on him. He'll make a mistake."

By the finish, Johnson has managed to place twentieth, his second consecutive top-twenty finish and his second consecutive lead-lap finish, showing he has a thoroughly competitive pace and speed. The winner is Álex Palou, Johnson's Ganassi teammate, who, in the winner's press conference, volunteers his thanks for Johnson out of the blue, as reporters' do a double take.

"Jimmie has been a really big help for me, I have to say," says the twenty-four-year-old IndyCar champion. Palou remembered when Johnson cheered him up after an engine failure during the Grand Prix at Indianapolis Motor Speedway the month before. "After the Indy road

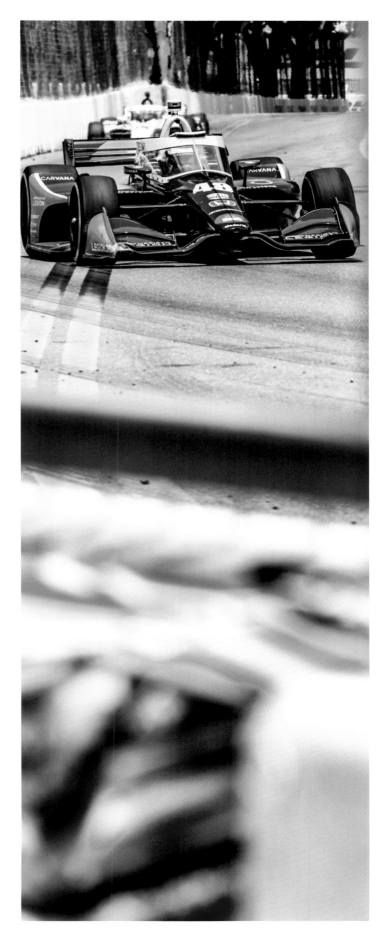

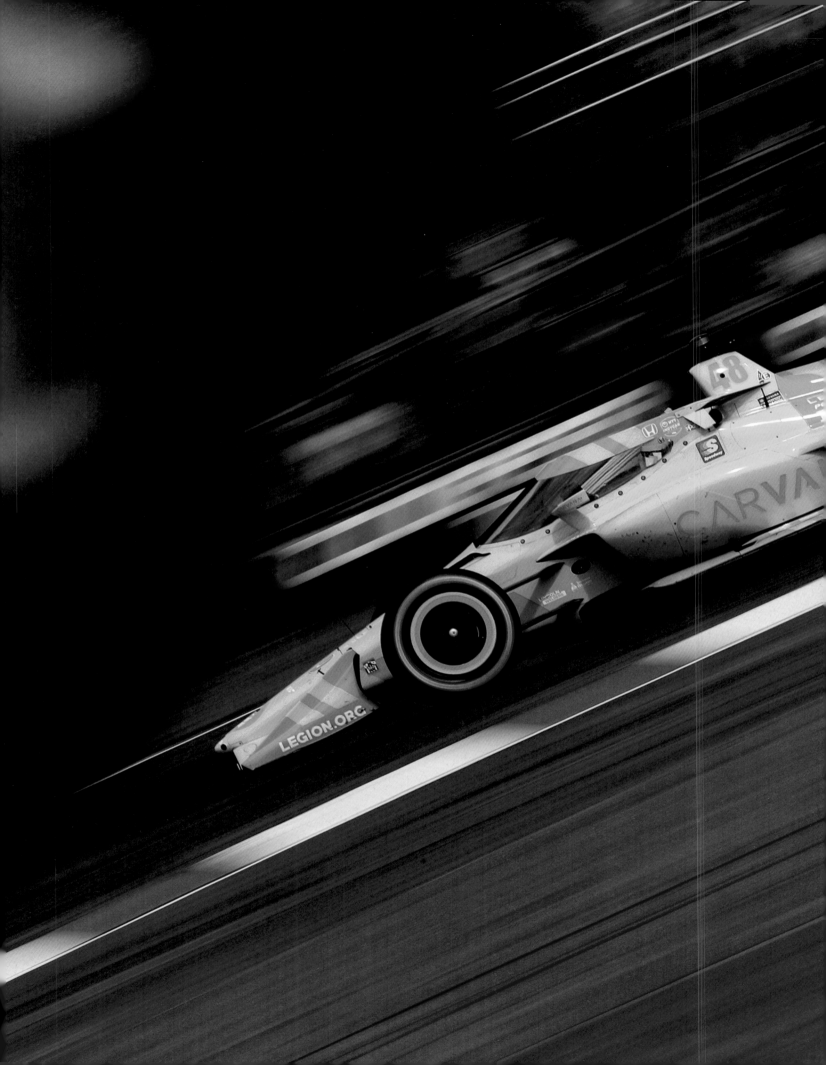

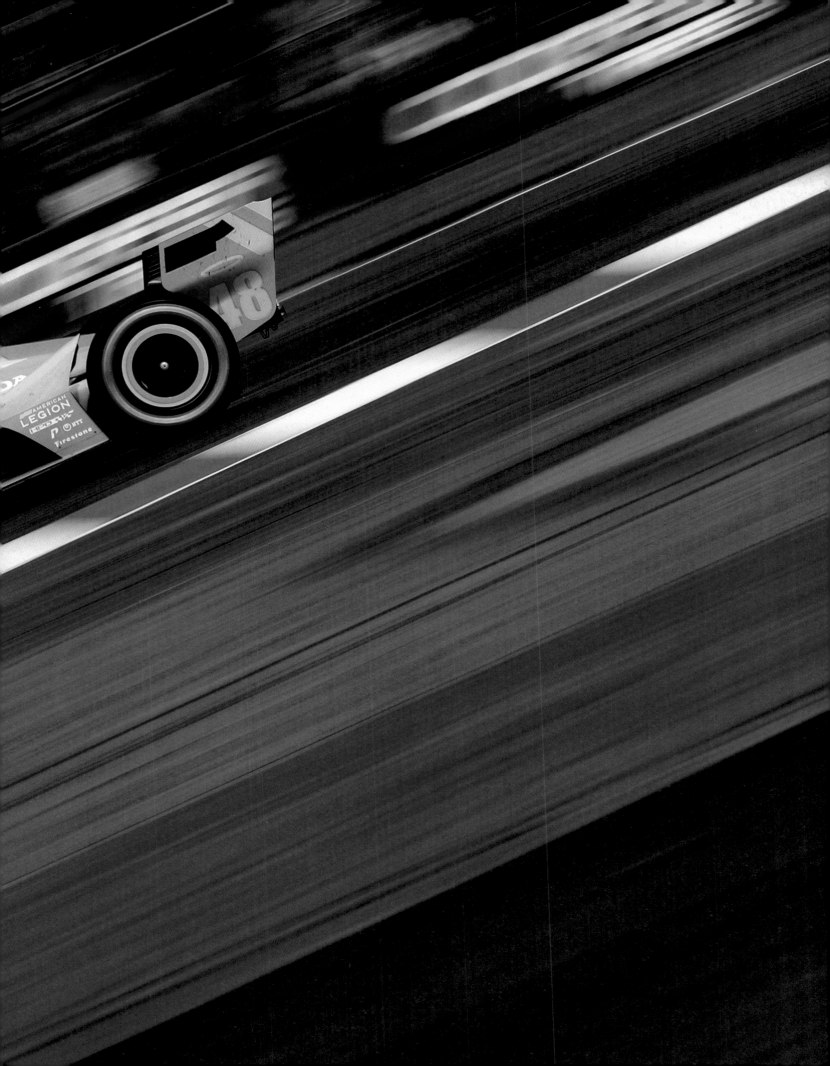

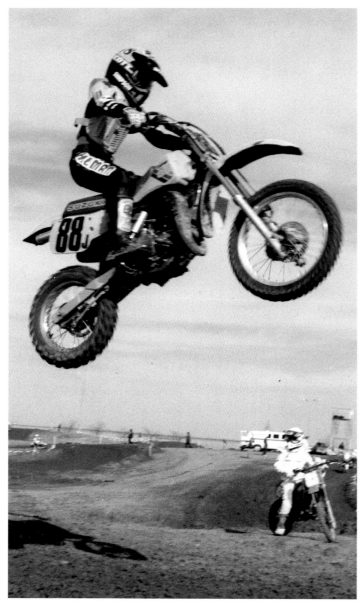

course, I sat with him," Palou said, "and he was telling me that early-on in his NASCAR career, he had moments like that and that he still won. He told me some tricks. He did the same after Gateway. Hopefully we can get a championship home."

When asked what kind of tricks, Palou would not divulge. "I'm not going to tell you," he said.

During his post-race interviews, Johnson, for his part, said that he was on his way, if maybe not as fast as he would have like. "Unfortunately, I may be stacking nickels, and I wish I was stacking quarters or more," he said. "But I closed up the gap so far. Now it's just down to those fine details, and it's just going to take more reps to really get myself closer to the front of the pack."

At one point on his West Coast swing, to the end of his rookie season, in between practice and his qualifying laps, Jimmie Johnson met with a group of junior racers, elementary school students who were invited by race organizers to ask questions of the superstar. The first question who was concerned with entry into IndyCar or NASCAR, or any kind of motorsports at all. "How can you turn into a race car driver?" a boy asked.

Johnson replied without missing a beat. "The best way to turn into a race car driver," he answered, "is to convince your mom to let you turn into a race car driver— or sometimes your dad, but usually your mom." He was relaxed and having fun, talking to the kids in a way that showed the fun he has with his own kids. (His daughters are eleven and eight years old.)

"How long have you been racing?" another student asked.

"I've been racing forty-one years." Silence. "Yes, I'm old," he laughed.

"How fast do you go?"

"Not fast enough. I always want to go faster," said Johnson.

Heads nod in understanding.

"Why did you win so many races?" asked another student.

"Well, it was a lot of hard work with a lot of great people. A perfect storm," replied Johnson.

"Are IndyCars harder than NASCAR?"

"Yes, by a long shot!" said Johnson.

One young fan asked if Johnson had ever raced on dirt.

"Yes, dirt is a lot of fun. Especially dirt with jumps." Johnson answered.

And then another boy asked the question that the adults had been asking for months: if he would ever race in the Indianapolis 500, which, at that point in the summer, was not yet a publicly announced ambition of Johnson's. He had been telling the press that he was thinking it over, talking with his racing team, his sponsors, and his wife. "I'm getting closer," Johnson said.

The Indianapolis 500 was something that Johnson dreamed about when he was a kid. This was before he wound up racing stock cars, back when he started out racing motorcycles. A story from Jimmie Johnson's own elementary school days gives an indication of how closely he tends to work with a given racing team. In this instance, he is seven or eight years old and racing a little yellow JR-50 Yamaha cycle that today he keeps in a warehouse in Charlotte—one that is stuffed with cars and an unbelievable number of trophies. At this point in his motocross life, he is a kind of veteran, racing since he was four. On this particular day, Rick Johnson is coaching him. Rick is eighteen at the time, and working as a professional off-road racer. Although he is close to Jimmie Johnson's family, they are not relatives—even though Jimmie wants them to be. "I always wished we were related, and I tried to believe we were," Jimmie remembers.

Jimmie is about to attempt a difficult jump on the course, and Rick takes him aside. "Jimmie, you can do this," Rick says. "If you hesitate, you're going to crash,

and you will get hurt. But you can do it." The eight-year-old Jimmie seems to take this in and, when at last racing through, pins the jump perfectly, soaring through the air on his Yamaha, ending with an exquisite landing. But then, after landing, Jimmie drives off the track and crashes. At this point, Rick runs to the boy, who is not hurt. "Jimmie, what happened?" he asks.

"I closed my eyes.", replies Jimmie.

"Your eyes were closed? Then why did you do it?"

"Because you told me to!" exclaims Jimmie.

When Rick Johnson got a contract with Herzog Motorsports, he pushed his young protégé. Today, the elder Johnson tells the story of Jimmie's decades-ago motocross jump as an early indication of not just trust, but commitment. It was a commitment that Rick Johnson experienced firsthand. By the time Jimmie Johnson was eighteen and racing against Rick Johnson in stadium dirt races, Jimmie would jump bigger and crash bigger and go bigger overall—and he would win, eventually pulling ahead of his mentor. "He's willing," Rick Johnson tells people today, "to put it on the line."

People say Jimmie Johnson retired from NASCAR, but the reason it's really not possible for him to retire is that racing has never been an extracurricular activity for Johnson. It has been his life—a life that started in a trailer park in El Cajon in the hills outside of San Diego, where his mother was a school bus driver and his father a mechanic. Occasionally, he and his brother, who was three and a half years younger, might be able to ride along on a summer trip to the zoo on one of his mom's school bus trips, but for the most part his parents left the house early. "We were on our own and got ready and, you know, didn't burn down the house," he says, marveling at the notion now that he is himself a parent. After school, he and his friends thumbed for rides up the back of the Granite Hills, threw their bikes in the back of any pickup truck headed to the top, and coasted down

with friends for hours on end. "And then when I got my license, I gave kids a lift to the top too," he says.

On weekends, Johnson, his parents, and his brother were off to the races with motorbikes thrown in the back of his dad's 1979 Econoline van, as well as games and sleeping bags. (A second brother showed up just as Johnson was headed to high school.) They raced and pitched the family tents everywhere, Johnson happily mistaking finite financial resources for luxury. "We camped all the time," Johnson remembers. "In the winter, we'd camp in the California and Arizona desert, and in the summer, we'd be at the Colorado River—the van stuffed with towing gear, trailer receptacle, trailer, and toys. Even when we raced dirt bikes across the country, we'd jump in the van and my dad would drive that thing all the way to Oklahoma or Tennessee." If it broke down, his dad fixed it and tried to teach the kids to do the same. "My parents were very interested in us learning a trade. You should see my brother weld aluminum! But I somehow avoided that by racing."

When the Vietnam War ended, Jimmie's dad came back to El Cajon to work in his grandparents' motorcycle shop, called Ken and Ruth's Kawasaki, in the service area. Later, the elder Johnson operated heavy machinery. By the time Jimmie was a kid, his dad sponsored Rick Johnson, Jimmie's motocross advisor, and eventually serviced an off-road racing team, getting to know the tire company and eventually encouraging them to sponsor his own son in in short course off-road racing. Jimmie raced what are essentially covered dune buggies and then Chevrolet trucks. The trucks flew around an indoor course, sliding and jumping and careening—a version of *Mad Max* that would turn up at your local sports stadium. On such courses, Jimmie Johnson was a natural—jumping higher, taking competitors on the turns, winning rookie of the year in each new series he entered and finally riding off-road trucks in

longer and longer races. He was a star on the rise, though by the time he was racing longer races outdoors in the southwestern desert, he had an accident that changed him.

It happened in 1995, in the Baja 1000, when, unbeknownst to him, he was leading the 1,000-mile race from Ensenada to La Paz in Baja. At some point very early in the morning he fell asleep at the wheel of his off-road truck. "I was pretty far into the race, like 800 or so miles in," he recalls. He had just come through the Sonora mountains in the rain and, at around four in the morning, as he was descending toward La Paz, he dozed off, awaking as the truck was mid-air and tumbling. He landed in a ravine with his co-rider unconscious. For a minute, Johnson feared his companion was much worse off, though he ended up okay. Johnson had nothing for communications except a CB radio that wasn't picking up anything. His companion finally woke. Johnson got to spend the next twenty hours waiting, worrying, and rethinking his career to that moment. Prior to Baja, he was a twenty-year-old racer who could flip hard and jump far to win. "Up to that point," he says, "I was fast and took a lot of chances. Literally, my job was on the line because these manufactures, you know, they want a champion, not just a fast guy." By the time his road crew found him, he was transformed. "That moment just really changed me, and got me to say, 'Dude, you're not going to have a job. You're not going to be a championship driver!'"

After Baja, he was still fast. but he vowed to be smart, to weigh percentages, and to develop what is known in the field as race craft—the art to know when to do what and what to do when in a split second or faster. After Baja, Johnson drove with his head. Baja changed him too in terms of training—turning him from a short course racer into an athlete concerned with endurance—specifically, the four-hour races that a NASCAR racer had to endure. Three years later, when he finally made it to NASCAR, he took what he'd learned off road and used

it to his advantage on the track. He took what he learned in life: to find people that he trusted and trust them, and to work as hard as possible to follow through.

"It's pretty wet out here," says Johnson. He's radioing in from No. 48, taking some practice laps in the misty gray morning at Laguna Seca on the day of the Monterey Grand Prix, the second to last race of the season. It's one of the more gorgeous racetracks on the IndyCar circuit or any circuit, with its famed corkscrew turn, descending from the coastal hills, this morning draped with clouds clearing out of Monterey Bay.

"OK, drive conservatively," Scott Pruett, Johnson's racing strategist, radios back. "It'll be sunny for the race."

Johnson pits, and the eight crew members descend on the blue and yellow car. Just as a cable is plugged into the dashboard to read the engine's diagnostic, Johnson, after climbing out of the car and stripping off his helmet and fire-retardant hood, seems to lock into Pruett, who is mostly asking questions, nodding. Eric Cowdin, Team 48's engineer, is standing by.

"The biggest thing I've seen Jimmie adapt to is the rate of change—to how quickly things happen," Cowdin says. Cowdin marvels at all Johnson's been working through: "The braking happens so quickly. The time for him to go from maximum speed on the straightaway to minimum speed on the corner. Everything that has to happen, all the nuances, all of the finding the car on the edge of its performance has to happen in a much tighter time frame. He has actually developed from learning the basics—knowing how to brake, learning the edge of the tire adhesions, knowing when to turn and how hard to turn the steering wheel—each one of those individual skill sets—to the point where, at Portland, they came naturally so that he could focus on driving and on the nuances of the track, not the nuances of the car. To me, when Jimmie says that he's getting in the groove, things

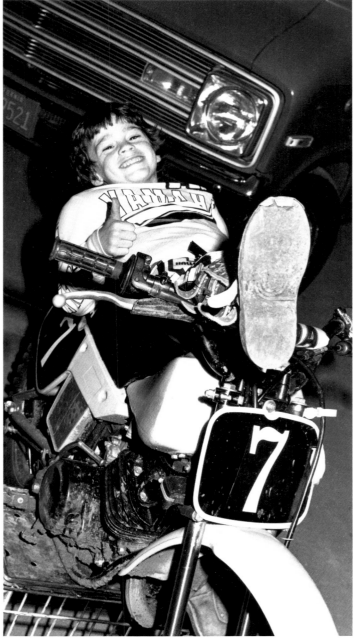

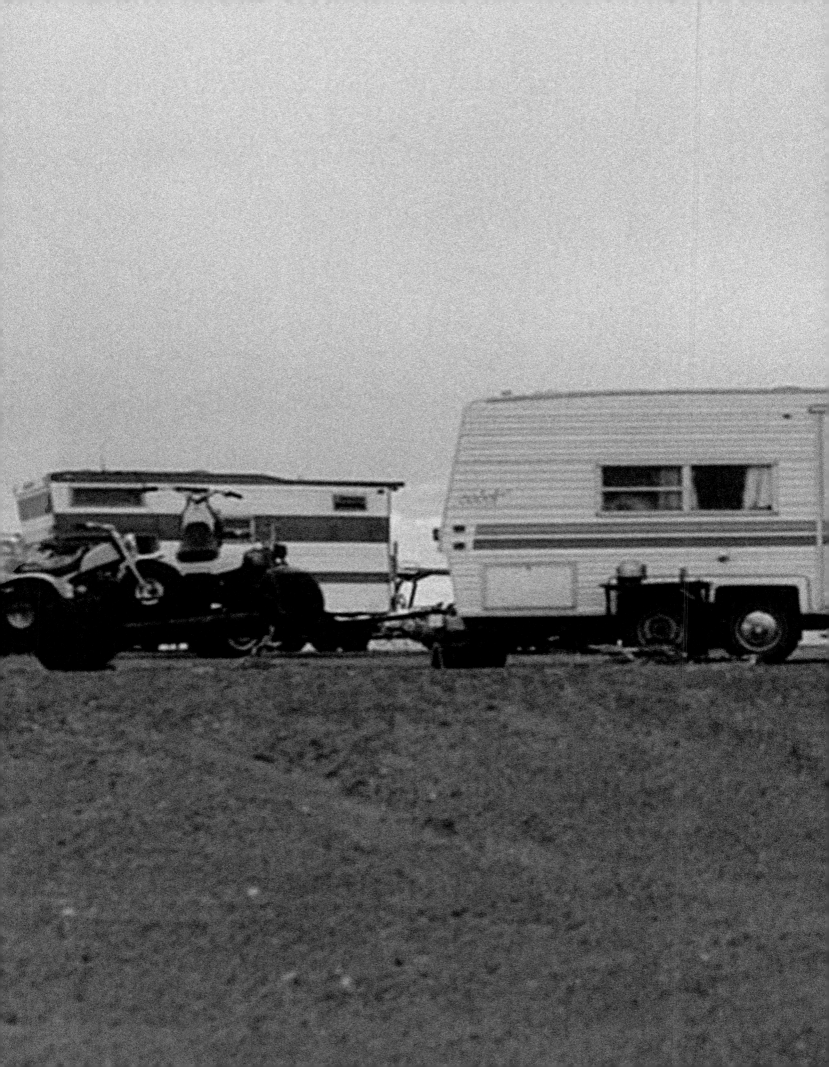

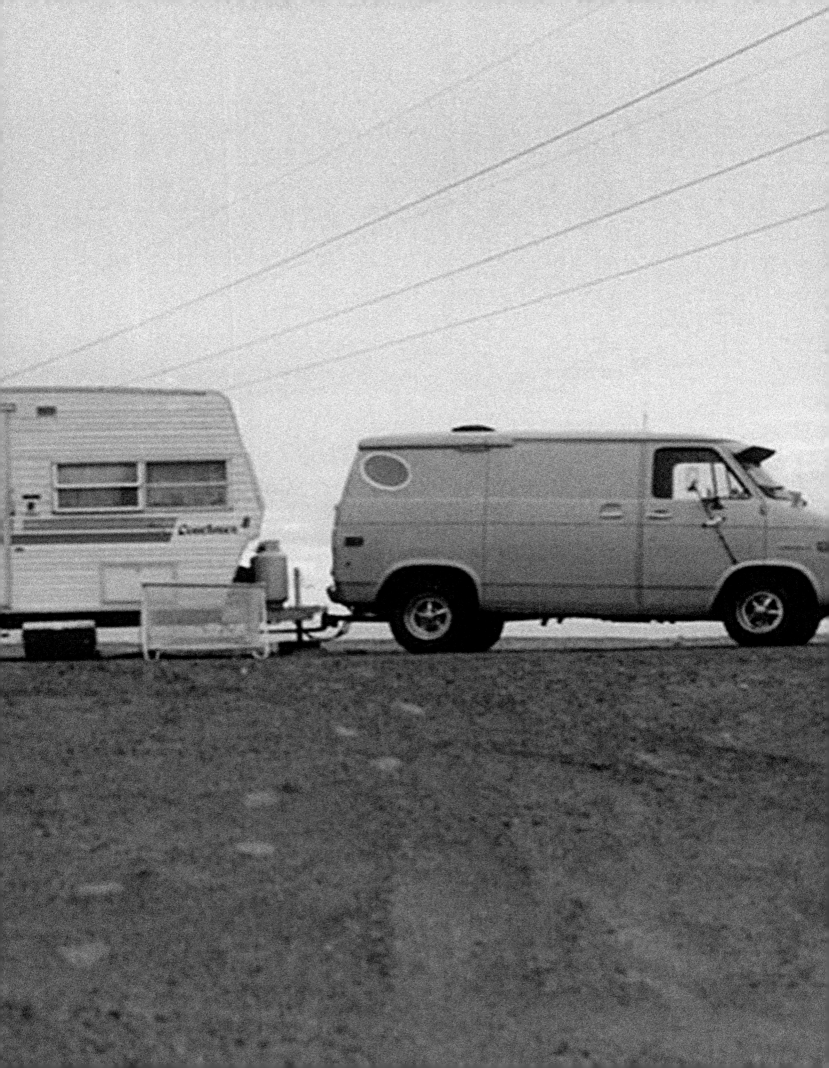

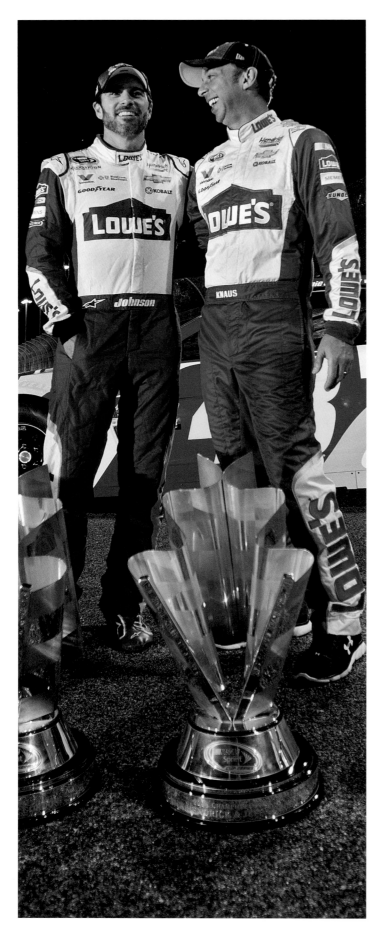

are starting to click, and he's thinking not about driving the car but about driving the track."

Pruett predicted Johnson would find a groove as his rookie season wrapped up. Just as Pruett also predicted, the sun is out by eleven, and the track is dry by noon. It turns into a gorgeous day on what happens to be Johnson's birthday weekend. Johnson has friends in town to celebrate after the race, and his wife Chandra is in town too. After practice, Chandra stops in at the trailers to say hello. She notices how excited her husband was post-Portland Grand Prix and that he has been talking about feeling competitive at last. She notices too that he was being too hard on himself, or so she thought. "He was hoping he would be there earlier," she says later. "But he hasn't had much seat time in these cars. The practice time is limited. I reminded him, 'It took you about five years in NASCAR to figure it out, and that was with double the races, much more practice—so just think about that,'" I said. 'It's amazing in this short time what you have been able to accomplish.'"

Now, both Johnsons greet Dario Franchitti, the retired Indy 500 winner who is now a Ganassi coach. As a driver, Franchitti was a Ganassi teammate for five IndyCar seasons with Scott Dixon, the other Ganassi IndyCar driver hanging outside the trailers now. The Ganassi team is chummy, sharing data (under the theory that all boats rise together) and jokes. Franchitti, a Scotsman, is teases Johnson about moving to London as Dixon tells a TV crew that he thinks Johnson is both amazing and a little crazy. "I don't think there are many people who would ever try what he's been doing," Dixon says. Álex Palou talks about hearing his phone at 6 A.M., Johnson asking about a turn at a time when most people are struggling to make coffee. "He'll text me at 6 A.M. and say, 'Hey what'd you think?'" Palou says. He also volunteers that he, like everybody else, is urging Johnson to sign up for the Indianapolis 500 next year. "C'mon, Jimmie," he says.

By noon, Johnson is headed back to the car, and the No. 48 team is huddling. "Let's have some fun," Pruett says.

"One hundred percent. No more, no less," Johnson adds. If he seems a little subdued, a little something-or-other, it's because he is working overtime at that moment, as he will note later, in an effort to beat the butterflies down and tone down the adrenaline. He's so excited, his heart is racing. He smiles, sort of … "Let's have a great day!"

—————————————————

If Johnson prides himself on being the best driver he can be, he prides himself too on being a hard-working member of a racing team, as is indicated by his collaboration with the racing team at Ganassi but also by his track record with Hendrick Motorsports. The driver drives the laps and holds the cup during the victory celebration, but racing is a team sport—a collaboration between the person steering the car and the engineers and crew. The relationship between Jimmie Johnson and Chad Knaus, No. 48's crew chief, was the fulcrum of Johnson's NASCAR cup-winning streak. As they racked up cup races for Hendrick Motorsports, they became NASCAR's Lennon and McCartney, automotive brothers. "These guys were almost unbeatable," Hendrick says.

In 2006, when the phone woke him up the night before the Brickyard 400, Johnson wasn't surprised that it was Knaus. "He had an idea for the left front shock that he wasn't sure was going to work," Johnson says.

Shocks, of course, are everything. A wedge adjustment, as it's known, will change the tension in a car's suspension and make for a subtle shift in how the driver controls the car, changing the way he comes in or out of a turn, which are matters related to steering being loose and tight or, in the drastically different language of IndyCar, matters related to what's called over- and understeer. "We had tried it in practice, and it wasn't conclusive. But as Knaus was sleeping with it, it dawned on him in the middle of the night that it was going to

work. "I would stay up late churning through data and paging through notes," Knaus says.

"So Chad called me around midnight," Johnson says, "and he's like, 'I got it! I know this is going to work!' I said, 'Sure, go for it! I'm going back to bed.'"

It's about testing the car, timing it, adjusting jack bolts in the rear of the car, setting out again, monitoring the camber or tilt of the wheels, balancing weight and speed, and always pushing things, while—as the motorsports saying goes—"trying to find speed." When things started to go south results-wise for Knaus and Johnson, their irritation with each other boiled over. Once, in a radio exchange overheard by America during a 2011 race at the New Hampshire Motor Speedway Johnson shouted. "Dude, your cheerleading is terrible," he said in one memorable exchange—a rare instance of Johnson losing his cool. In Johnson's defense, it had been a rough day. The car's right-front suspension had been smashed, thanks to Kyle Busch's car, with only a dozen laps left to go. In Knaus' defense, he was trying to rebuild a relationship using the tools that were cutting edge when they started but had gradually worn out. At one point amid the bickering, Hendrick sat them down in his office and presented them with a gallon of milk and snacks. "If we're going to act like children, then we're going to have some milk and cookies and a time out," he said. He left the room when they finally started talking.

They won another Cup in 2013, attended therapy together for a time, and managed to win one more Cup (Johnson's seventh), in 2016. But in 2018, they went winless, the first time in Johnson's career. Subsequently, they split, though they've remained friends. Johnson sounds nostalgic when he sums it out for me: "We had seventeen seasons together, and all my success came with Chad at the helm, but we weren't being productive anymore." Recently, Johnson reunited with Knaus in a Hendrick Cadillac, a No. 48 racing on the IMSA Circuit. It was a chance for Johnson to try another dream car and

to be on a team not just with Knaus but two other drivers in the twenty-four-hour race in Daytona. Hendrick is very happy. "To have Jimmie and Chad back together in the Cadillac is so cool," says Hendrick. Knaus enjoys working with his old friend again—this time with Johnson in a twenty-four-hour race split between three racers working in shifts. "It's a high-performance vehicle that you need to drive at high speed and also protect during the race," says Johnson. "You're basically trying to keep yourself in contention for twenty two hours. Everybody talks about the race starting with two hours to go."

It's a type of driving that complements his IndyCar training while also adding to his menu of post-NASCAR experiences. In 2020, when he retired from NASCAR, he wasn't just looking for a new car, he was looking to change things up: to drive with a new routine—a new version of racing work mixed with a new version of life.

The high-pitched roar of the Grand Prix of Monterey commences. It's the sound of automotive precision—hyperefficient horsepower—as those twenty-seven cars disassemble from their starting grid and pour like a multicolored stream onto the twists and turns of the two-mile-long Laguna Seca Raceway, moving up and down in a thirty-story-elevation change through eleven turns. The dry green coastal hills watch over the cars, as does the crowd camped out at the top of Turns 8 and 8A, the infamous twist known as The Corkscrew. A spotter at that hairpin turn at the start of the course radios in early: "It's a shit show at one and two!"

It's not Portland's first turn, but it's not good either. Johnson hits his brakes after the straightaway, downshifts, then shifts up and eases through. Today, the team is not just pushing Johnson, but pushing him to shift his racing demeanor—to move to where he wants to be, no longer just learning but racing. "Overtake is available," says Scott Pruett, referring to the steering wheel's button for extra passing power. Referring to Alexander Rossi,

an Indy 500 champ, the race strategist says, "Rossi, behind you, is a lap down."

If things were good in Portland, then they are looking even better in Monterey, as Johnson holds his pace as he overtakes cars and battles his way through the field. He is up two cars from his starting position just a few minutes into the race.

"Alright, let's get some good laps here," Pruett says. Then, a few minutes later, he says, "Keep that pace. You're catching the guy in front of you!" The leaders are doing a lap in 74.4 seconds and 75.5 seconds—Colton Herta and Álex Palou, respectively. (Herta will eventually win.) A few minutes later, as Johnson approaches another car, Pruett radios, "Go get him!" They are sensing Johnson's energy and confidence and urging him forward. "You are hitting your marks," says Pruett. "Be smooth. You're doing a great job." An hour in, Pruett's counsel is calm, or an aggressive calm, you could say. "Stay on him, man. He'll make a mistake," he says. Johnson may not be in first place, but he is way ahead as far as Team 48 goes. "That's how we'll win the race," Pruett tells him. He is passing cars ahead of him. He is ahead of drivers who have won the Indy 500 (a big deal) and holding back a couple more.

At some point, Johnson mentions oversteer. "Ten-four," says Pruett. The car pits. An adjustment is made. The tank is filled and splashed with water to check any potential invisible flames as it scoots from the pit. It seems like a thousand hands move to fuel and adjust in six seconds.

With about six laps to go, coming around a hill, Johnson battles with Romain Grosjean, who is closing in on the two race leaders, Herta and Palou. On the treacherous Corkscrew, Grosjean swipes Johnson's car. At one point, the two racers appear to be riding only two of their combined four wheels. In a few seconds, Johnson lets Grosjean squeeze by, but the message is clear: Jimmie Johnson's No. 48 can fight in a turn. A whoop goes up in the No. 48 pit.

The checkered flag is waved. Herta wins, and Johnson

pulls in. He has finished seventeenth, matching the previous week's success. He thinks he could have snuck up to fifteenth but, before he can say so, Johnson is out of seat and standing before Pruett, the two of them beaming. "You were racing today, man," Pruett says. "That was really cool. That was awesome. Really good."

"That was a lot of fun," Johnson says.

Pruett's running down the list: "Car looked solid. You look solid. Looked like you were just really comfortable."

Johnson is nodding and beaming.

Later, Pruett will elaborate on how pleased he is about Johnson's increasing fluency in the language of his new car. "He was asking for things from his car from an Indy-Car perspective, not a NASCAR perspective. That was his best race of 2021 by far. Jimmie had a breakthrough. Now, we're going to be talking about qualifying. That's the next step on our way up."

The success means continued success the following weekend at the Long Beach Grand Prix, where he also finishes seventeenth. The Ganassi teams finishes well for the season too. With three drivers in the top six, they were breaking a record set in 2005 by Roger Penske's team. It was a nice showing that has its own sweetness given that Long Beach, in the Los Angeles suburbs, is the course that Johnson grew up visiting when he was just starting out as a teenage driver. "As a racer in Southern California, IndyCar was it," he says. The success also means more prodding by friends, fans, and, of course the press, regarding the Indianapolis 500. In large part for matters of safety, Johnson has constrained himself to road courses and street courses and avoided ovals, which are faster, out of concerns about safety. Will he feel comfortable attempting what is essentially the fastest race in motorsports on an oval track? At the Indianapolis Motor Speedway, in Speedway, Indiana, in 2022?

He is working on that is what he tells reporters. He is pouring over schedules and still talking to his sponsors

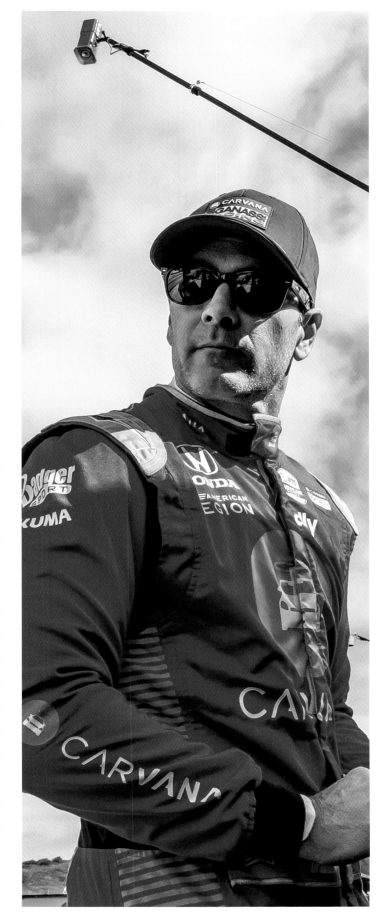

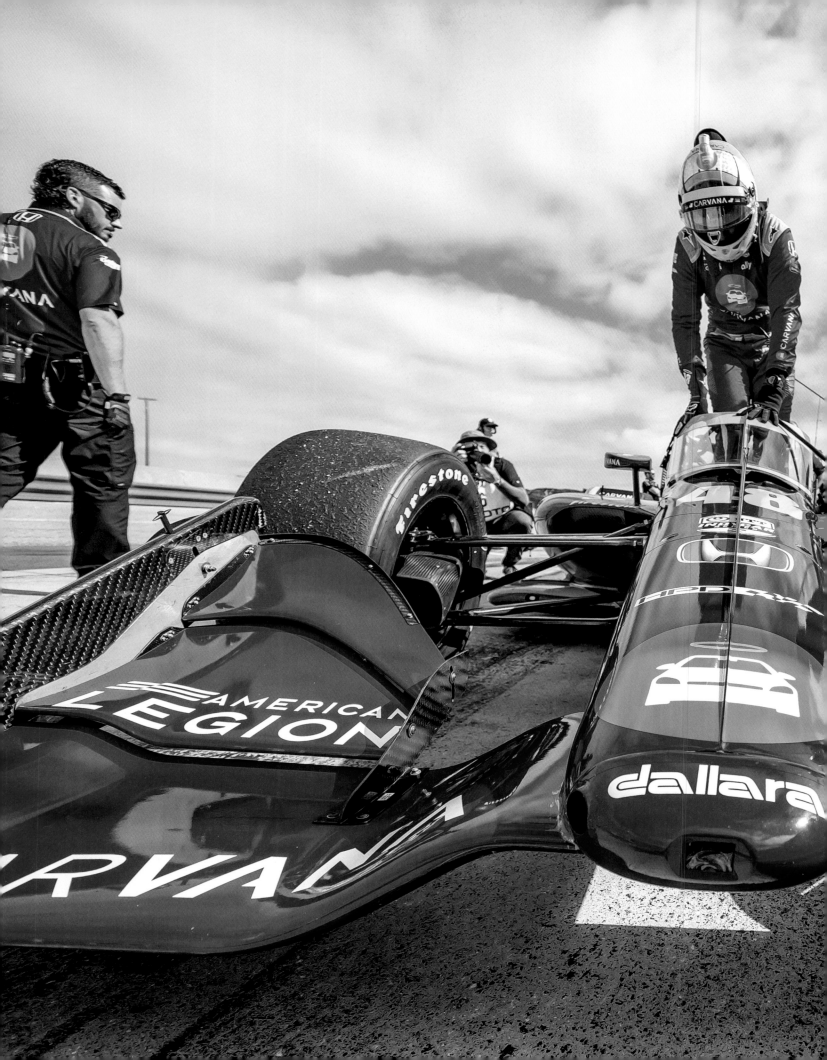

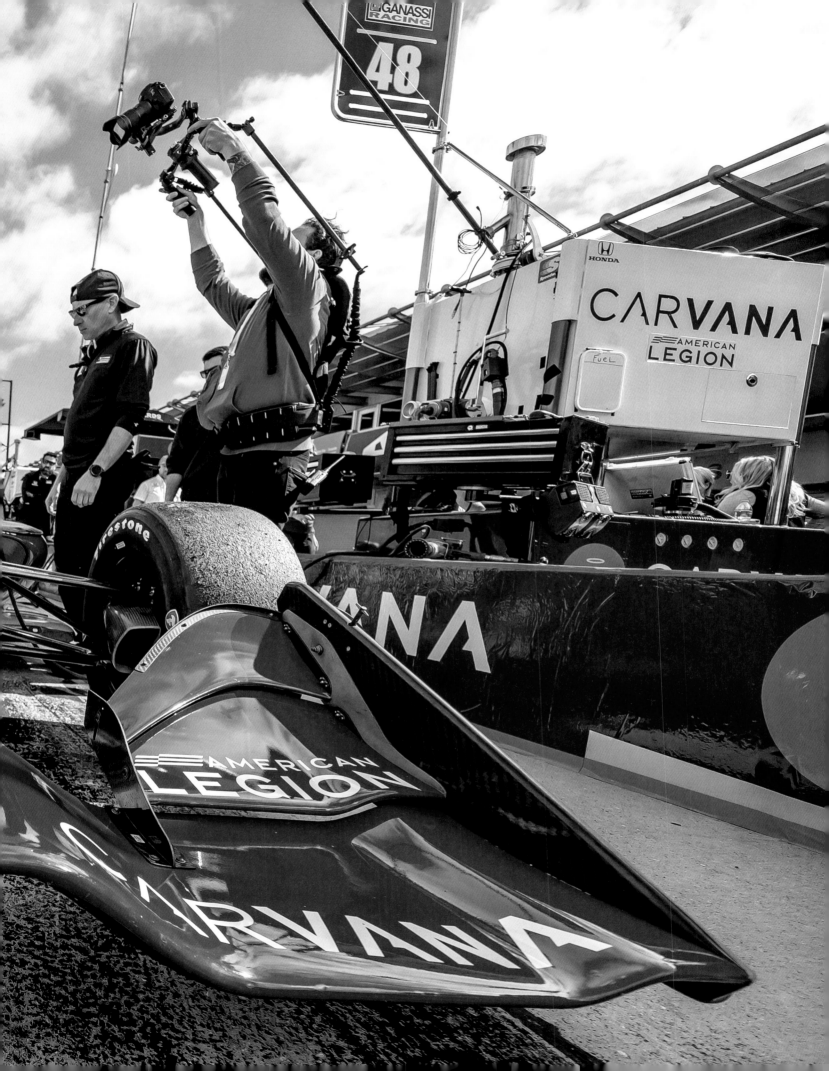

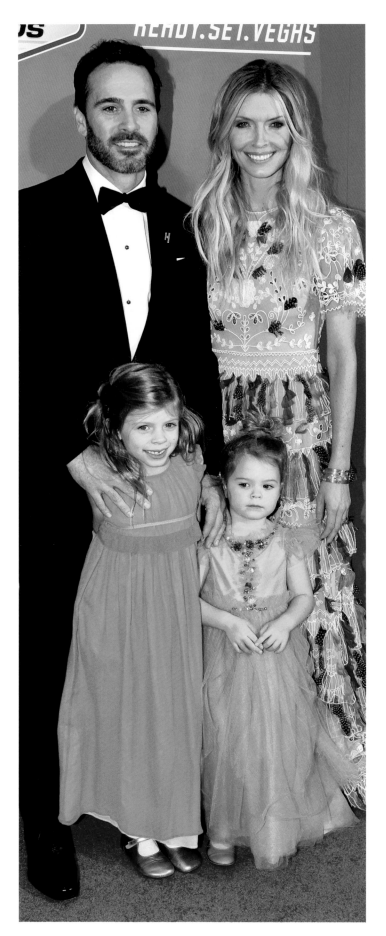

and, most crucially, his sponsor at home. But after Long Beach, he is content to savor the last days of racing as a rookie. When he talks about those races, he kept returning to Monterey and Laguna Seca. "I mean, I finished my career highest at that point," he says. "Which from a thirty-thousand-foot view was a nice accomplishment. And specifically in the race, I think there were twenty-eight cars and I finished seventeenth. So that was a lot of overtaking and working my way up through the field." Although he would file the moment away as the season faded, arranged among the myriad small mental victories that were now nicely piling up, when I talked to him just after he still felt charged from managing to fend off a pass by the leader, Colton Herta. It was a day when cars were wearing out their tires, and it all came down to strategy. Suddenly, his spotters radioed him that the leader was nearby. "So, the team is telling me that the No. 26 car, which is Colton, is the leader. On my dash, I notice that the No. 26 car is now behind me. I look in my mirrors and I start to panic."

What does panic mean for Jimmie Johnson? Well, it's not the same as for the rest of us, but it would likely be perceptible on a brain scan at that particular moment in time, categorized as what evolutionary biologists refer to as the fight-or-flight response, though Johnson sees it in that moment in terms of the course and the guy behind him. "That fear, that anxiety runs through your veins. The race!" says Johnson. "And we were trying to stay in the top twenty-two in points, so there were championship points on my mind." As he tells it, he managed to calm himself by breathing and heading Scott Pruett's steady calls.

"I realized I'm holding him off! He's not getting by!" says Johnson. "And then I start to exhale, and then I start improving my lap time. I really stop thinking about him after a while. After four or five laps, I'm like, alright, he's not getting by.'"

And he didn't get by, until No. 48 hit the pits, at which

point No. 26 just inched out faster. You'd probably have to remind him about it if it ever happened today, but as he ascended through his rookie season, it was a tasty note—another little thing to build on. "I was able to hold him off for a long, long time," Johnson says. "Coming from the NASCAR world, where getting lapped is an embarrassment, and with the new learning curve I'm on, to hold off the leader and avoid being lapped for an hour was a pretty damn big accomplishment."

A little after 8:30 A.M., Jimmie Johnson eases his Tahoe slowly into his driveway in Charlotte, North Carolina. His house is a redesigned builder's home in a quiet tree-lined neighborhood. He steps inside to make me a very good cup of coffee, and then, elbows on the counter, gives a sort of dramatic reading. "Listen to this," he says.

As he reads, he is dressed in jeans and a crewneck sweater, having traded the racing suit for his trademark relaxed and low-key offtrack vibe. He is reading an excerpt from *Hunter*, E. Jean Carrol's biography of the late, great Hunter S. Thompson, who Johnson has gotten to know, in a sense, as a resident of Pitkin County, Colorado, where Thompson lived and where Johnson and his wife Chandra love to ski and now love to ski with their two daughters, Genevieve, 11, and Lydia, 8. (They've owned a home there since 2013.) The drama of the lines Jimmie is reading works better when you know that he has just dropped the kids off at school and when you know that, after some work downtown for his foundation, he is aiming to take the kids to dance lessons. Dance lesson pickup time is kind of like lap time at Laguna Seca: you want to hit your marks. He was inspired to read from *Hunter* after I admired a large, framed photograph taken by Hunter Thompson of the Hell's Angels, the bikers Thompson famously reported on in 1967. It is one of many art pieces in the house. The great number and diversity of artworks on the walls is due in large

part to the fact that Chandra Johnson owns SOCO, an art gallery in the nearby Myers Park neighborhood of Charlotte. She is off on an art-related trip today, leaving Jimmie solo with his home team and thereby—and this is partly where the drama is in Jimmie Johnson reading aloud about Hunter Thompson, a guy whose writing he admires and who still feels like a part of Aspen after all these years—putting Jimmie in a position that is acutely opposite that of Hunter Thompson, in terms of parental responsibility but also in terms of maintaining the kind of peak physical condition that Johnson aspires to as an IndyCar driver while simultaneously being a parent, speaking of great physical feats.

"Okay," Johnson says, "Here's how Hunter Thompson spent his day: At 3:00 P.M., he gets up. At 3:05, he has a Chivas Regal with the morning papers and a Dunhill cigarette. 3:45: cocaine. 3:50: another glass of Chivas and a Dunhill. And 4:00: another cup of coffee."

Jimmie's shaking his head—in part because he got up early and worked out in his gym and in part because, after he gets the kids home from dance lessons and feeds them dinner, he will be in bed by midnight. "Midnight," Johnson says. "That's when Hunter S. Thompson is ready to write!"

Johnson ends the reading, half freaked out and half amazed by the strange but committed discipline. Nothing commands Johnson's respect like dedication and discipline.

"Let me show you around," Johnson says.

The house is lovely, filled with a mix of prints, paintings, and photographs that make sense given Chandra's expertise and keen curatorial sense. Aside from running the gallery, she sits on the board of the Mint Museum and the North Carolina Museum of Art. The couple has collected paintings and prints together for seventeen years. (Chandra has visited artists' studios on nearly every NASCAR series race stop.) If some art collectors tend to make their home into minimalist spaces, showcasing the art above all, the Johnsons have made a place where you

immediately feel at home. "The goal was to have every kind of art—from Sol LeWitt to our daughters' paintings living comfortably in the same room," Chandra says. The success of that goal makes the house feel relaxed and lived in, with a Richard Pettibone complementing the family calendar. The kitchen is like an IndyCar control room but for relaxing and hanging out. Despite its share of trophies and old photos, Jimmie's upstairs office is less like a man cave and more like a place to make decisions or, during the Covid-19 lockdown, teach the kids at home. "Teachers are saints," he says on a Zoom call during the pandemic.

The gym is out back of the house in the garage-turned-carriage house where guests stay. Jimmie seems tickled to show off a guest book signed by all the artists they have hosted. Imagine Jimmie at seventeen as a student at El Cajon's Granite Hill High School being hard pressed to picture his life at forty-six, commuting between Charlotte and a racing simulator in Indianapolis, with a house in Aspen, and reporters calling and wanting to know if the legend of NASCAR will race the most famous oval in the world at Indianapolis Motor Speedway. Today, he is remembered fondly at Granite Hills High as one of many so-called desert rats from the class of '93. It was a hotbed of motocross. He is also remembered as the swimmer, diver, and water polo player who was inducted into the school's hall of fame. (The number 48 was retired from all Granite Hills jerseys.) He is known today in El Cajon (and at schools in the Charlotte area) for the work of the foundation that he runs with Chandra, with grants to build spaces at Granite Hills, as well as donations to the local chapter of Habitat for Humanity.

Chandra remembers Jimmie first as a friend. They lived in separate cities. She was working as a fashion model who was based in New York, and he was a racer who was based in Charlotte. They had been introduced by Jeff Gordon and Richard Bren in 2002, when Jimmie

was a rookie. Jimmie was just starting out and not yet a household name. They were married two years later. Chandra moved to his house on Lake Norman in Charlotte, a bachelor's pad that was, as Chandra describes it, just how you would imagine a bachelor pad, no offense to bachelors—heavy on the big screen TV. "There was a leather sofa," she recalls. "The house was on a lake. It was a lot of fun." Their house in Charlotte was their first partnership as a couple, and it was Jimmie's first foray into design, just as visiting Jimmie at her first NASCAR race had been Chandra's first foray into racing. She grew up in Muskogee, Oklahoma. "Racing was just not part of our vernacular growing up," Chandra says. "It was college football. I'd really never been exposed to it. I'd never even watched it on TV! When I look back to going to that race, I had no idea how much it would be a part of my life."

Or their children's lives. The way Chandra sees it, Jimmie's racing spirit is maybe most initially obvious in their youngest, Lydia, since she attacks a hill on a dirt bike like an eight-year-old version of her dad. (She has somehow managed to convince her father to set her up with flying lessons.) As mentioned, both girls dance, and it was Chandra who danced and did gymnastics before the kids were born. But Chandra notices No. 48 in the less obvious places. "Our oldest rides horses and jumps, but she goes about things in a different way." Chandra thinks father and daughter share a strategic vision in how they interact with people and in how they enjoy themselves. "Jimmie is very calculated in his decision making, but he also leaves a little to joy as well," she says. "He's so relaxed and chill, but he's also intense and focused. It's so interesting to me that he can be both of these things."

Chandra confirms that the secret to Jimmie's success is in his surroundings—in his family and friends and in the loyalty that he feels for them and that he engenders.

"Yes, exactly," she says, "Jimmie has always been loved in his life, and that's what's amazing about Jimmie. A lot of people love Jimmie. He loves his universe, and I think about this all the time because I watch him and I'm curious. I love trying to break things down and unpack, and think about what makes him who he is. I think he's incredibly disciplined, and he's not afraid. He's really not afraid to take a risk. He just likes that. I take risks and you take risks, but I'm always thinking a little bit about the unknown outcome, whereas Jimmie's thinking, 'I'm going in, and I like being in this unknown place, where I don't know what the outcome is.'"

"You can't break it," Johnson says. Although part of me believes him, the part of me that has just driven off the road on a simulated version of the ten-hour Petit Le Mans in Atlanta that he is to drive the upcoming weekend is, yes, concerned. We're in his gym, and he's letting me fool around with his racing simulator. It's not as accurate as the simulator he uses in Indianapolis, but I get off the device pretty quickly, not wanting to smash even a virtual car. He takes the wheel for a minute in a futile attempt to school me. As I watched him drive virtually, I remember something that Chad Knaus told me: "Jimmie's strength is holding the steering wheel, which is different than a lot of the drivers coming into the world now, because the world is so data-driven that they are born and raised in that environment. His strength is his race craft. His ability to get into a race car, drive that race car, and understand that, whether it's a ten-hour race or a 500-mile race, he's got to manage that race to get the best finish that he and that car are capable of doing. That's Jimmie's strength. He hasn't always been the fastest guy. He hasn't always been the best in practice or qualifying, but he was, throughout the majority of our career, the best at figuring how to pass that car in front of him. And that's just race craft."

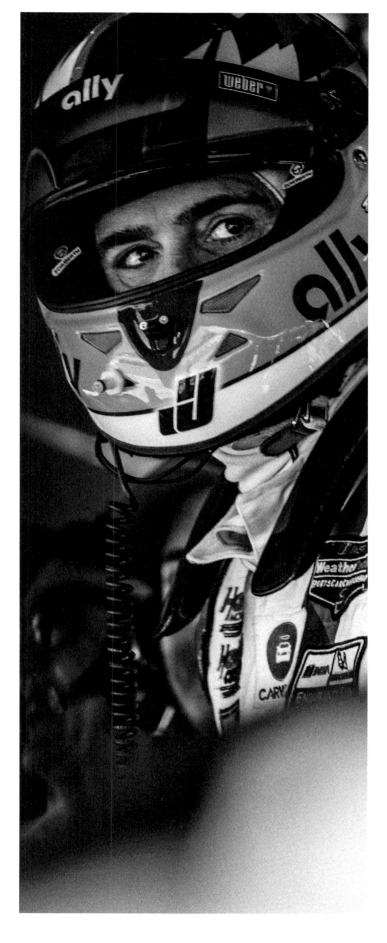

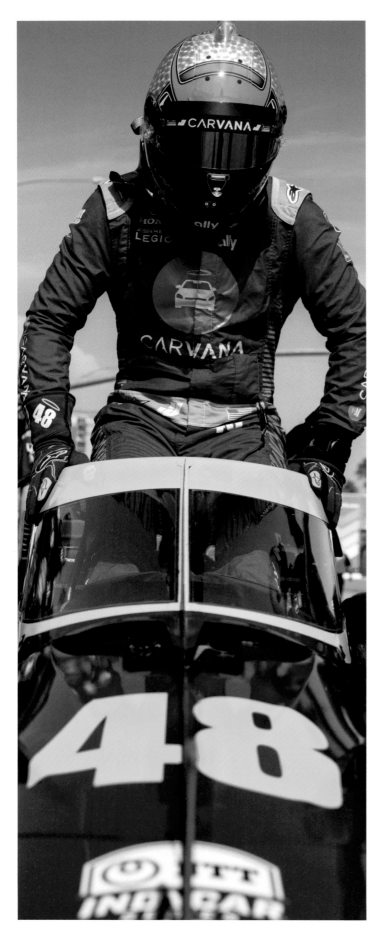

His home gym is where Jimmie builds up the racer to practice his craft. All during the pandemic, he worked to transform his body for IndyCar, starting with his legs (as previously discussed, the brakes are everything) and then moving to his arms, given the loss of power steering. In a sauna, he practices cognition tests, picking off lights and numbers to simulate the fast-steering wheel choices made in the hot cockpit with an IndyCar wheel. Downstairs, the garage is a garage. There's a vintage station wagon that they drive around with the kids and a 1986 Rolls Royce Silver Spur that they use for the gallery or other special occasions. We are eventually back in the Tahoe, which we take downtown for lunch. Driving with Jimmie Johnson, you might momentarily wish you were in an action film with a bad guy chasing because your car is being driven by Jimmie Johnson, but most of the time, you are just in a car driving downtown, stopping smoothly and signaling at turns. No big deal. "I know what it's like to crash," he says.

We get barbecue and then find a place to talk. He has been thinking about driving the Indianapolis 500, and he describes his decision making. Sometimes, given how careful Jimmie Johnson is and given how patient and hardworking, you can forget the risks involved, though he does not. Hardly a day passes when he doesn't remember Blaise Alexander, his old NASCAR friend who died in a crash. It might not be obvious to the racing public, but if race courses are risky, ovals are more so—primarily because of the speed, which easily exceeds 200 mph. IndyCar is faster than Formula 1 racing, or faster than almost anything that you see on TV on Sunday, unless you are watching land speed record breakers out on the Bonneville Salt flats in Utah, where the record, at last check, was 417 mph.

Coming into IndyCar, safety had been a concern for Johnson, a reason he limited the races in his first year. But in the past three years, as he sees it, IndyCar has made

changes to its design that he considers encouraging for a racer focused on safety—and not just in the car but in the cockpit design. In the end, with Chandra, they decided to go forward. In 2021, he tested a car on ovals, which in part meant testing himself—first at the Texas Motor Speedway, then at Indianapolis. As far as the stats and the handling went, he was immediately competitive, as he would be when he went to the Indianapolis speedway a few weeks later, even though rain cut his orientation short. As far as the feel of the car went, if he was blown away by his first Formula 1 experience, then he was blown away yet again when he tested on an oval. "Speed on ovals is insane," he tweeted. "Currently recalibrating my eyes."

From an aerodynamic perspective, the IndyCar is designed to press into the turn. Air flowing across the car is channeled to create a pressure called downforce, which presses the car to the track. In so doing, it increases its ability to hold to the track on the corners. "At a certain speed, especially on a straight, you lose sense of where you are," he says. "And it's more about the vehicle and how it's connected to the road. So the straight-line speed didn't seem so overwhelming, but approaching the turn, I was thinking, 'They tell me it's going to stick!'"

In those first moments, he wondered if he could hold the gas pedal down on the floor for the entirety of the track through all four of Indianapolis's four legendary turns. Intellectually, he knew he could, but even Johnson doubted what he knew to be true just a little bit. "You're in a very interesting conversation with your right foot." he says. At this point, the crew is on the radio, but nobody is talking. "You're on your own," he says. "You pick up speed." At 225 mph, as the engine seems to scream, there's a tremendous G-force. The faster you go, the lighter the vehicle feels. The car gets twitchy and more and more sensitive to any movements in the steering wheel. You hold on tight and strong. He'd been around both the Texas and India-napolis tracks before in a stock car. This was very different. "I think it's safe to say that my first time, by tiptoeing my way into it, was faster than I've ever been around either of those tracks in a race car," says Johnson.

In December 2021, Johnson made a public announcement, saying he would go full-time with IndyCar in 2022, including racing the Indianapolis 500, arguably the marquis racing event in the world. He made this announcement on "The Today Show," which of course is live TV. It seemed ironic, given that it was precisely while he was trying out as a racing analyst, covering the Indianapolis 500 on live TV, that he felt overwhelmed by a desire to race the Indianapolis 500. He almost couldn't take it. "It was my first time attending the race," he tells me. "I had massive FOMO."

On the last day I spent in Charlotte talking to Johnson, we were talking about 2022 and IndyCar, sitting on a bench outside a barbeque place, when I noticed that Johnson was suddenly distracted. I quickly realized he was distracted by a car that was cruising the avenue. "He has gone by twice," Johnson said. When we split and I drove home, I thought about Jimmie in an IndyCar every time I came to a highway curve. I drove for most of a day. Each time I was passed or passed somebody else, I could only think about how many different kinds of cars there are in the world and how many cars there are that Jimmie Johnson still wants to race.

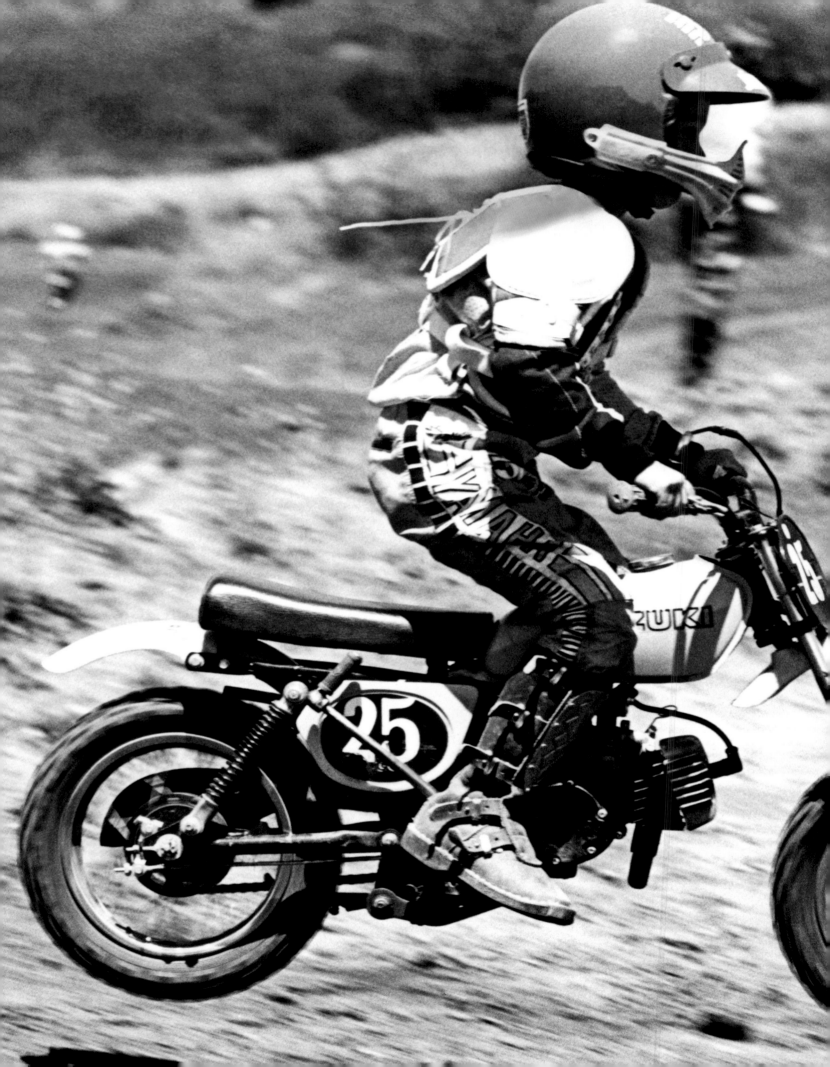

THE STARTING LINE
1975—2000

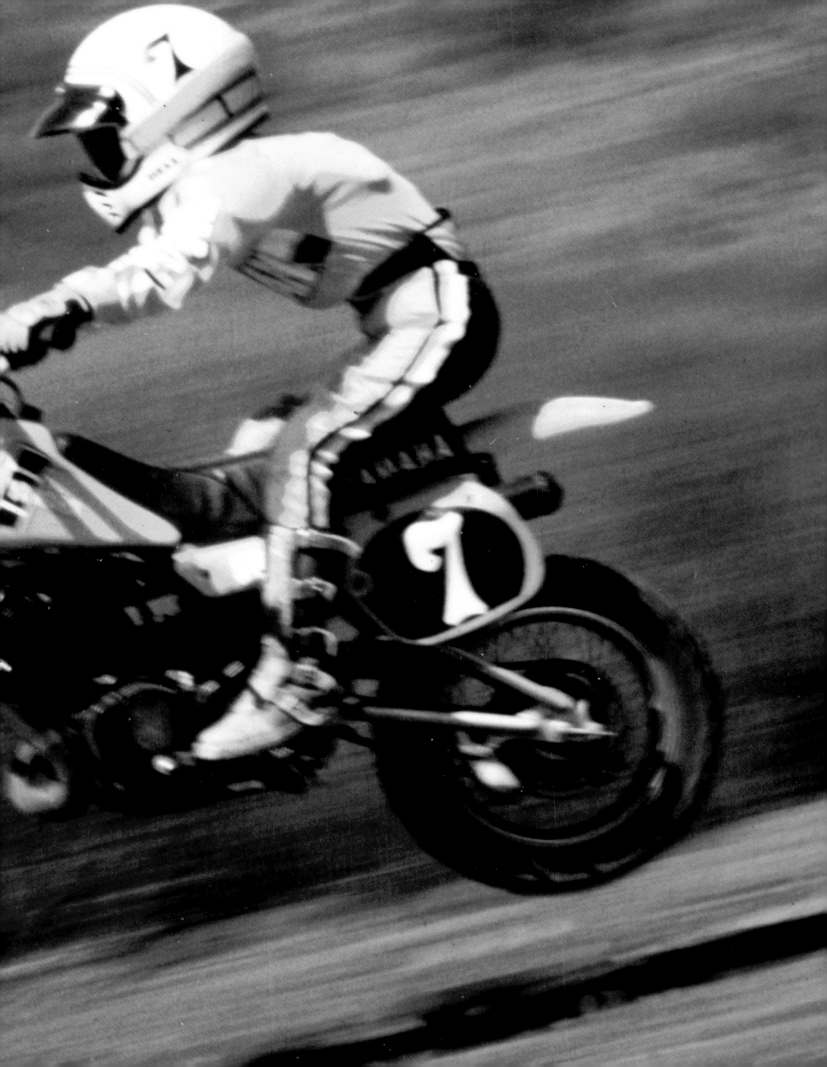

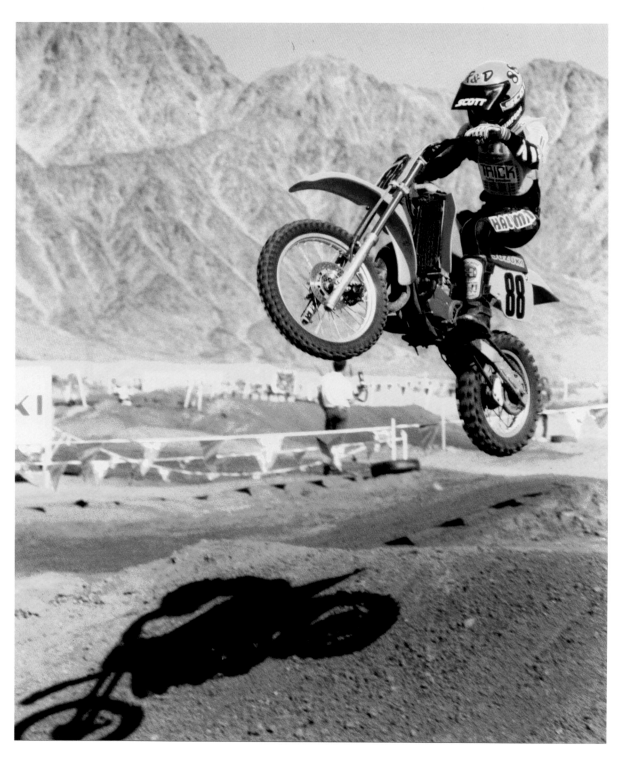

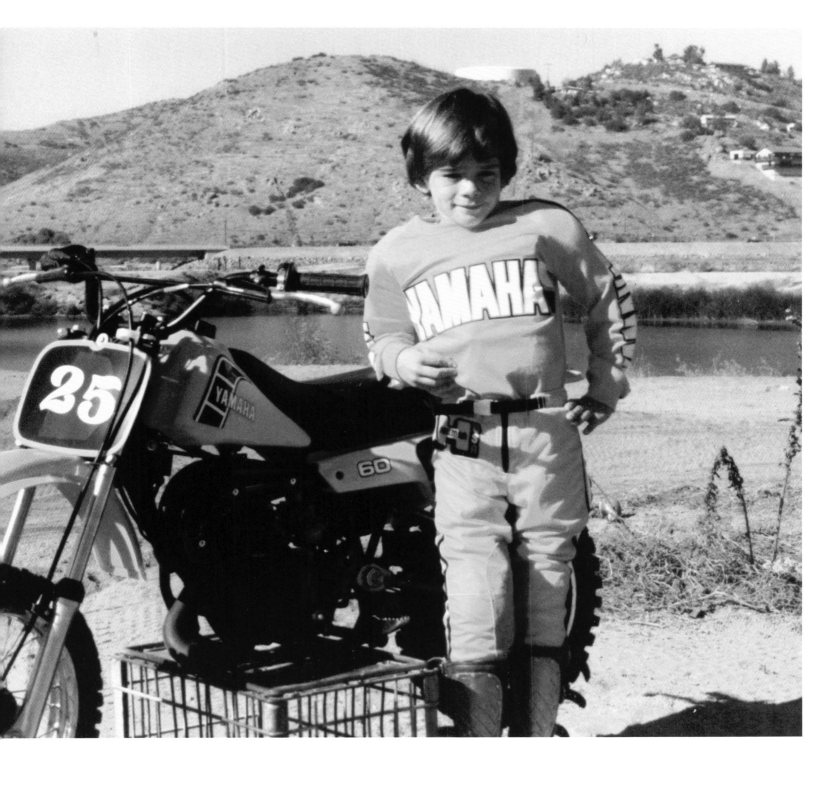

ABOVE: "My little number 25 motorcycle. I'm around seven or eight. This was taken at the Santee Sand Pits track. It's where I first learned to ride when I was four." **OPPOSITE:** "In this picture, we're at a track in northern California racing a regional event. It's such a cool picture with the number 88 on the side of the bike!"

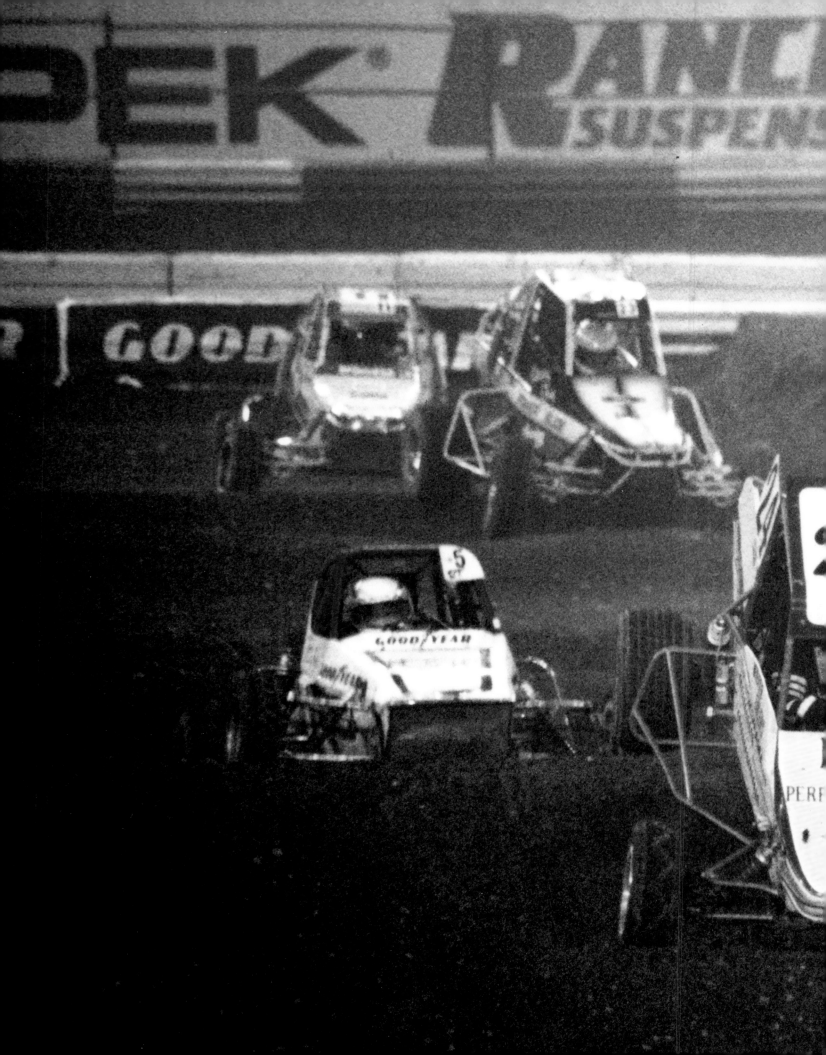

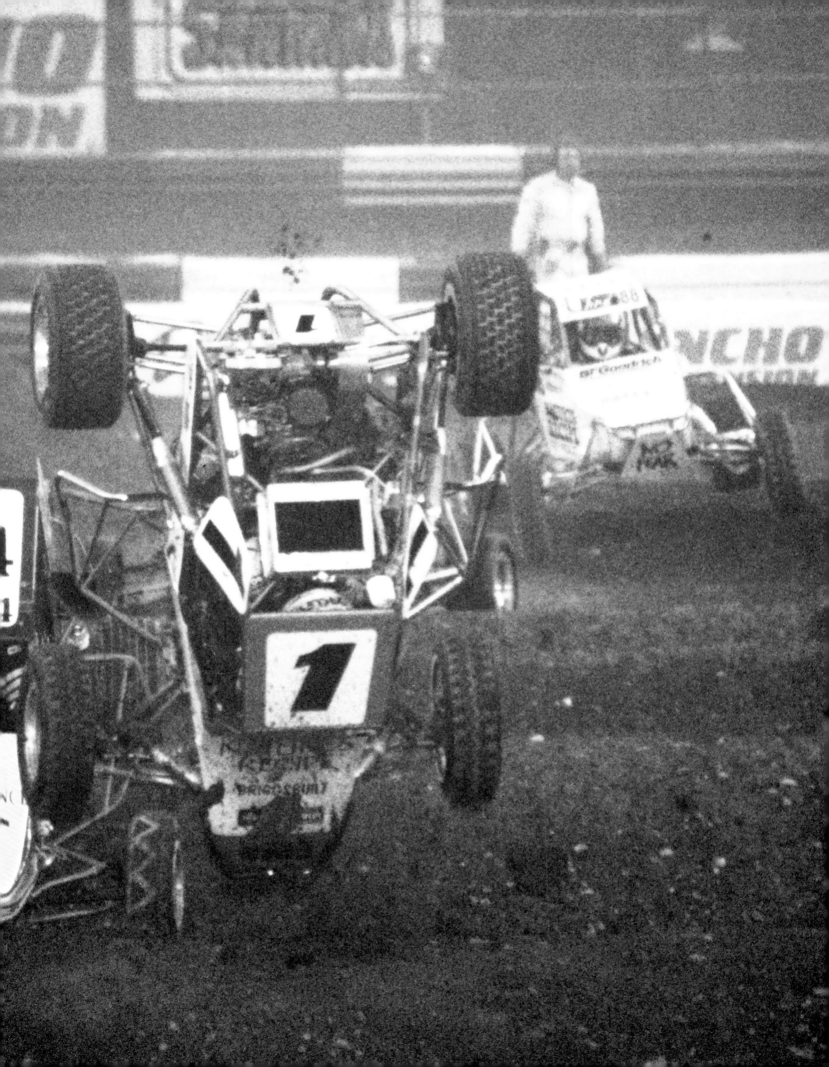

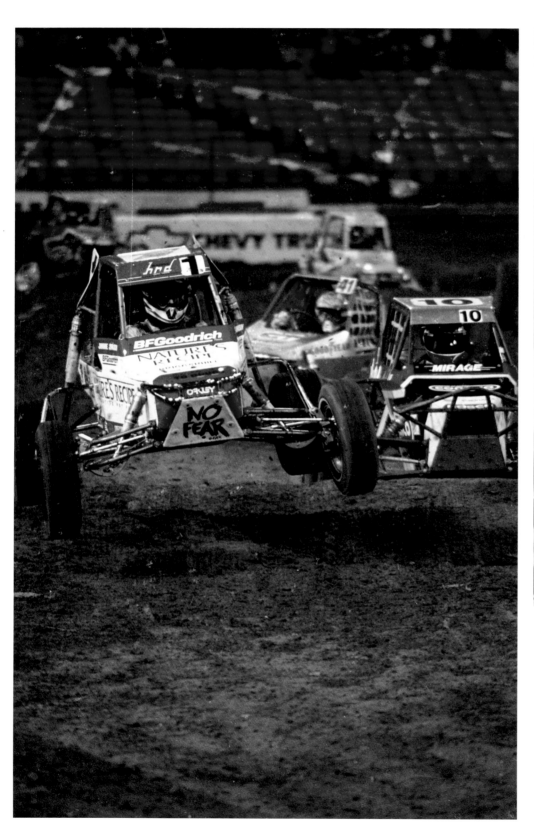

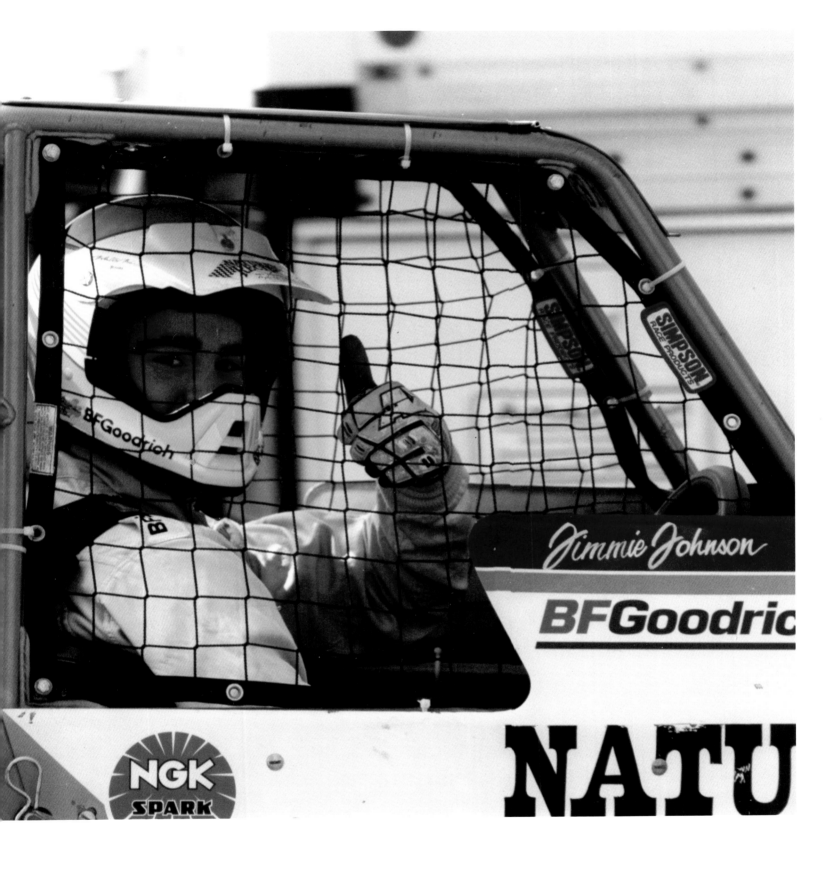

OPPOSITE AND ABOVE: "So this little buggy is the start of my four-wheeled career. The photo (**PREVIOUS SPREAD**) where I'm flipping, this is in a heat race. I flip, keep going, and then come back and win that night and win the feature. Everybody was so impressed that I had my bell rung during the flip, and then I got my composure back and won the night."

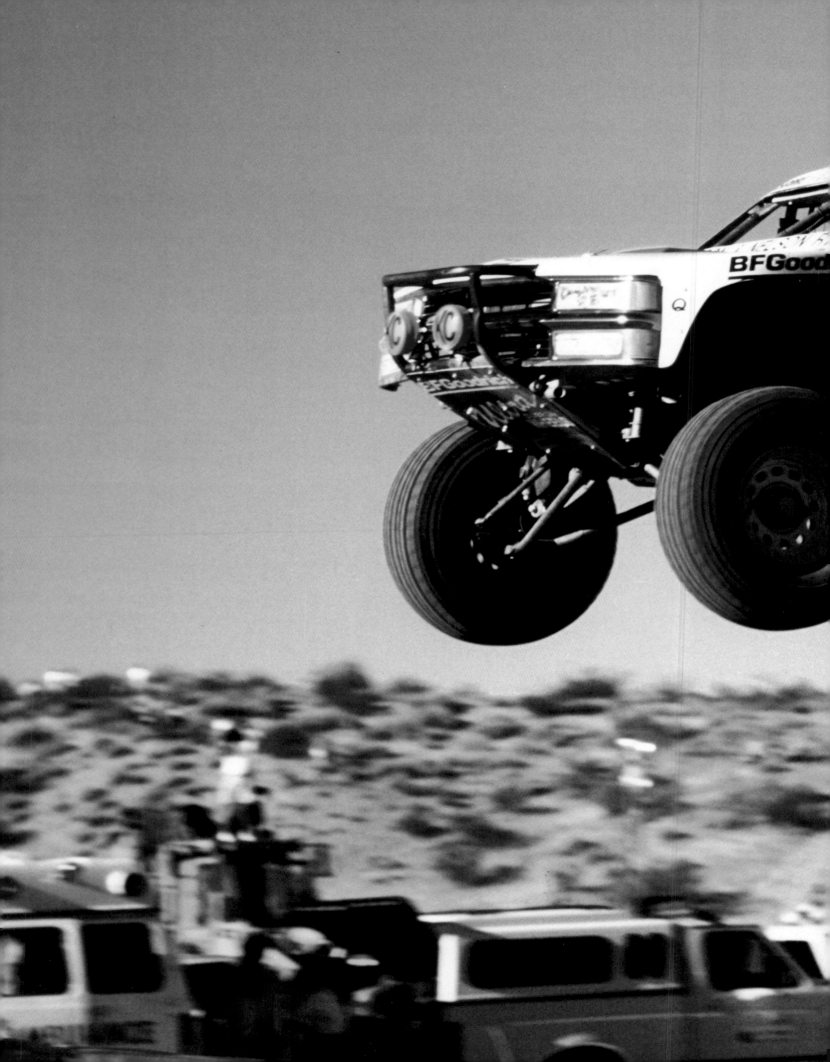

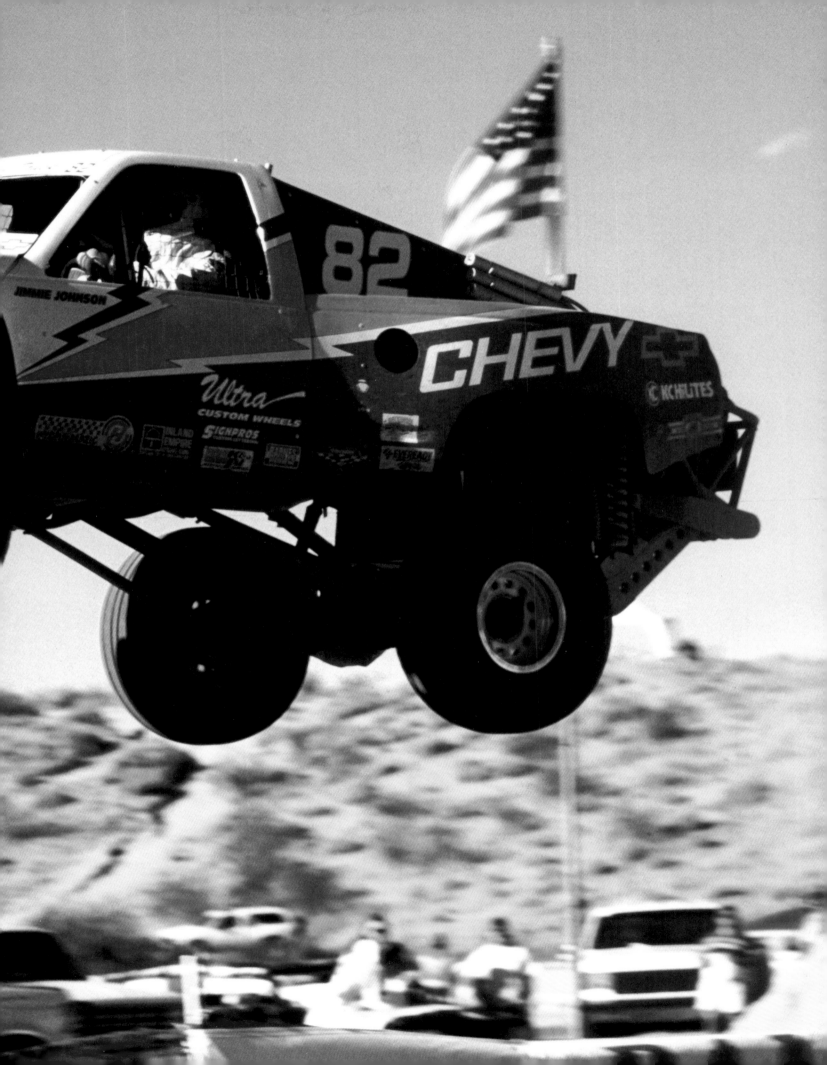

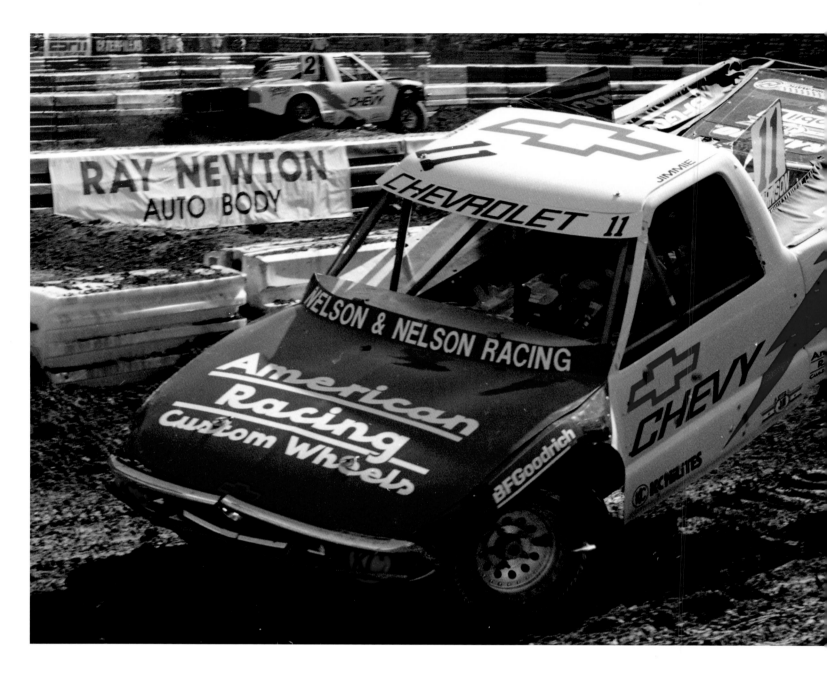

"That was my vehicle at sixteen. This little stadium truck was my first experience with Chevrolet. The rush of racing in front of those full crowds was pretty wild. I had just got my driver's license, but they raised the rental age to eighteen. And then once I turned eighteen, they raised it to twenty-five. I had the hardest time renting a car for a large part of my career!"

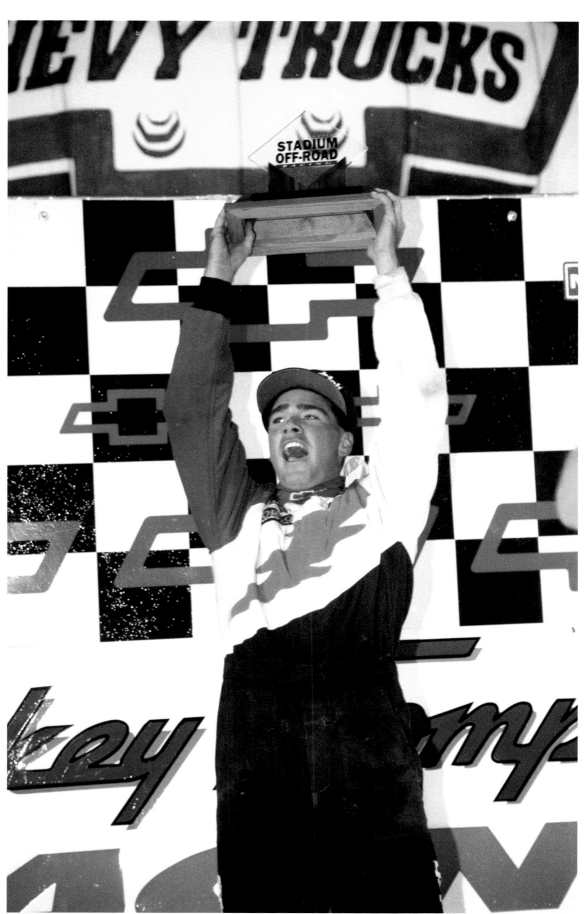

"This is the crash in Mexico. This was my shift to endurance racing. I started in the stadium truck, and then that series went bankrupt. Chevrolet needed me racing, so they put me in this endurance series. I was in the premiere class at sixteen years old, and now had to go from a five-minute racing mentality to races that at their shortest, were like eight hours. I crashed all season long. I had the hardest time."

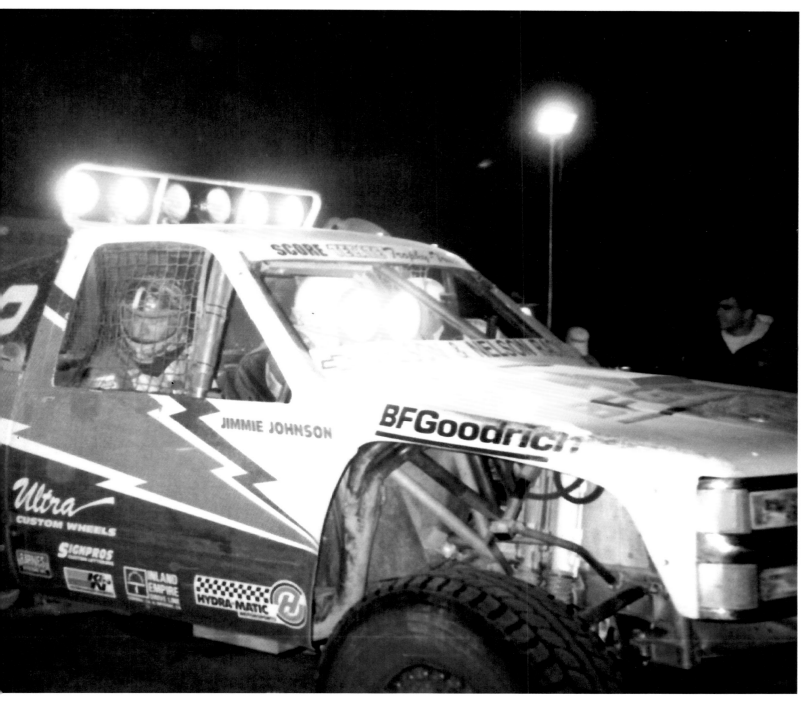

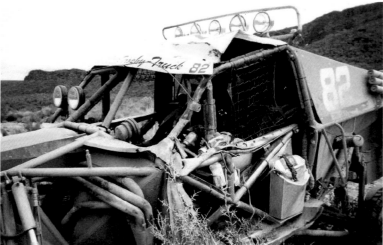

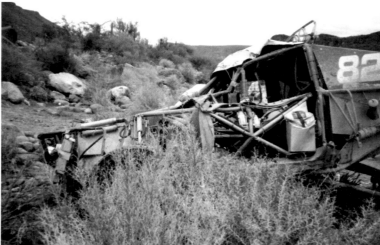

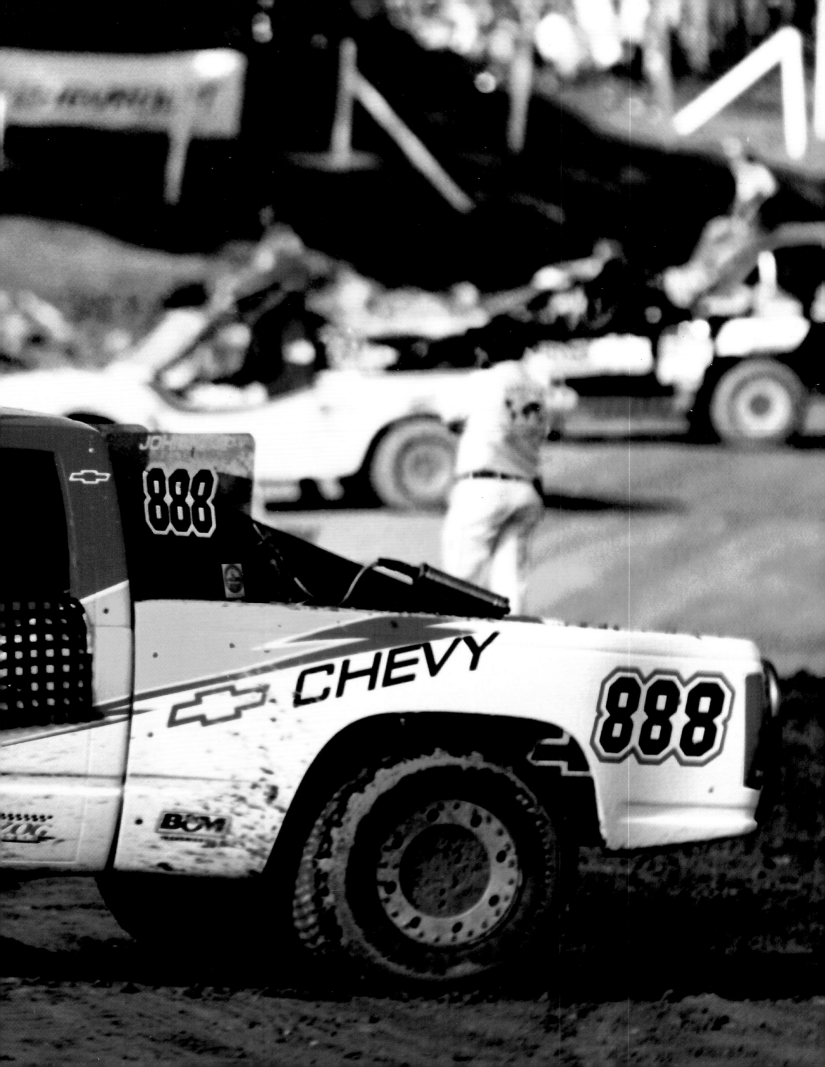

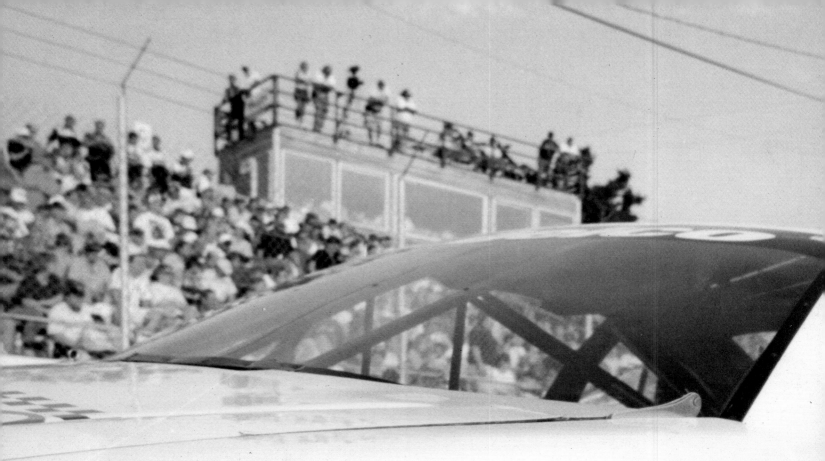

GOODYEAR

ASA
AMERICAN SPEED ASSOCIATION

Edelbrock

PENSKE
RACING SHOCKS

Holley
CARBS

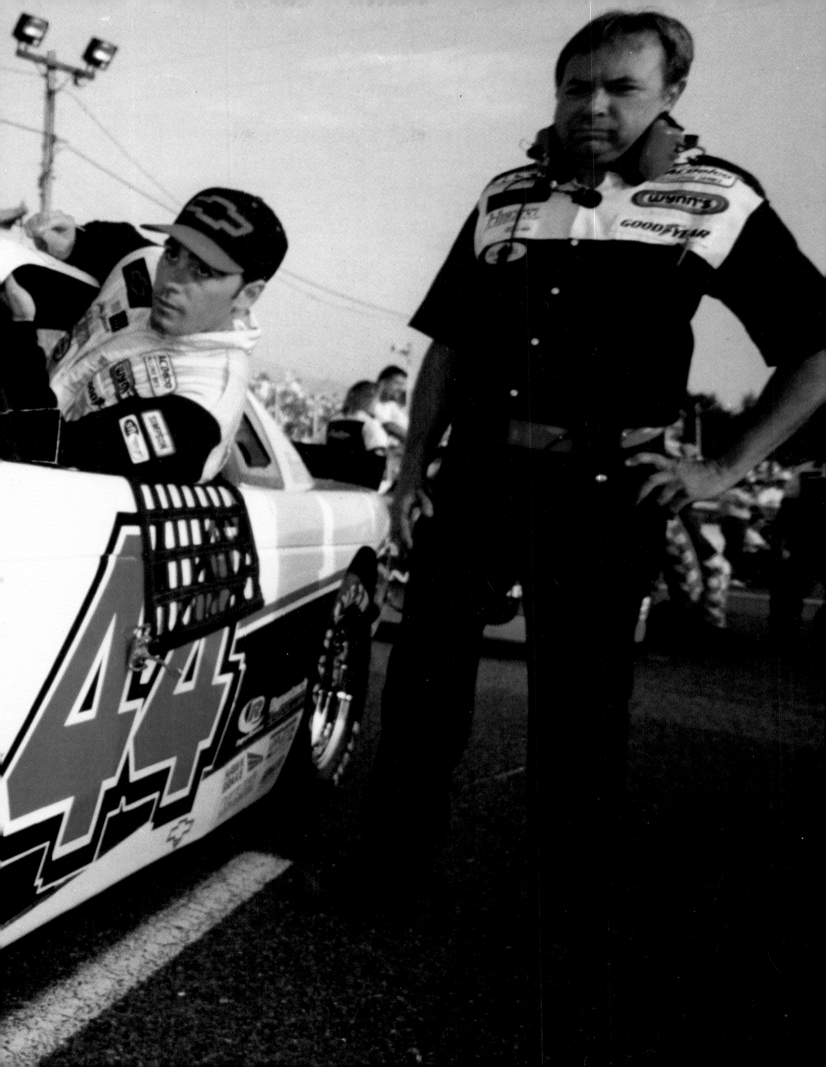

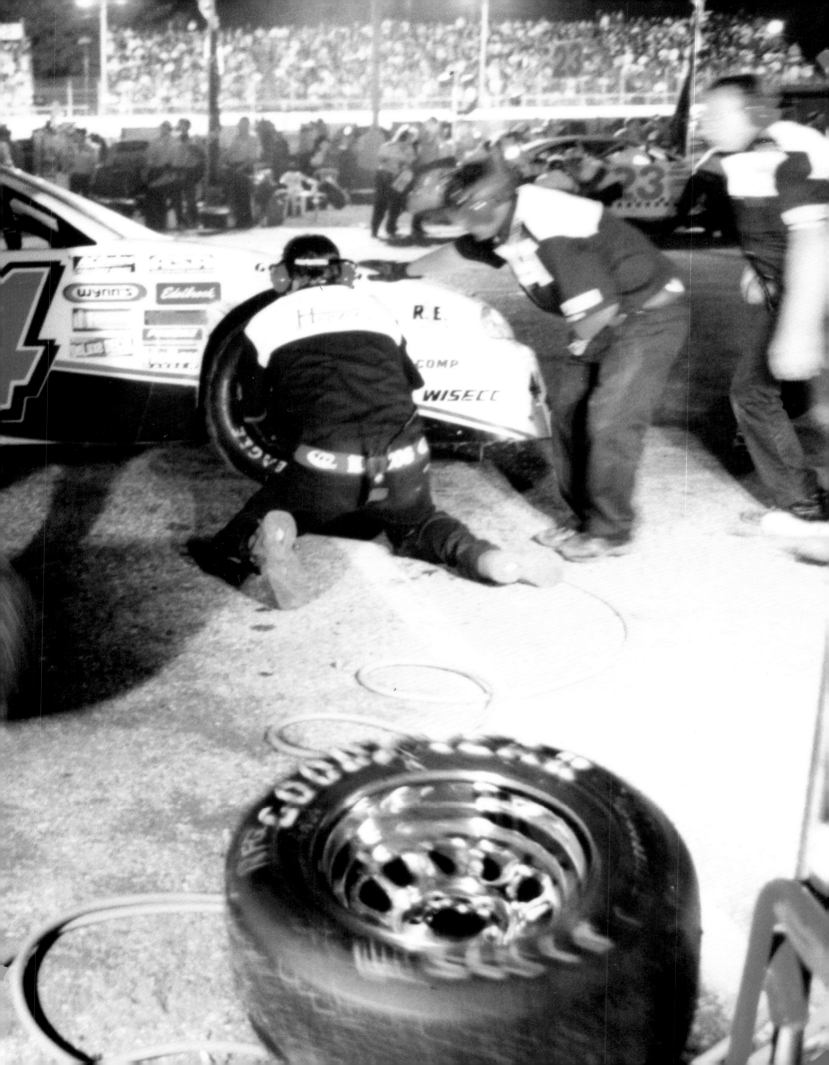

THE
NASCAR
YEARS
2000—2020

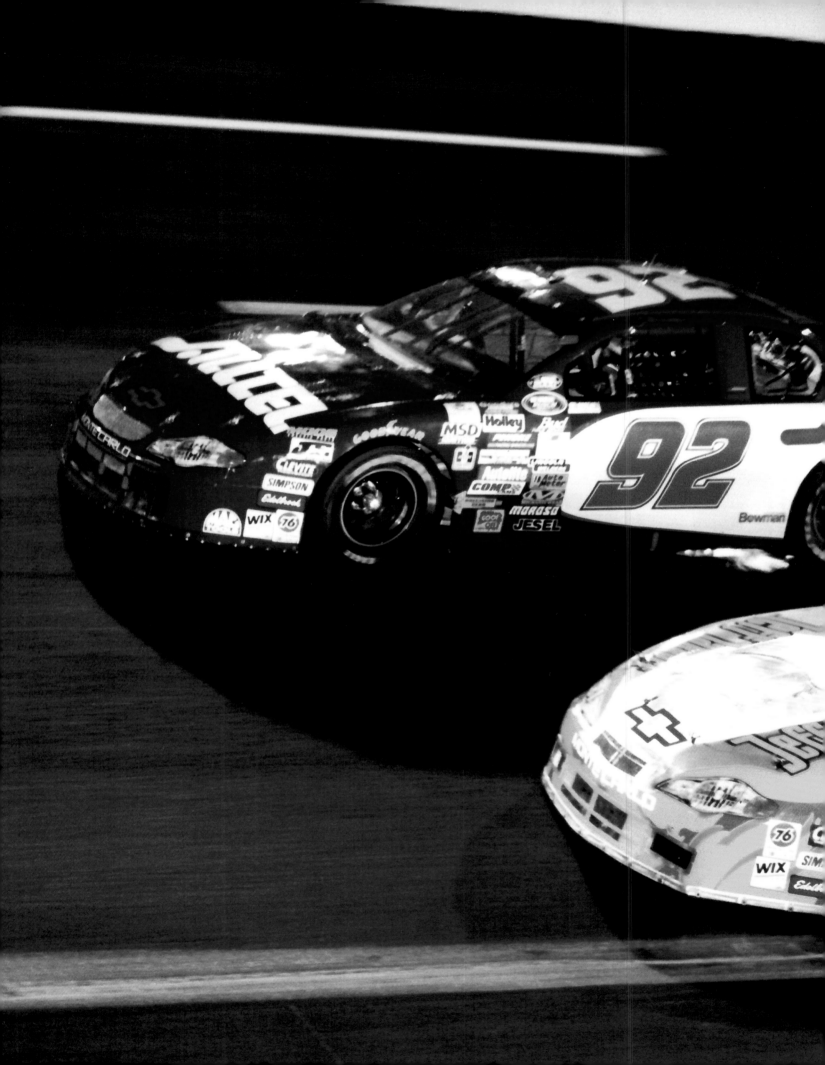

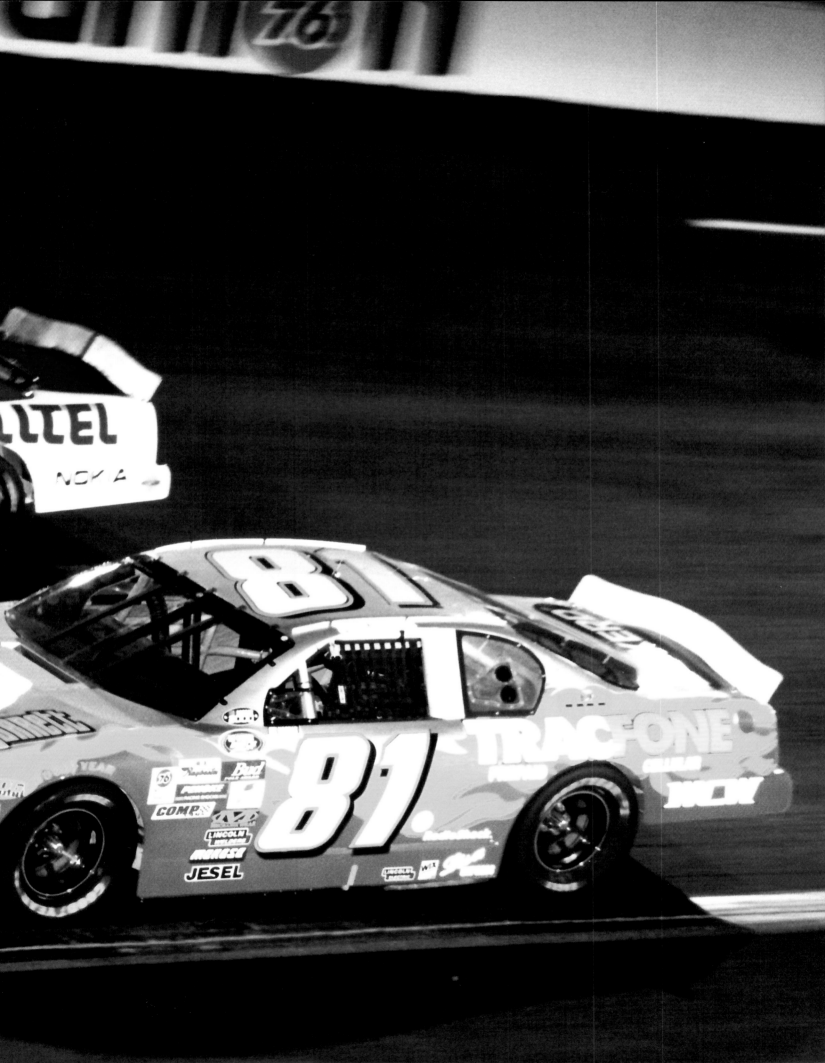

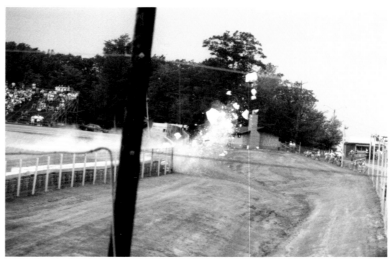

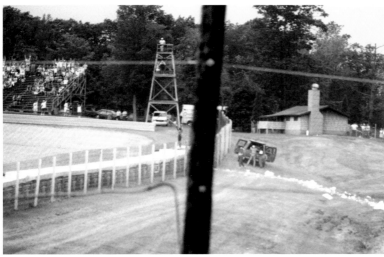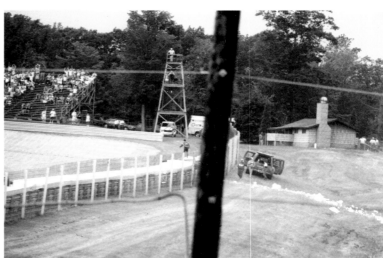

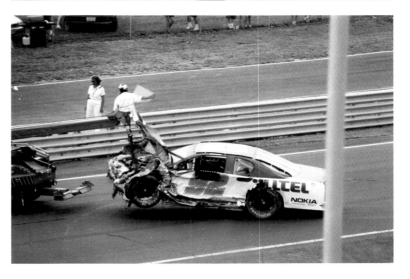

"When the brakes went out during that turn, it was in the summer of 2000. I was on the forty-sixth lap in Watkins Glen. I came flying across the track and crashed into that foam barrier. This angle really shows the force of the impact – the wall exploding. I think of it as one of two moments when I was in a race car when I thought I might die. Prior to hitting that wall, I was sure it was made of concrete. This was before the regular use of soft walls. In general, white walls during that time were almost always concrete. When I hit this one and it wasn't—well, let's just say I was so happy!"

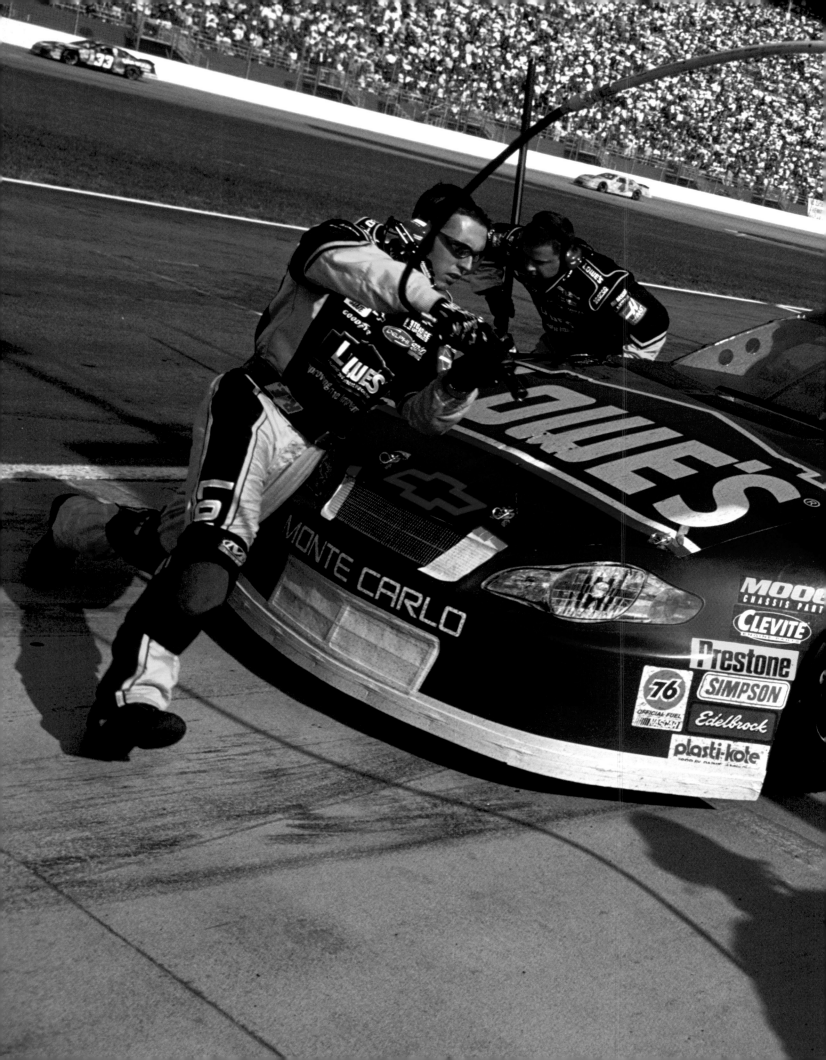

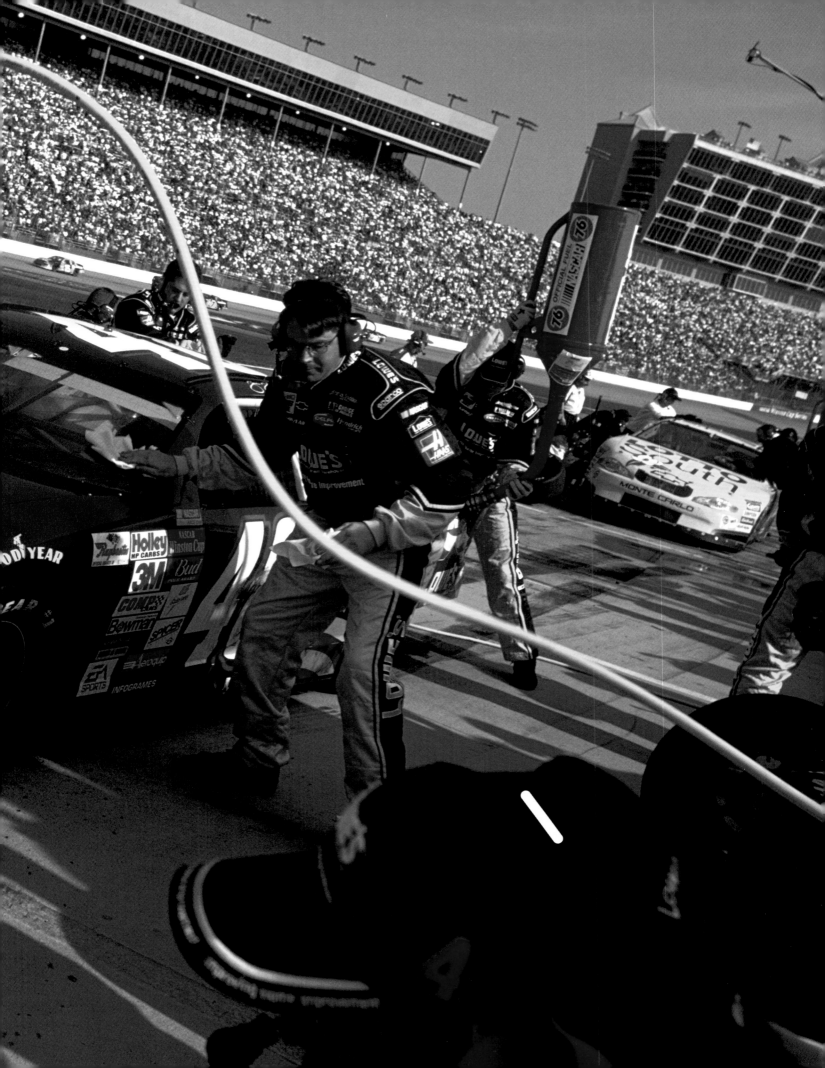

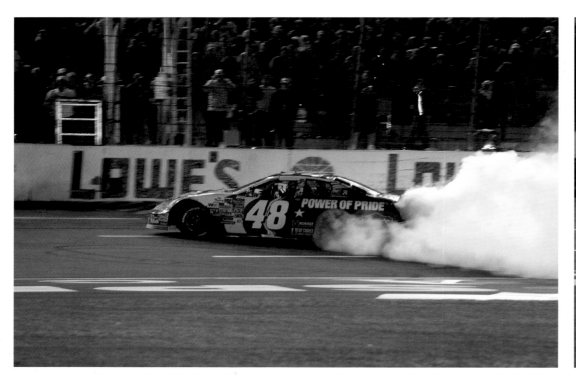
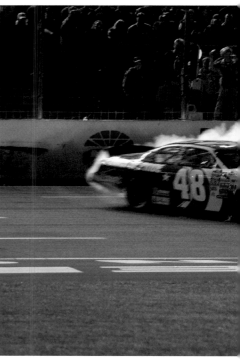

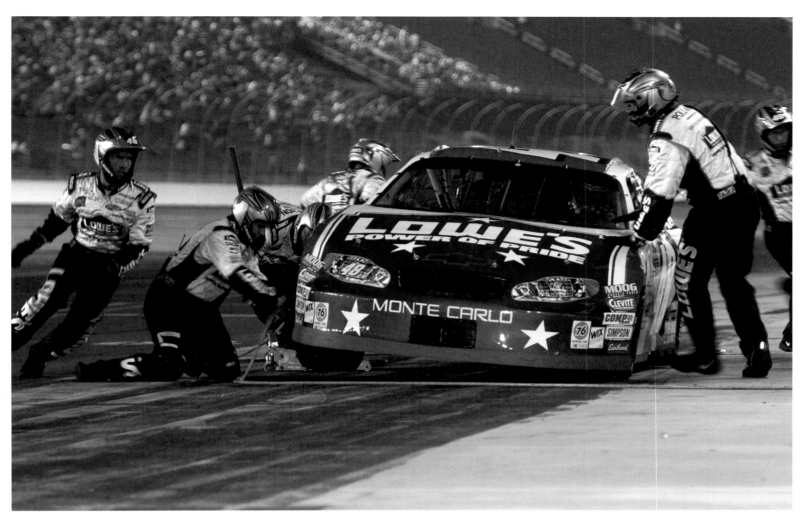

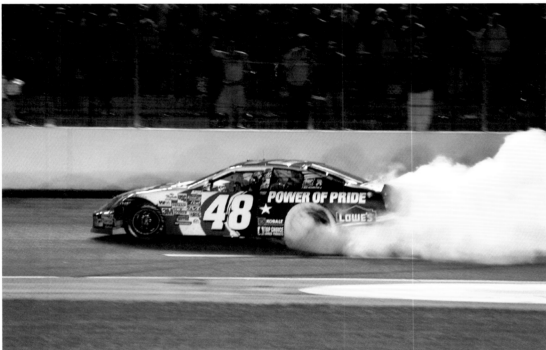

"The Donut: that's the moment. That's the victory instead of the victory lap. That's your moment. That's your victory dance. It was not always done. My generation started doing it, but the ones before me did not do it. The first time I did it, I exploded the engine. Oil just spewed out of the bottom. It was like the Valdez pulled up. There were some orders given to me after by the Hendrick engine department."

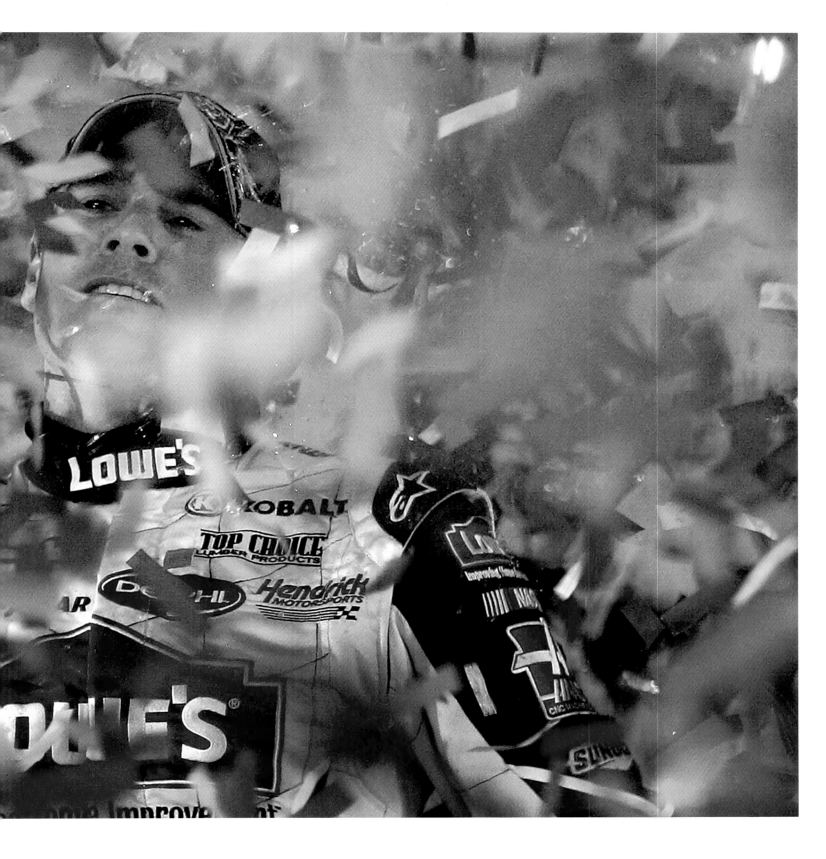

"My first Daytona 500 win. This fire suit is now an artwork created by artist E.V. Day and installed at the Mint Museum in Charlotte. In 2005, we lost the championship again. Mr. Hendrick felt that both Chad Knaus and I were behaving immaturely and needed to grow up. He invited us to a "milk & cookies" meeting to make the point. After having our milk and cookies, we got into this intense meeting, focused on how to behave more professionally. I need to take some pressure off of Chad. We needed to evolve as the "48 car." This photo is from Daytona, the first race of the 2006 season. Chad was suspended from the race due to a technical problem with the car. The engineer stepped up to be the crew chief, and we won the race. This is the moment of victory. We went on to win five more championships in a row. That's why the fire suit is now an artwork. It represents such a pivotal moment in my career."

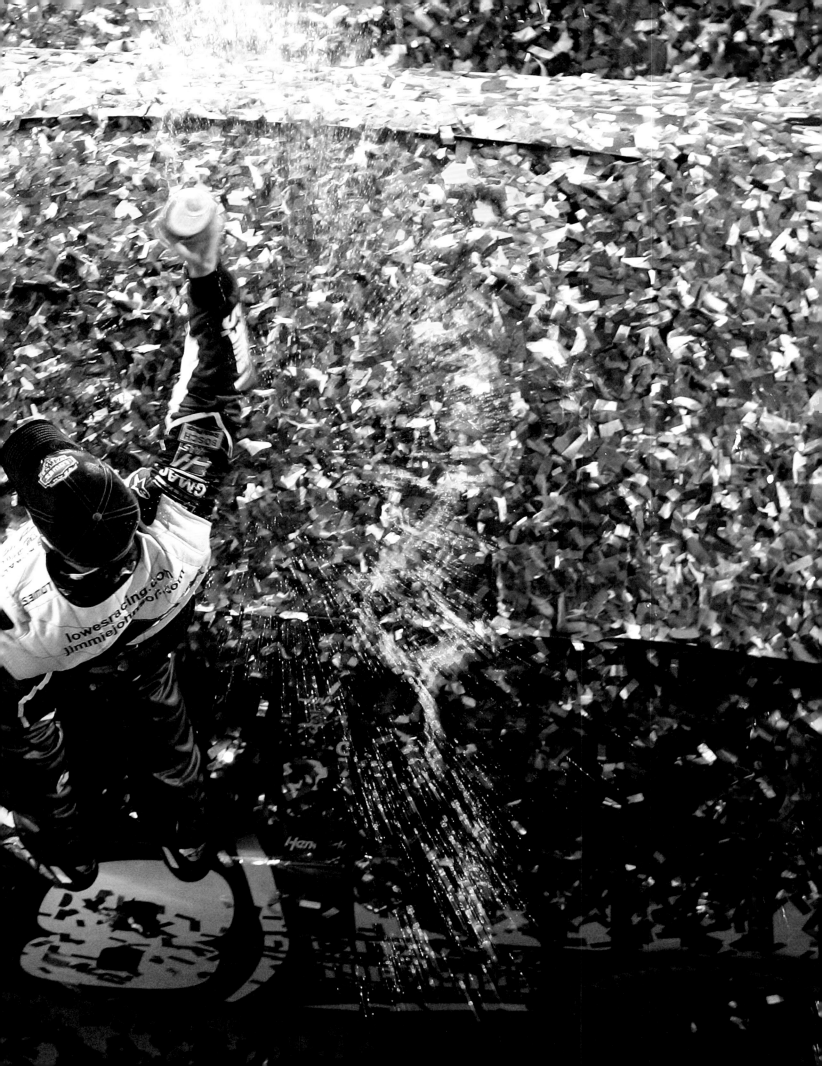

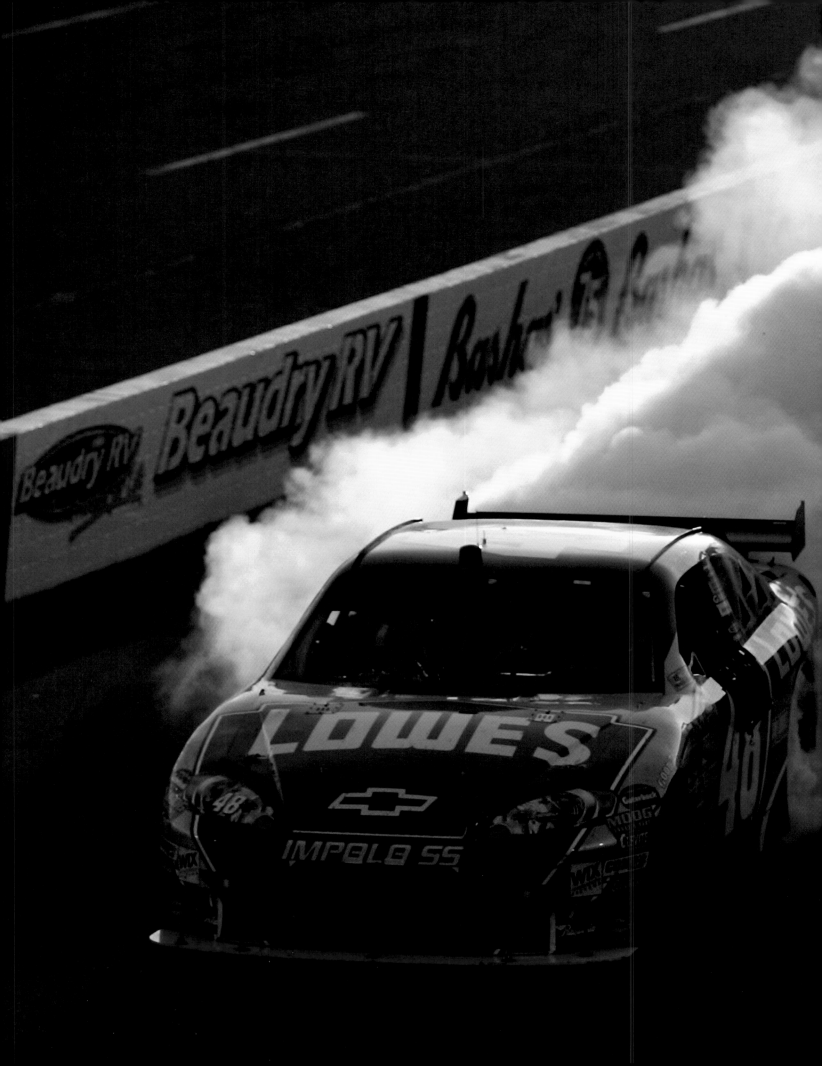

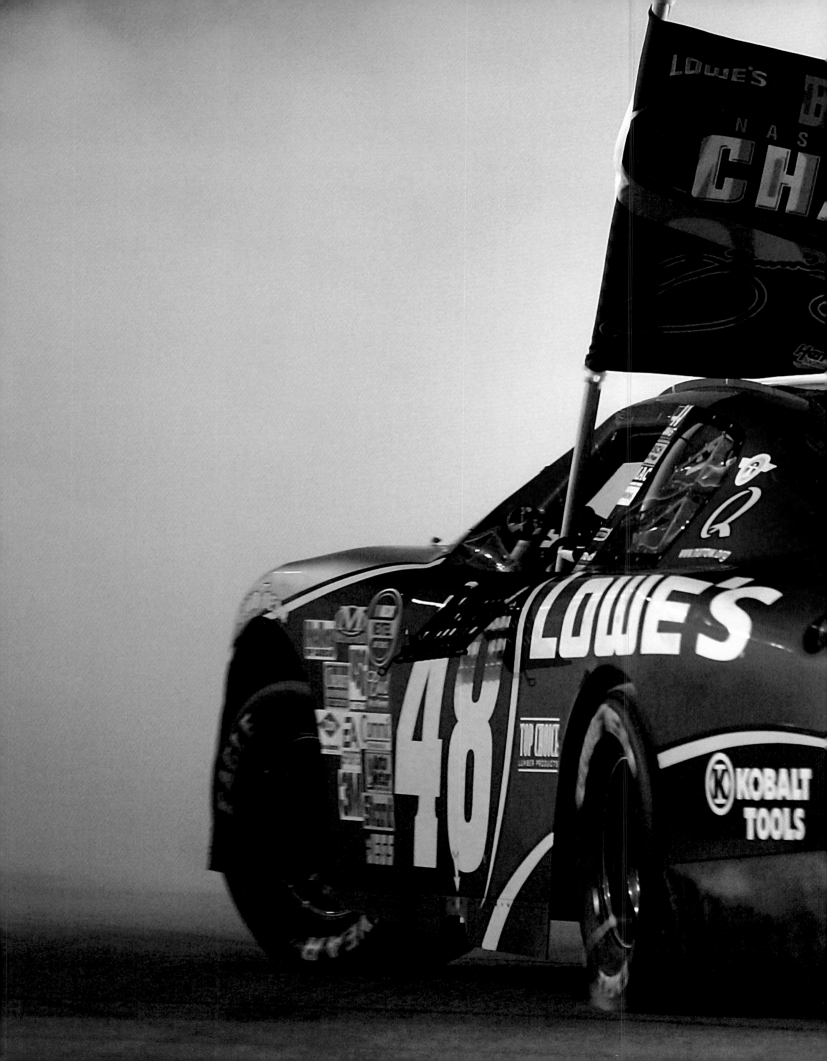

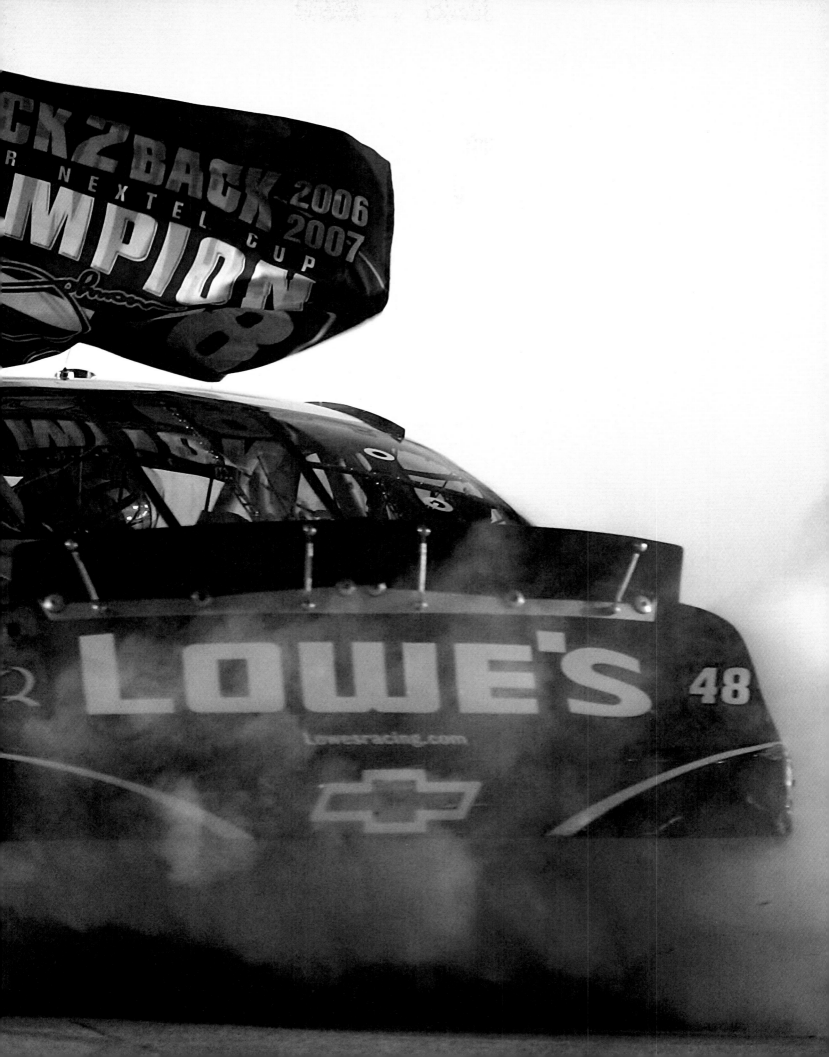

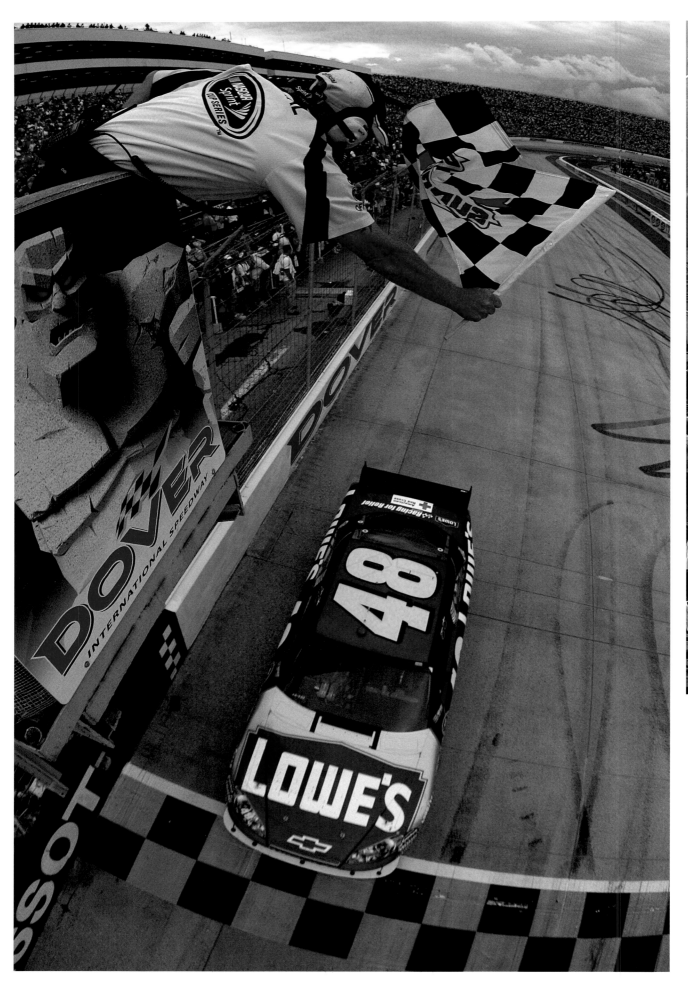

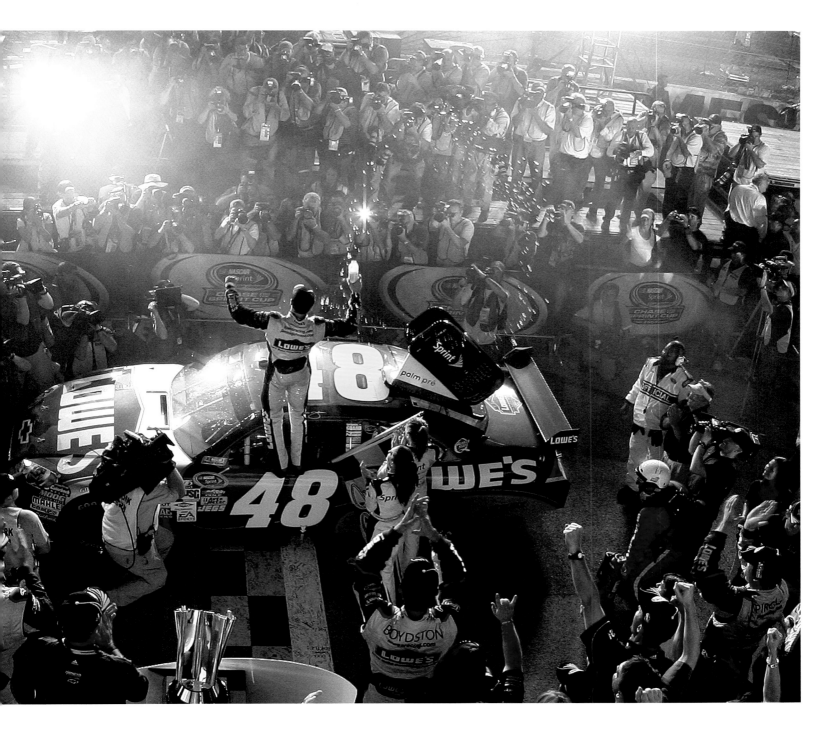

"I think there's a big misunderstanding when the driver gets all the glory. It's not fair. We get too much glory. It really is a team sport. Until you get close enough to it, you can't see and understand it. I think drivers are often teased for always talking about the crew at the shop, but we all know how important they are. We know that they don't get the recognition that they so deserve."

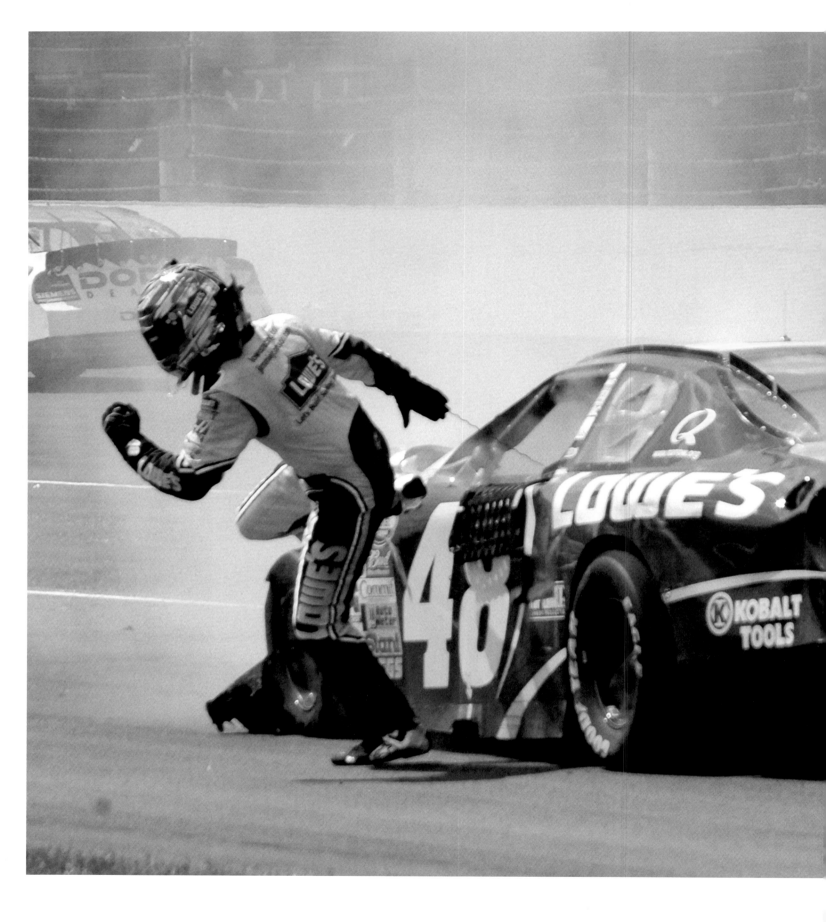

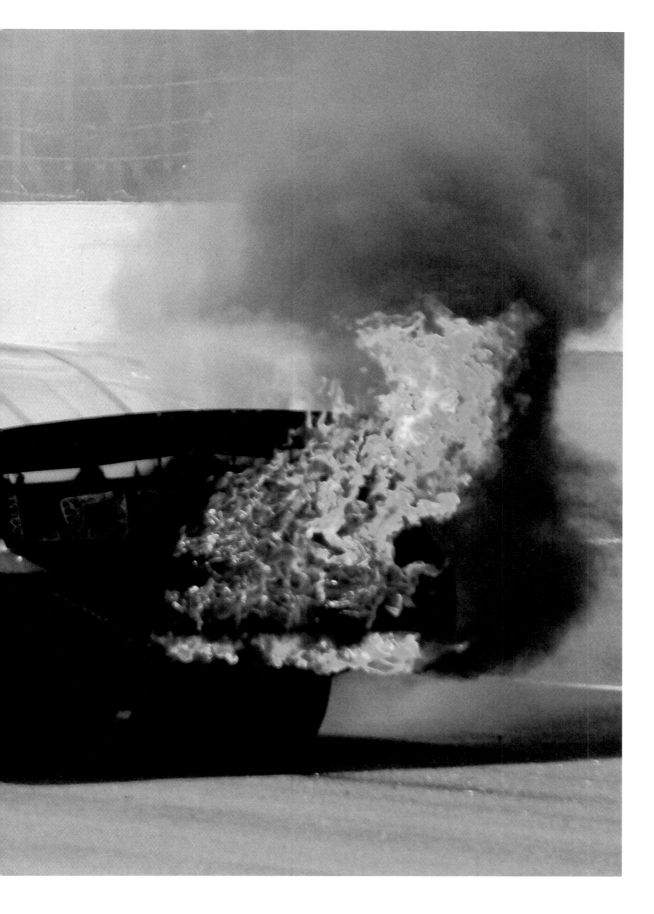

"I was at the Indianapolis Speedway, doing well over 200 mph, when I blew a right front tire in Turn 3. Let's just say that the impact with the wall was significant—and then the fire started. Almost before I knew what was happening, a fireball came over me. When the car finally came to a stop, I was pretty eager to get out of that thing and start running. I remember my visor came up on my helmet. I ended up with singed eyebrows and eyelashes. I didn't realize anything had happened until I was doing an interview later. Jamie Little, the pit road television commentator, said, "I smell burnt hair. Oh my God, Jimmie! Your eyebrows are singed!"

"I am walking out to the qualifying grid at the Bank of America 500. Chandra and I always joke about 'race face.' Like when it gets close to race time, I would get quiet and have my 'race face' on. I think this photo represents that."

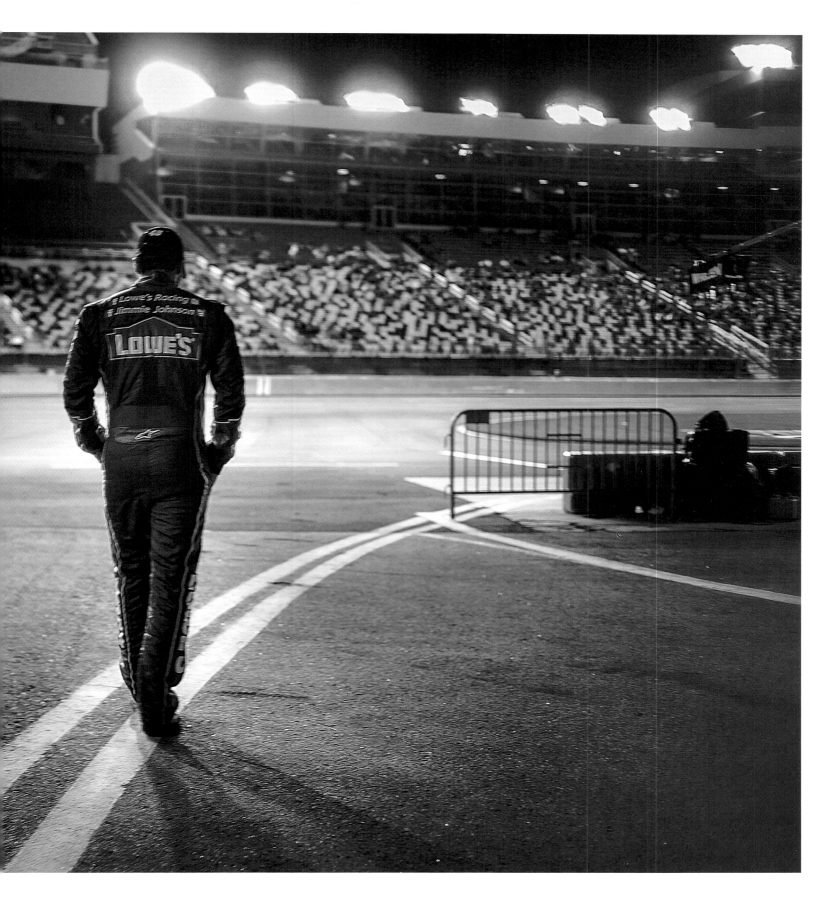

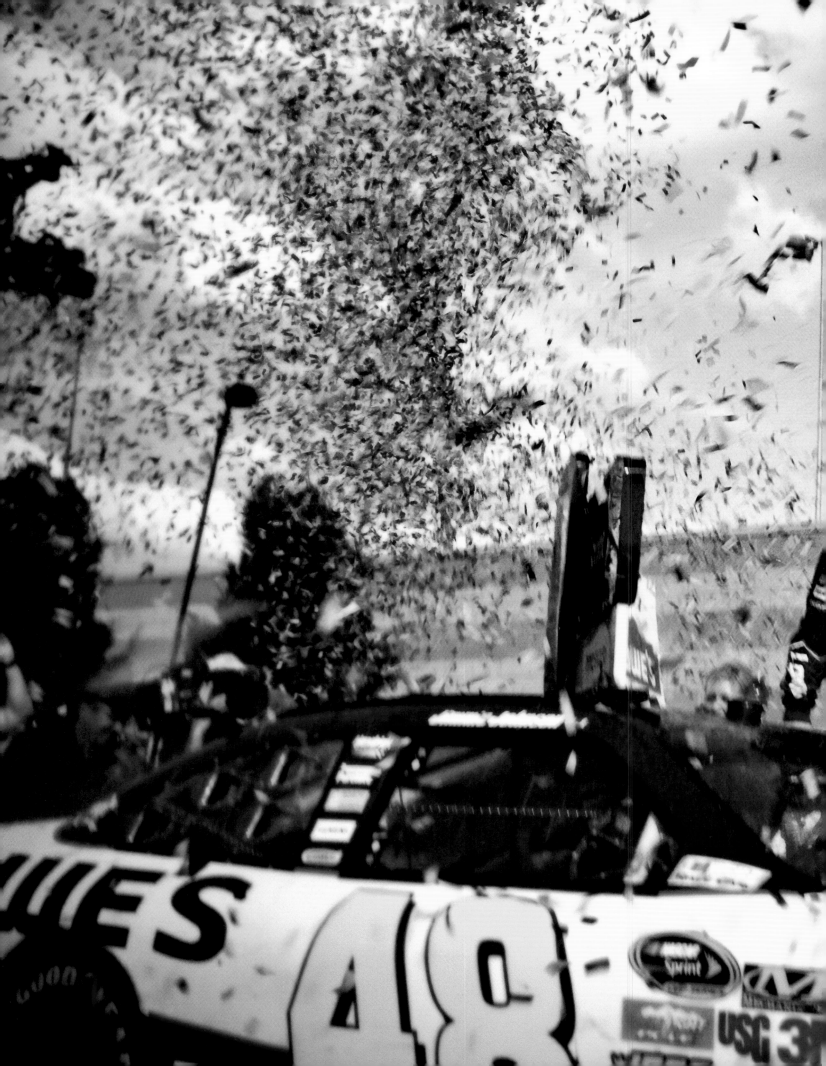

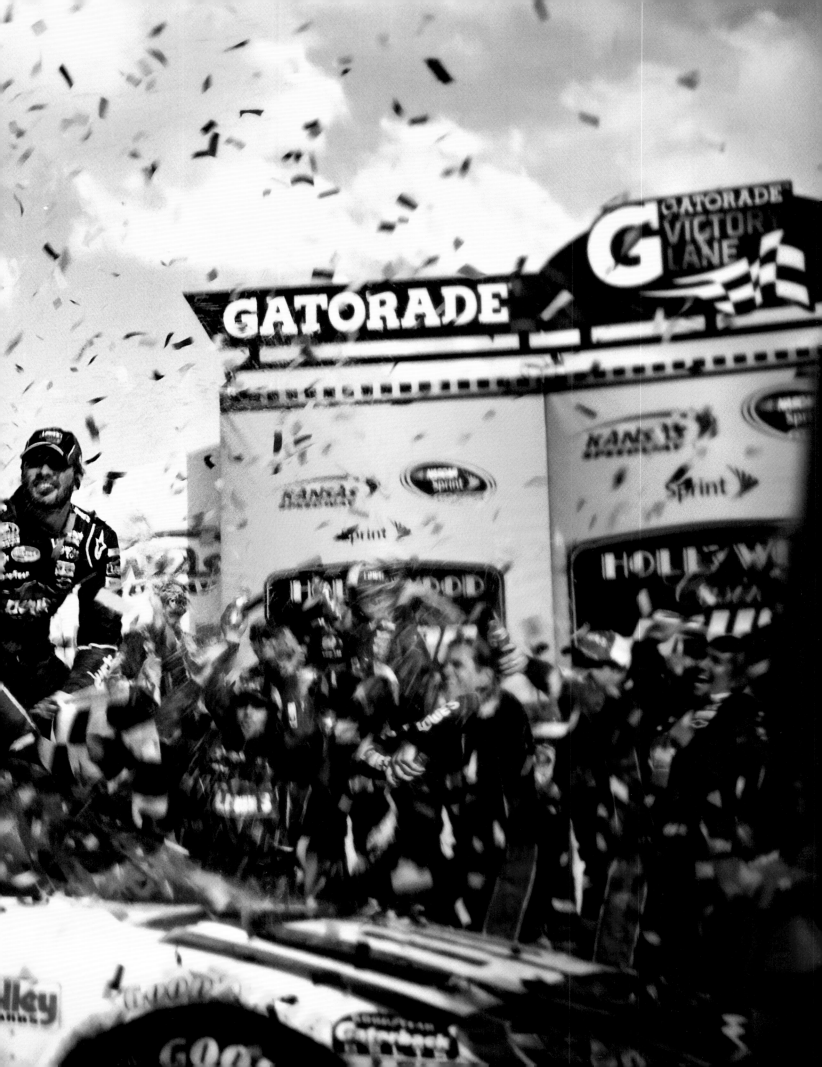

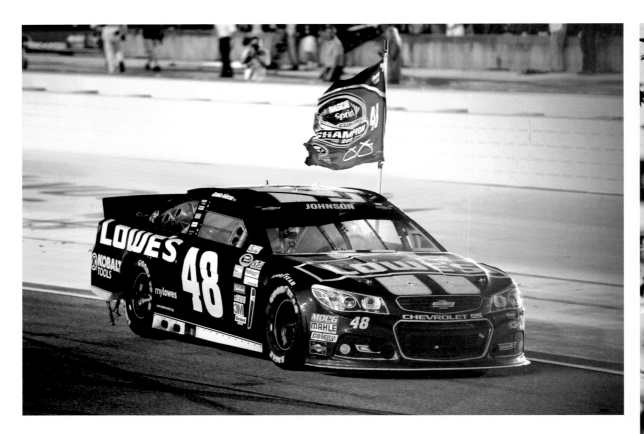

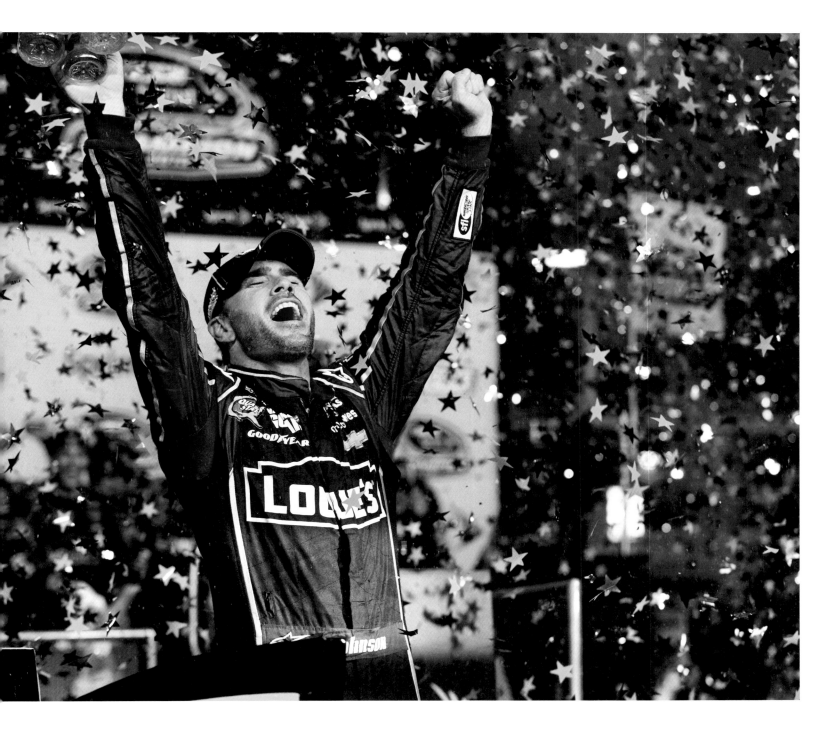

TWO PREVIOUS SPREADS: "That was the highlight of my championship efforts in 2011. The reason 11 is so significant is that I was trying to win my sixth championship in a row. This was the peak of the playoffs. After this, it went downhill, and we didn't win the championship." **OPPOSITE AND ABOVE:** "This was when I won my sixth championship. No one ever thought it would be possible to have a shot at seven. And the reality of winning six was like, 'Oh, my gosh, seven it out there!' We had won five in a row, had a couple of years off of winning championships, and then got it done in 2013."

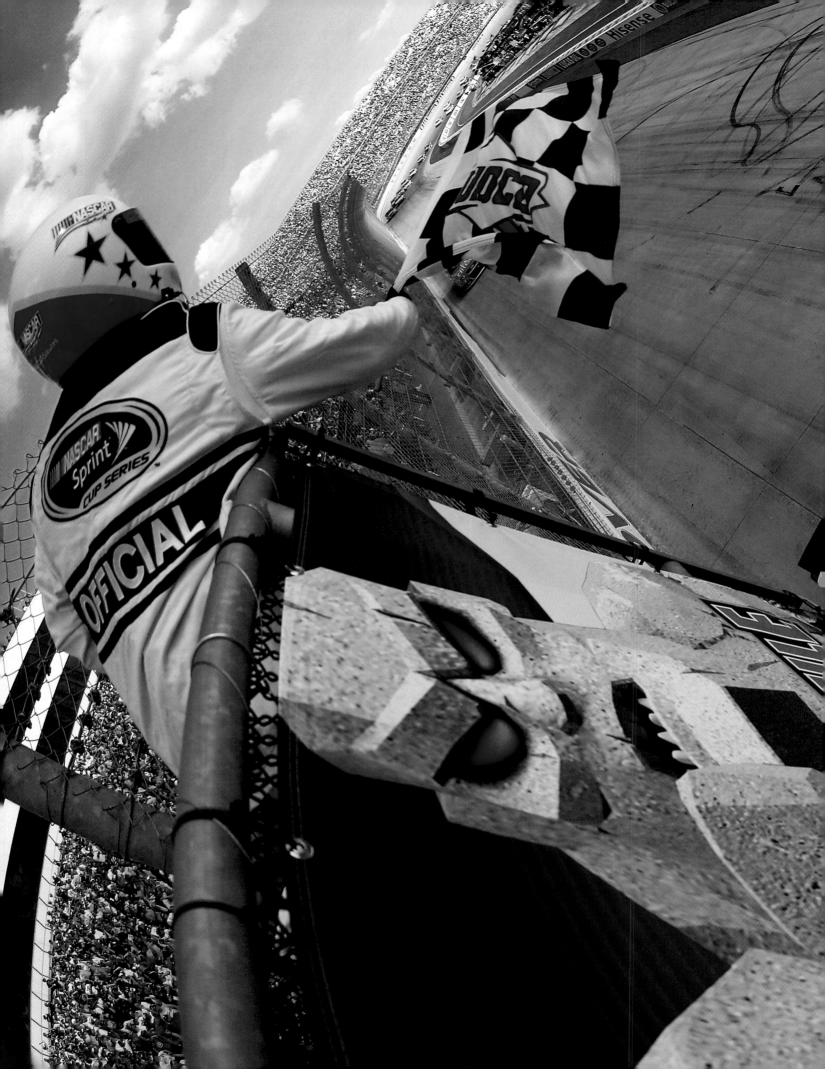

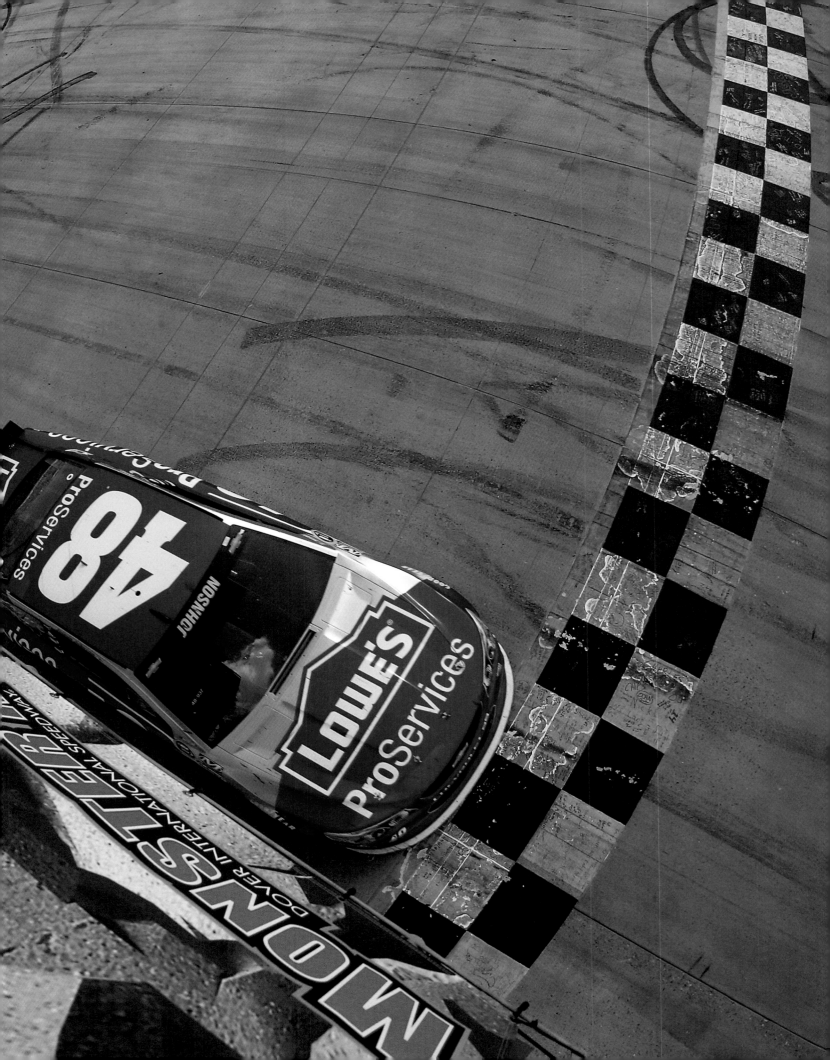

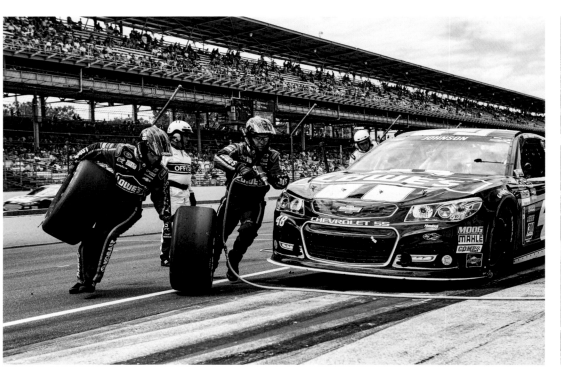

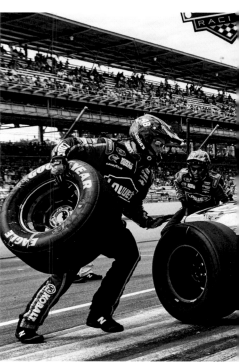

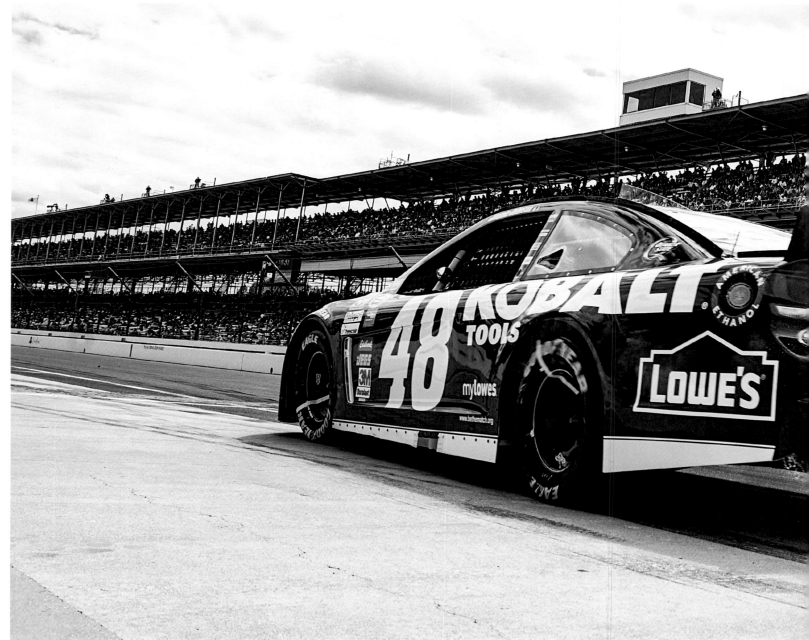

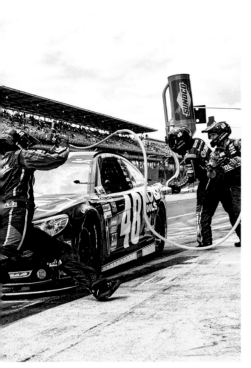

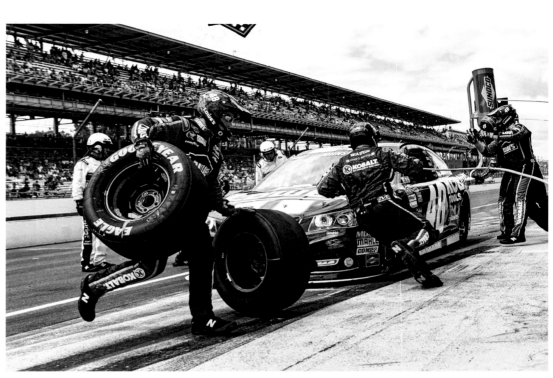

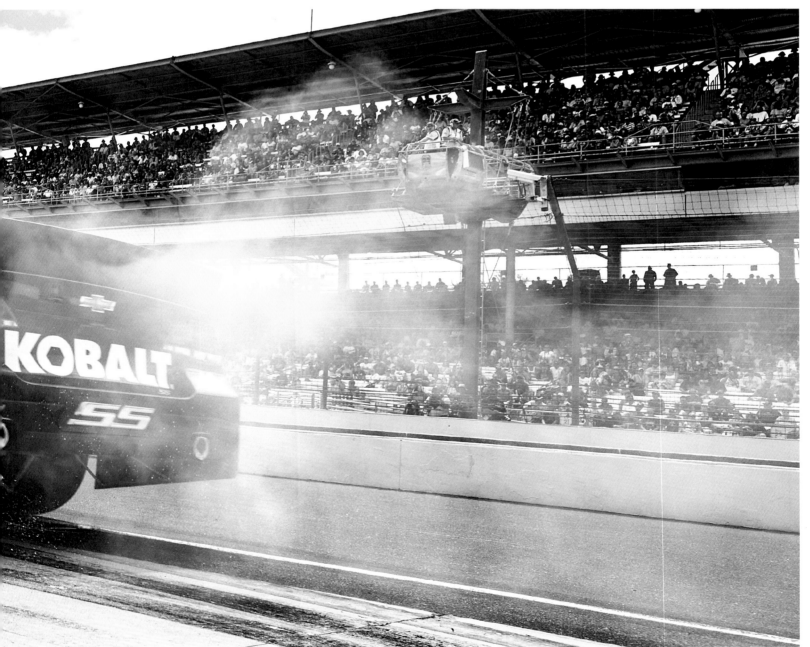

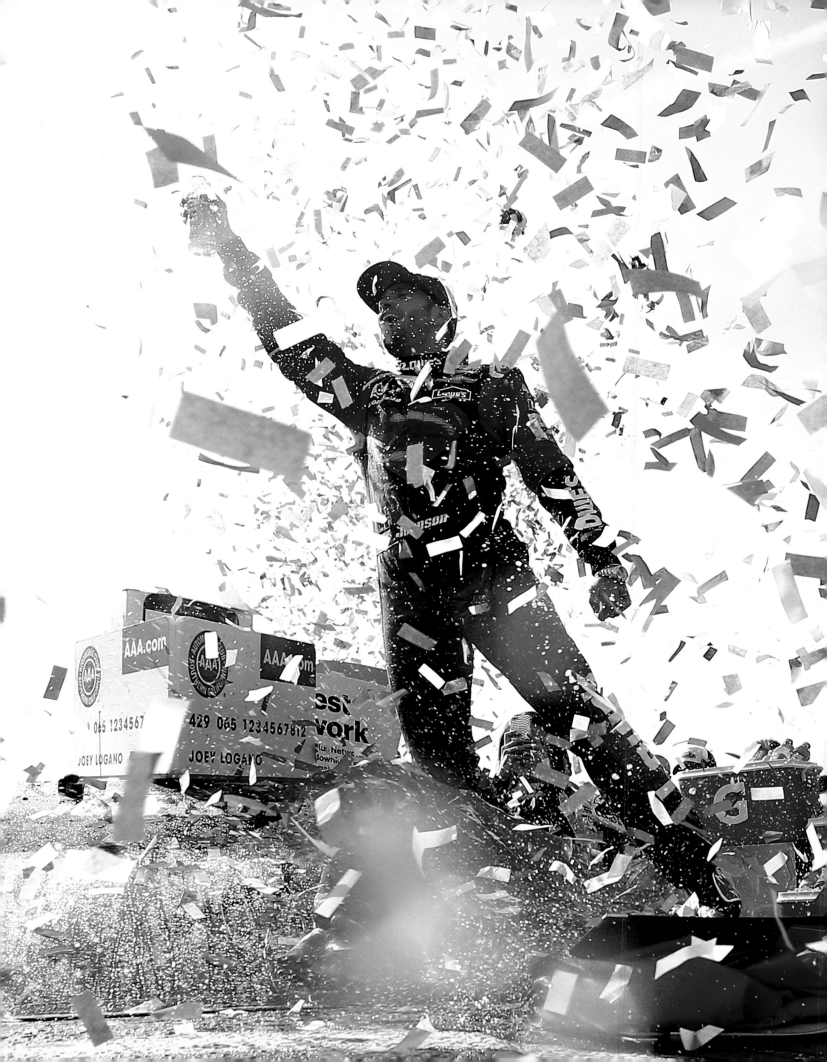

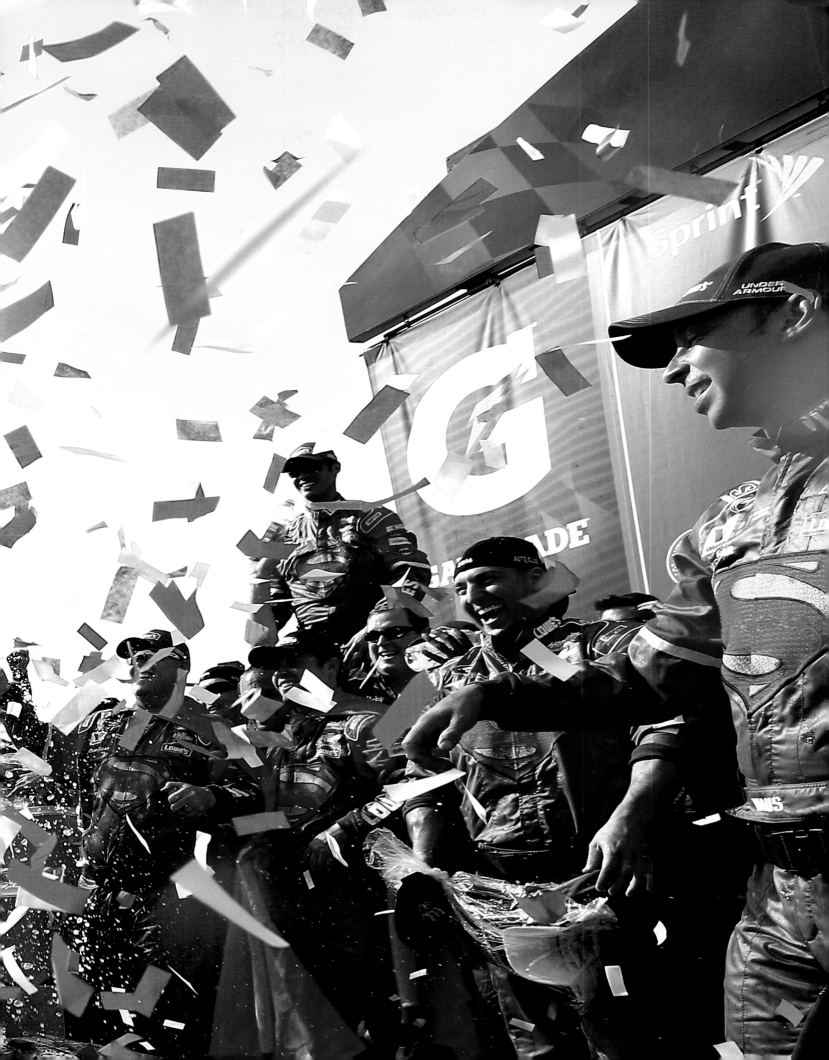

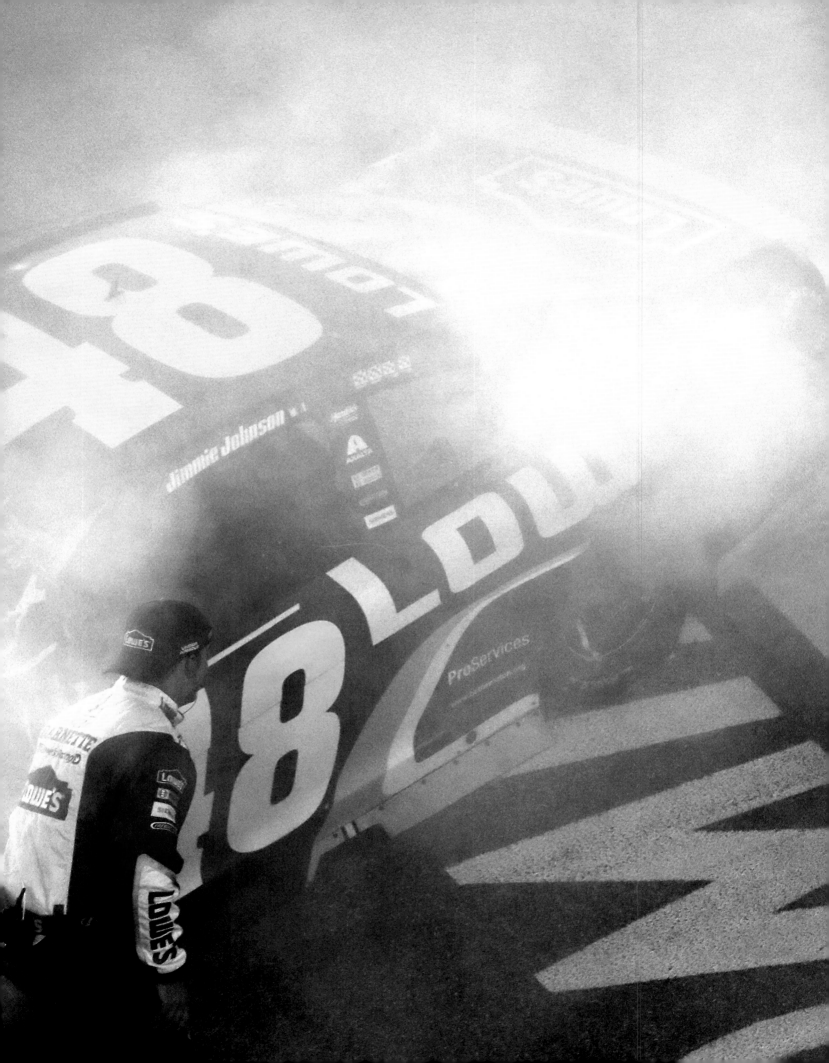

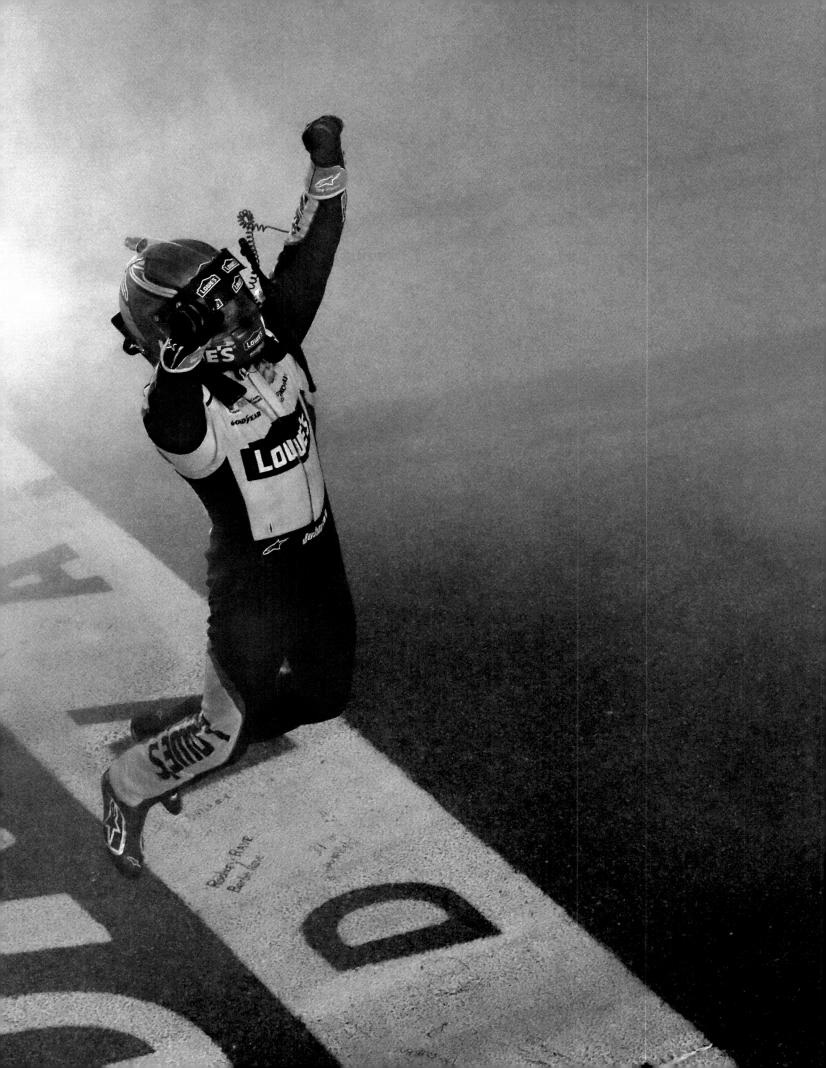

SECTION
224

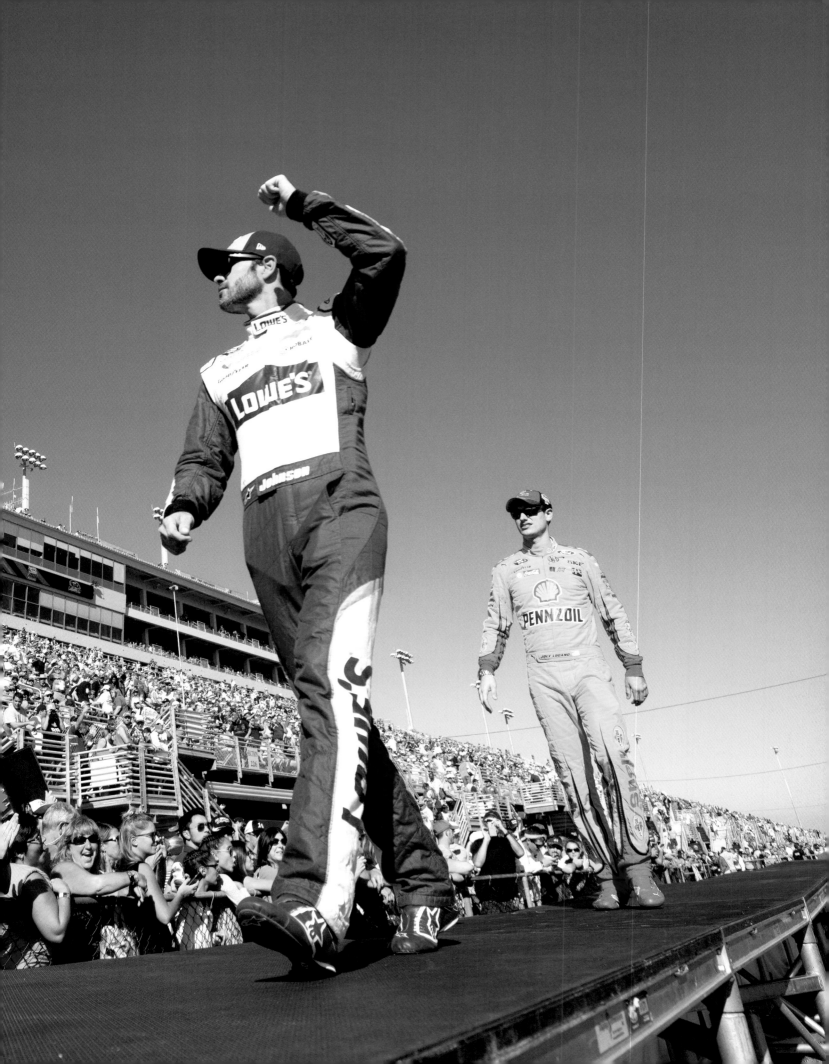

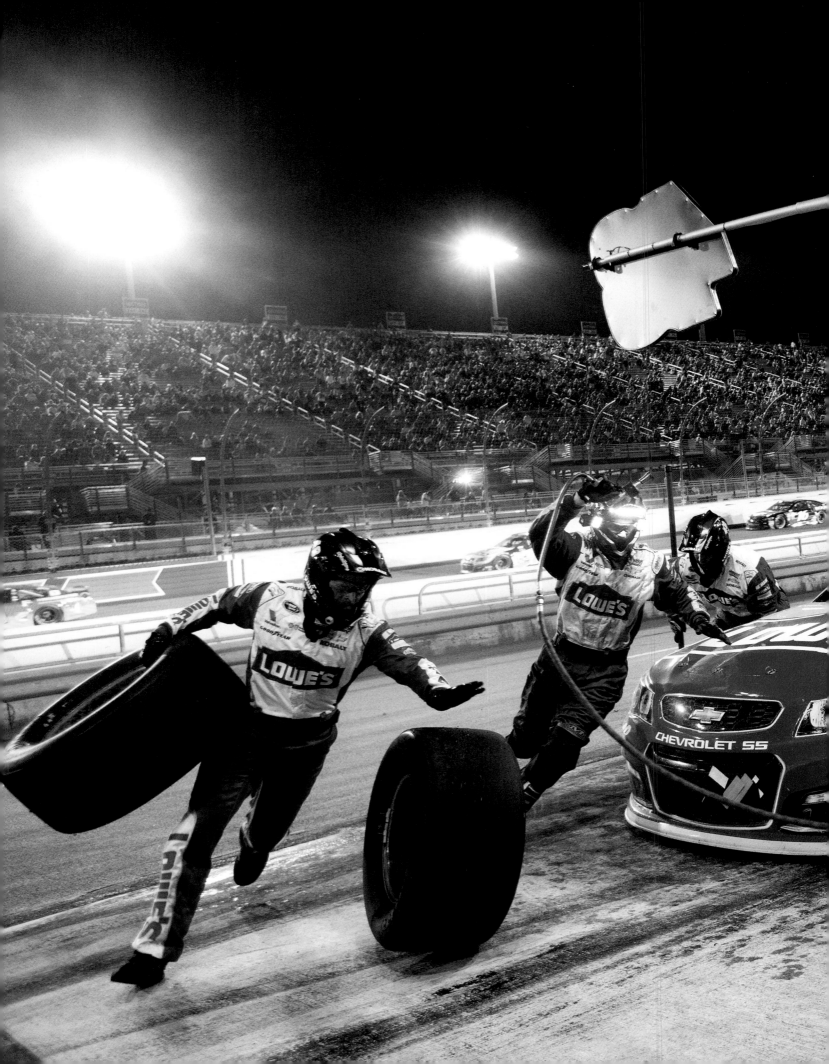

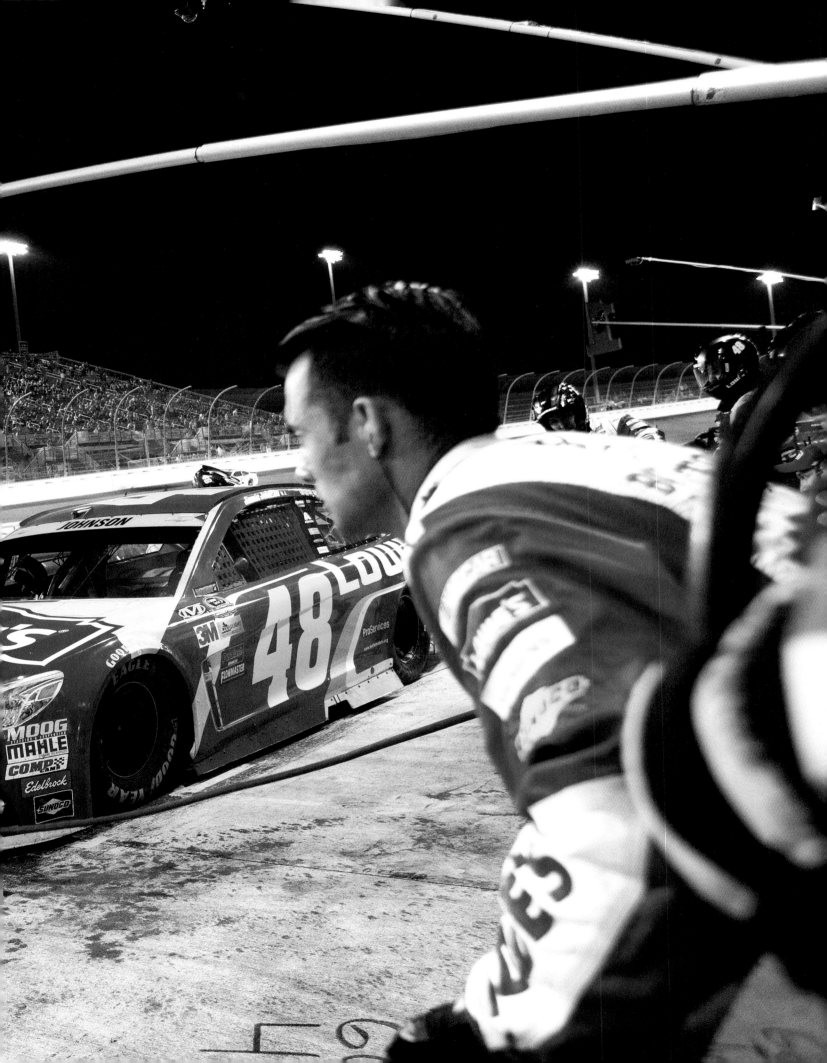

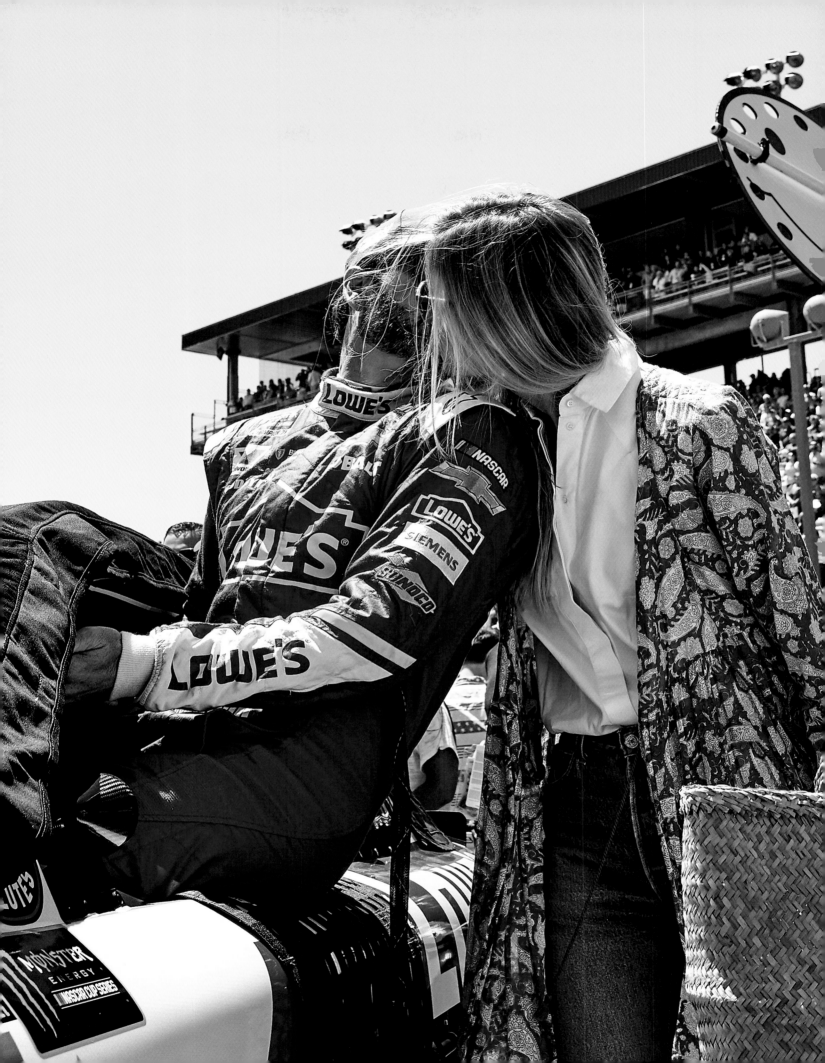

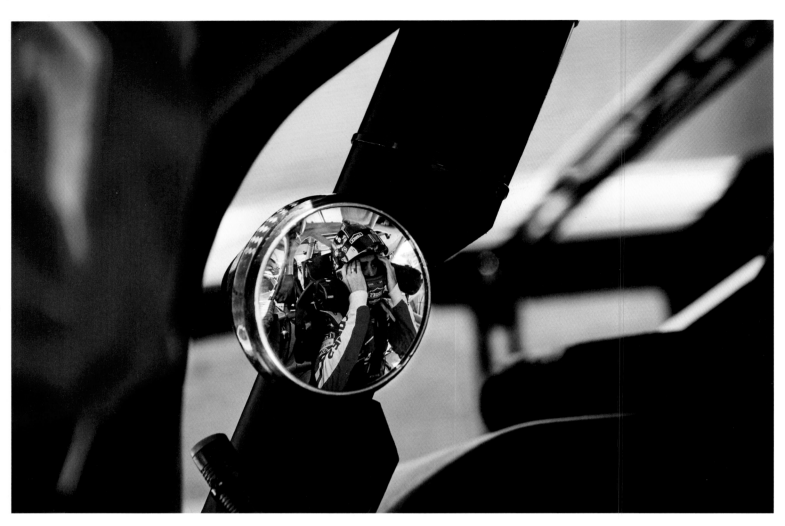

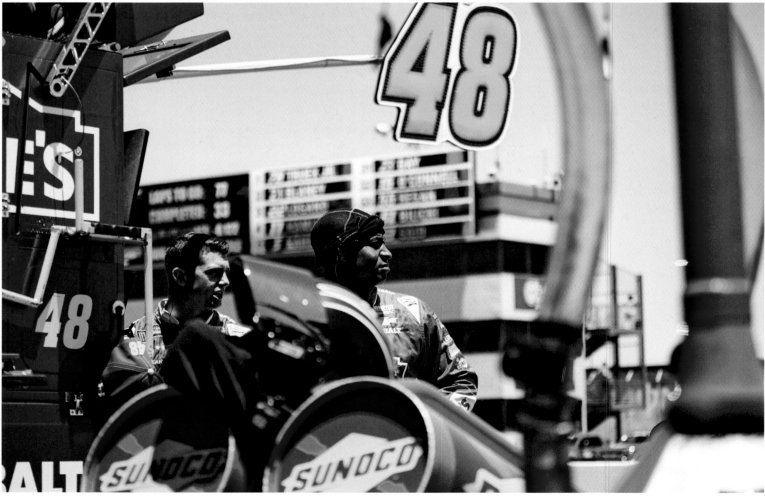

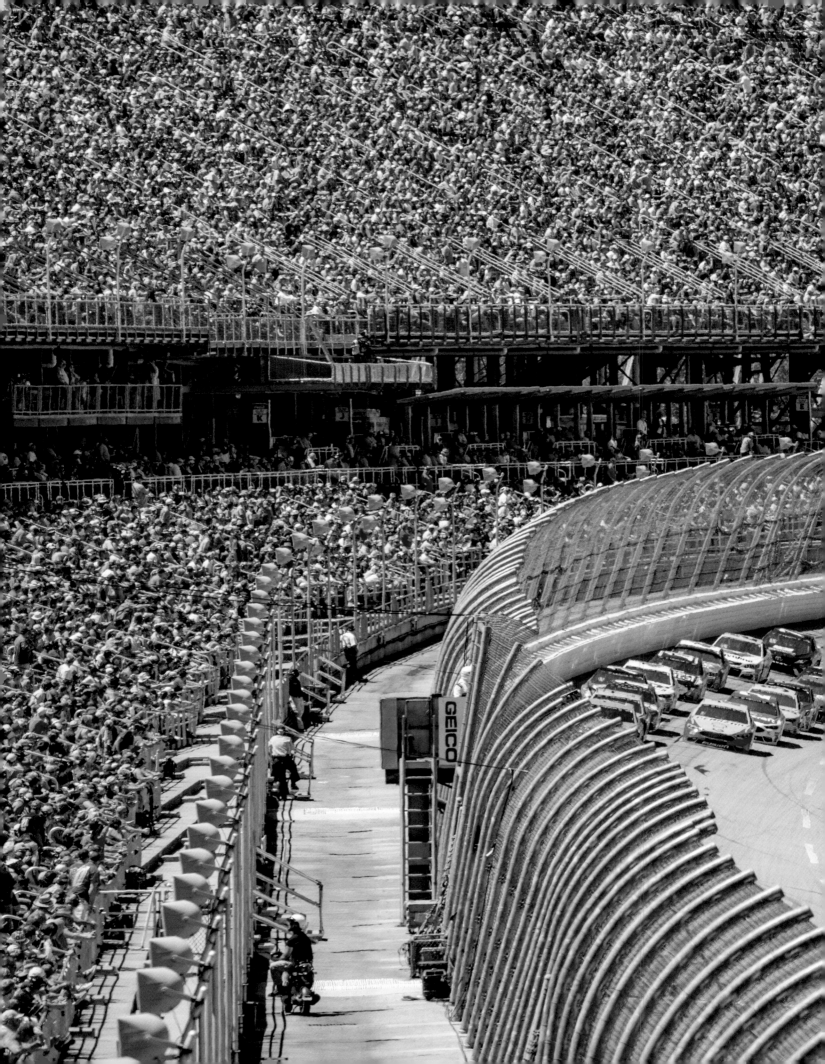

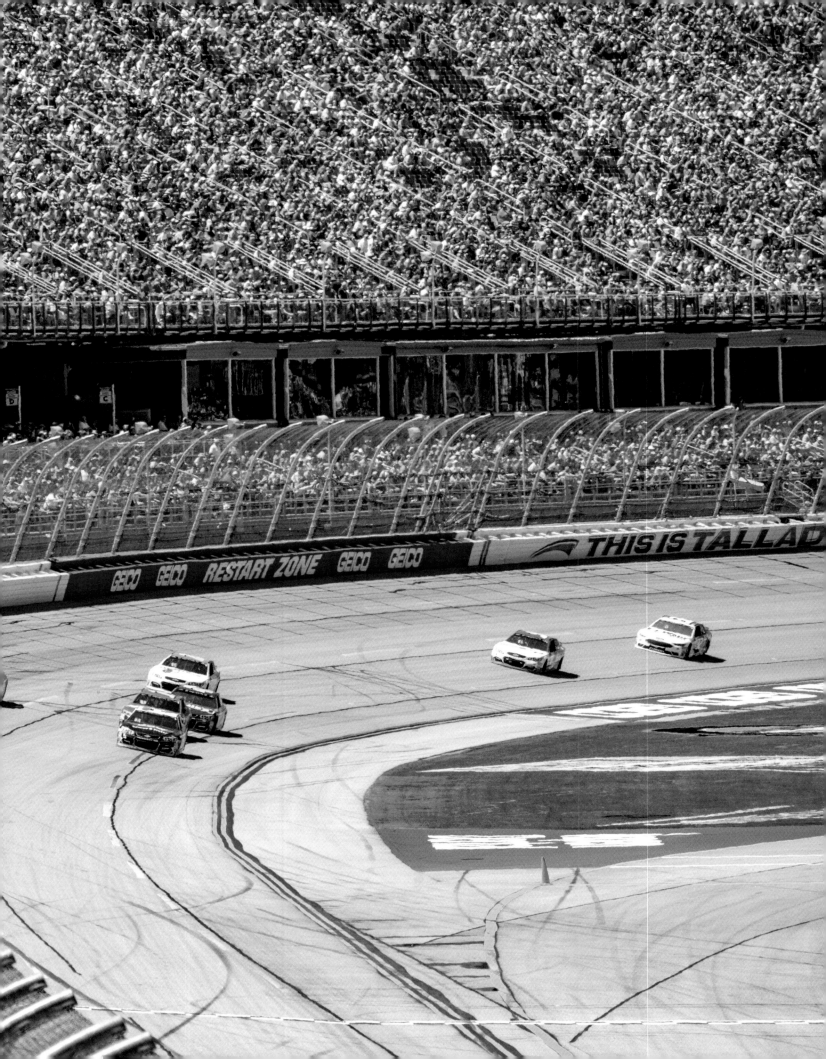

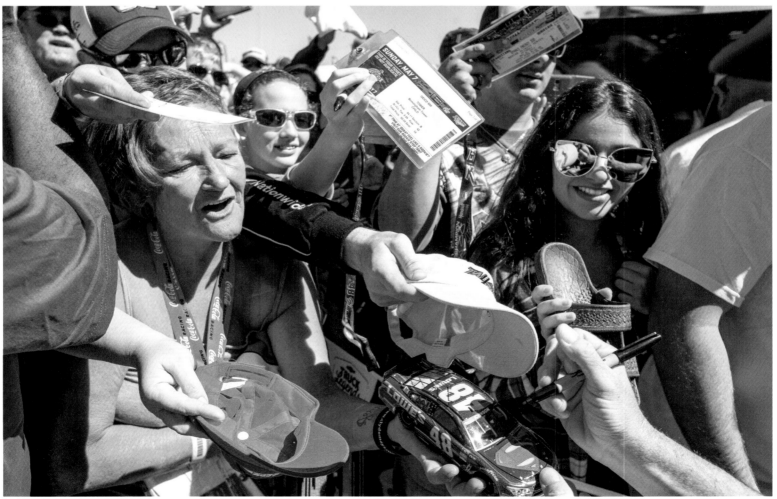

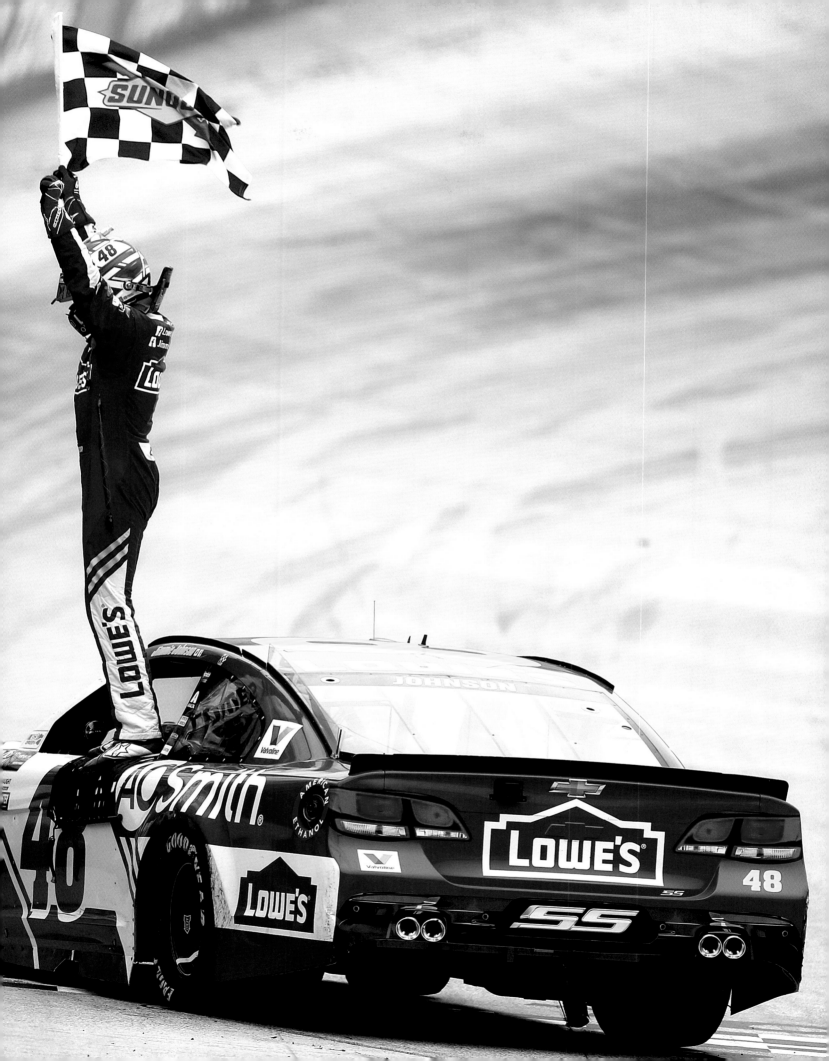

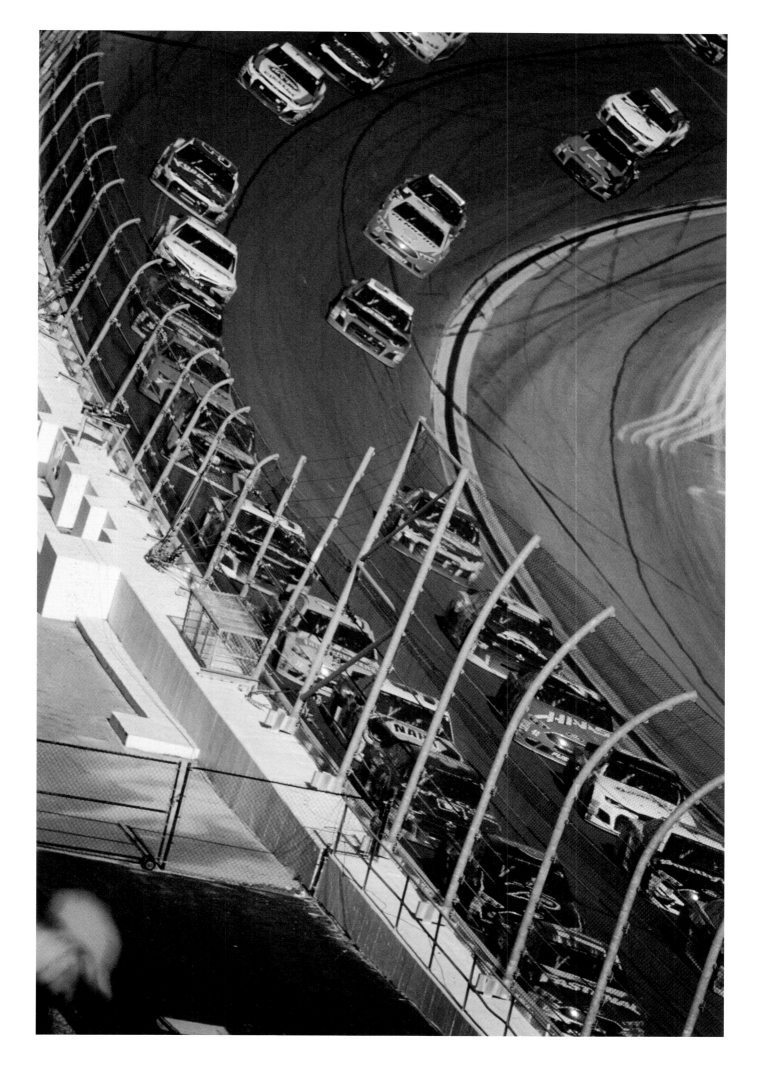

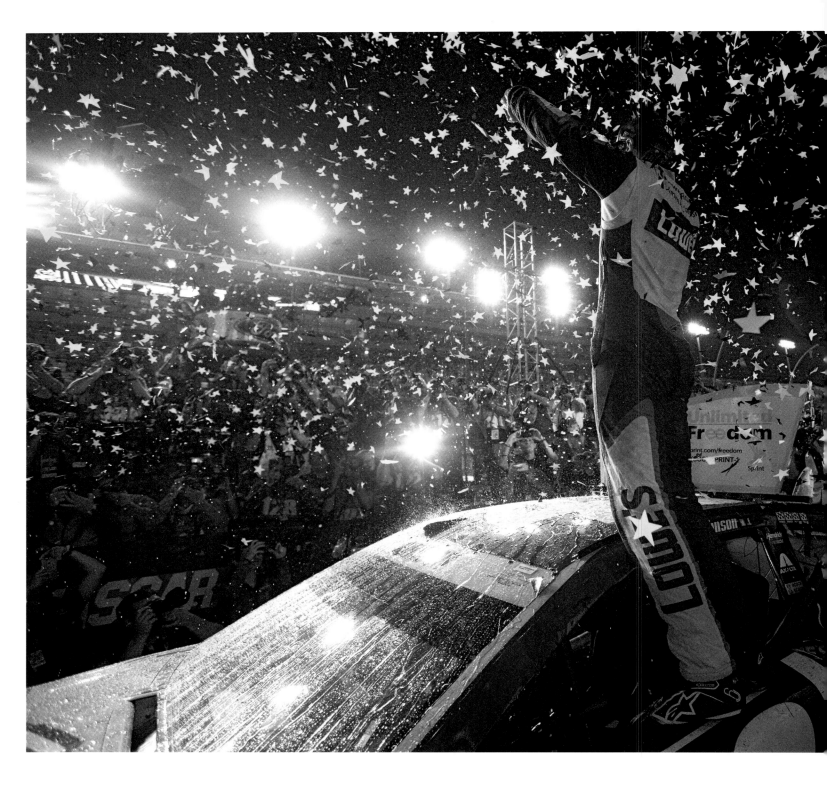

"The first three hundred and eighty miles of the race, I was not in contention, but then, with a few caution flags and restarts late in the race, I was able to get myself to the front, so that suddenly I managed to win not just the race but the championship. Just that swing of emotion–from being convinced I was out of it all to winning everything–made it an unforgettably emotional night. Believe it or not, I took a nap during one of the caution flags that then turned into a red flag at the end of the race. When I woke up, I felt refreshed and ready to go and made my way to a win that, again, I was pretty sure wasn't going to happen. I'd say that for Chandra and the kids, for my fans and everyone involved, it was the most epic roller coaster that we'd ever been on."

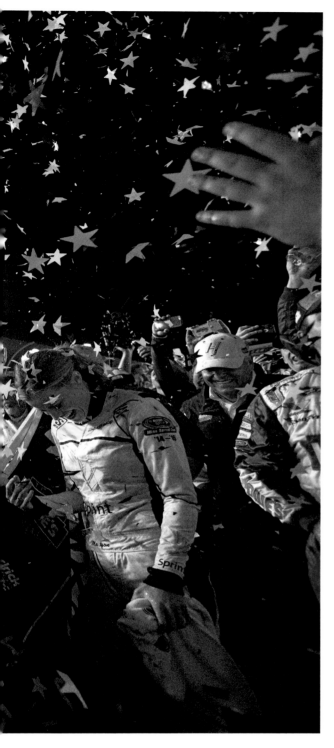

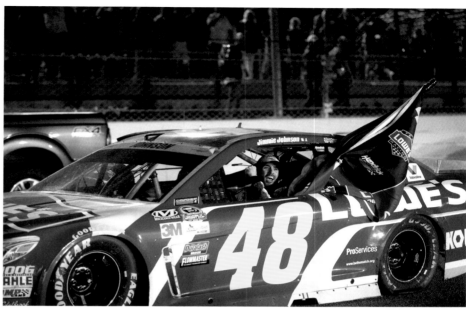

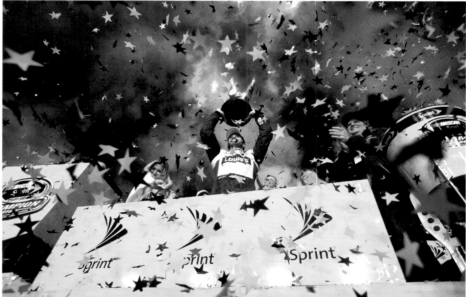

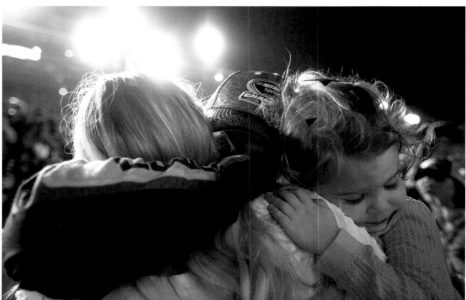

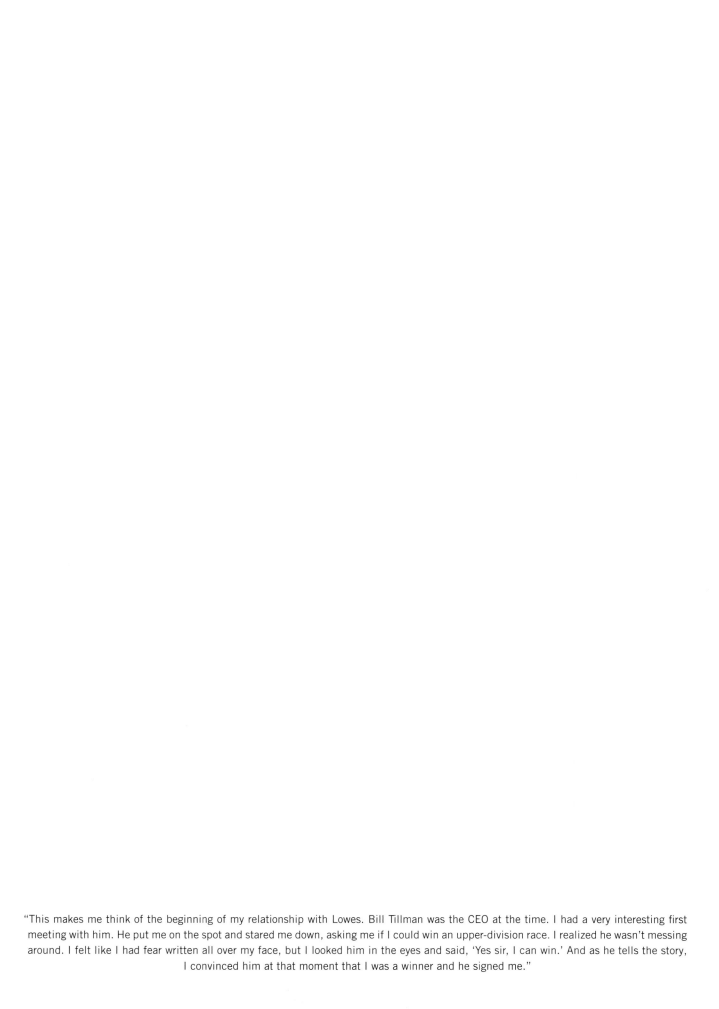

"This makes me think of the beginning of my relationship with Lowes. Bill Tillman was the CEO at the time. I had a very interesting first meeting with him. He put me on the spot and stared me down, asking me if I could win an upper-division race. I realized he wasn't messing around. I felt like I had fear written all over my face, but I looked him in the eyes and said, 'Yes sir, I can win.' And as he tells the story, I convinced him at that moment that I was a winner and he signed me."

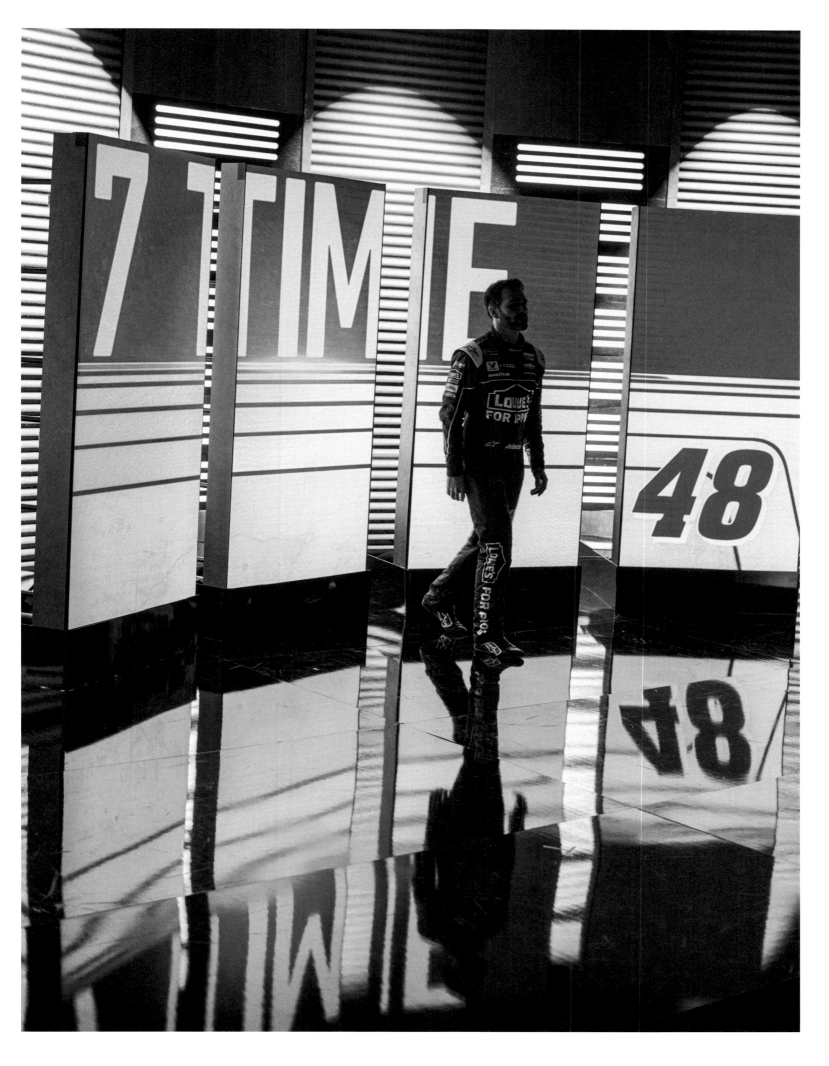

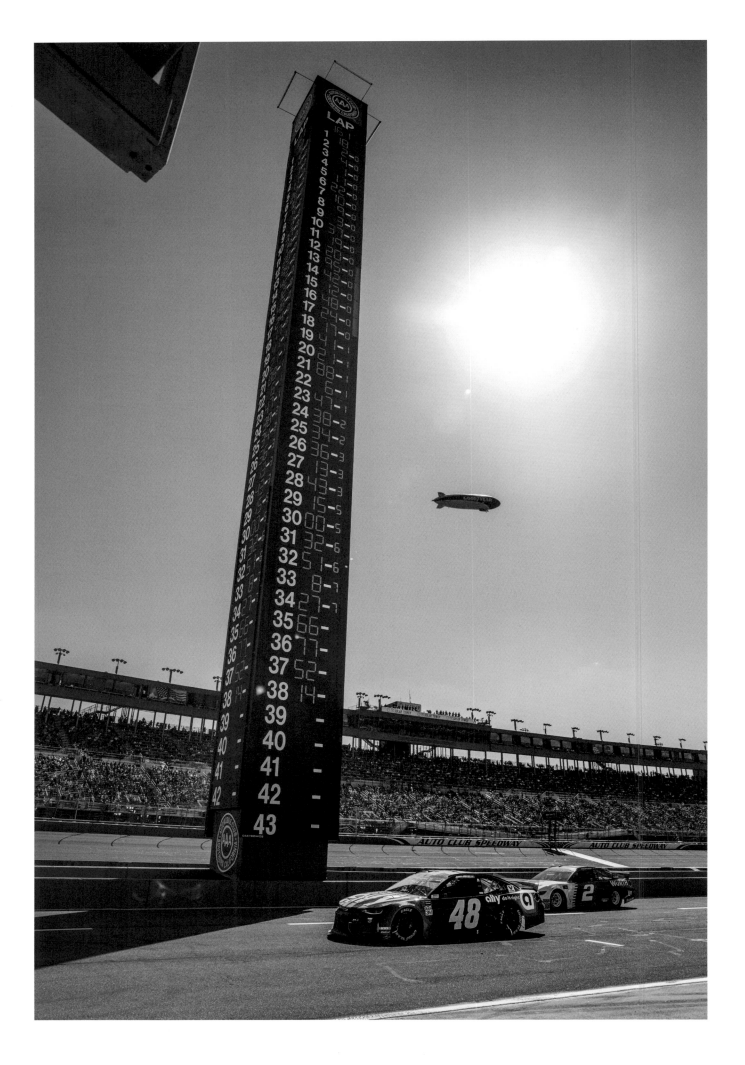

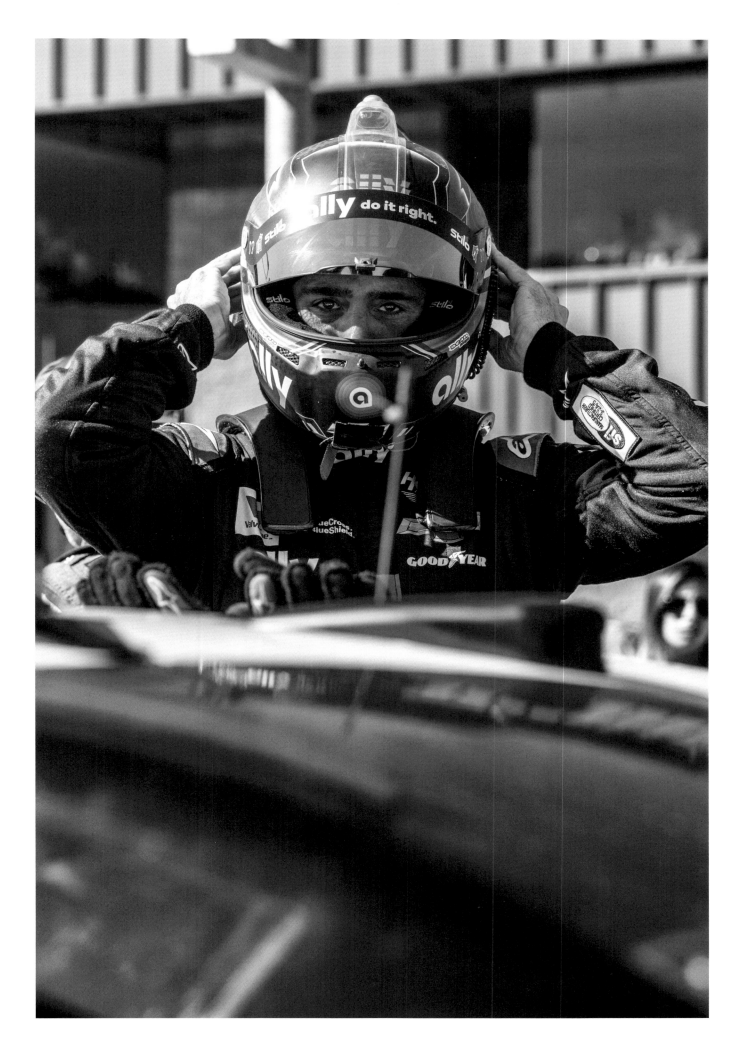

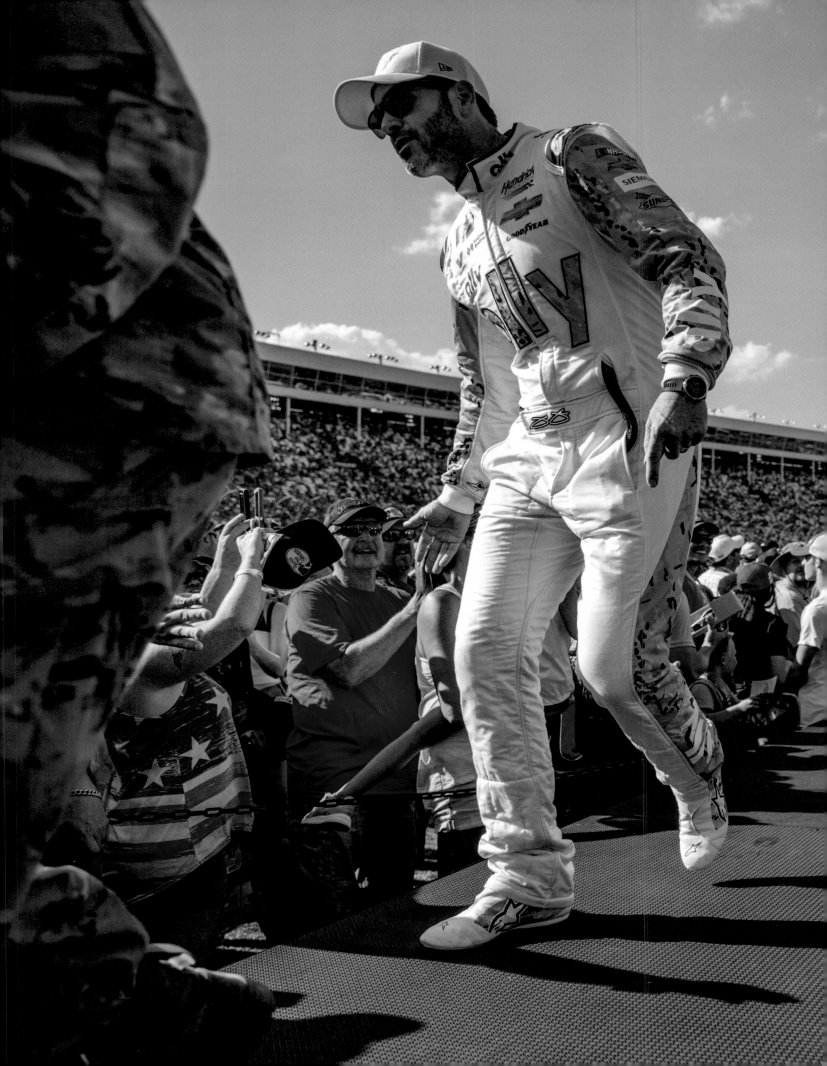

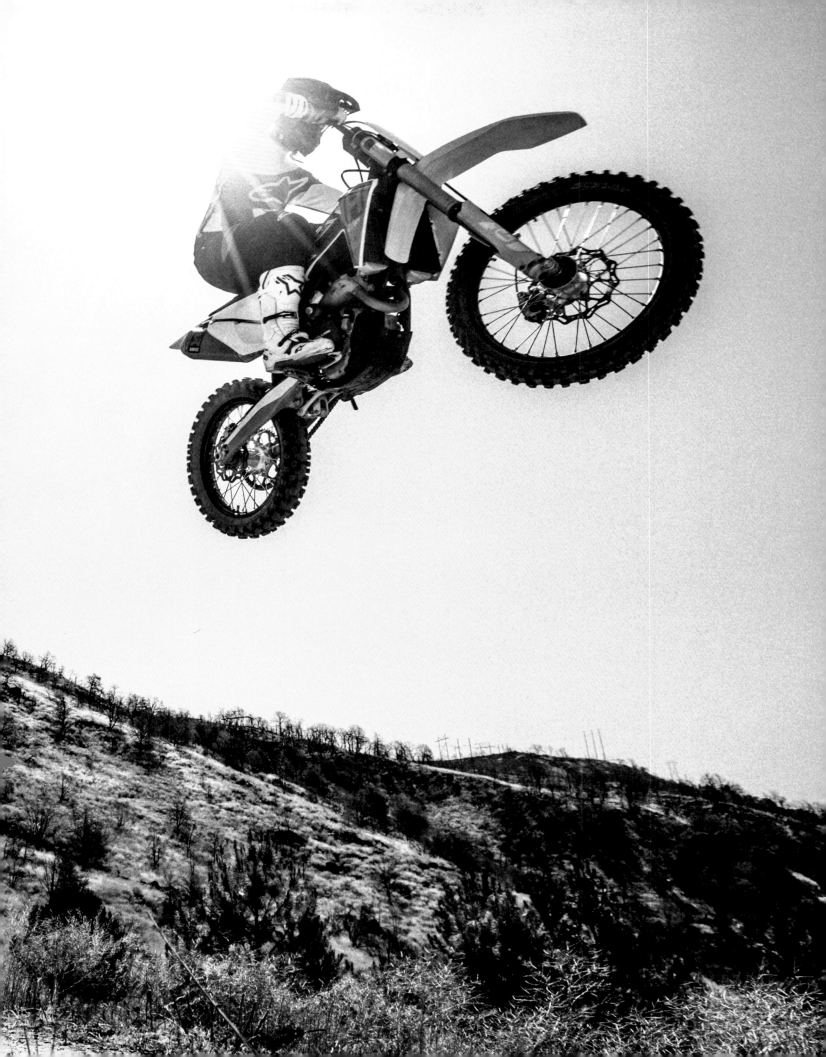

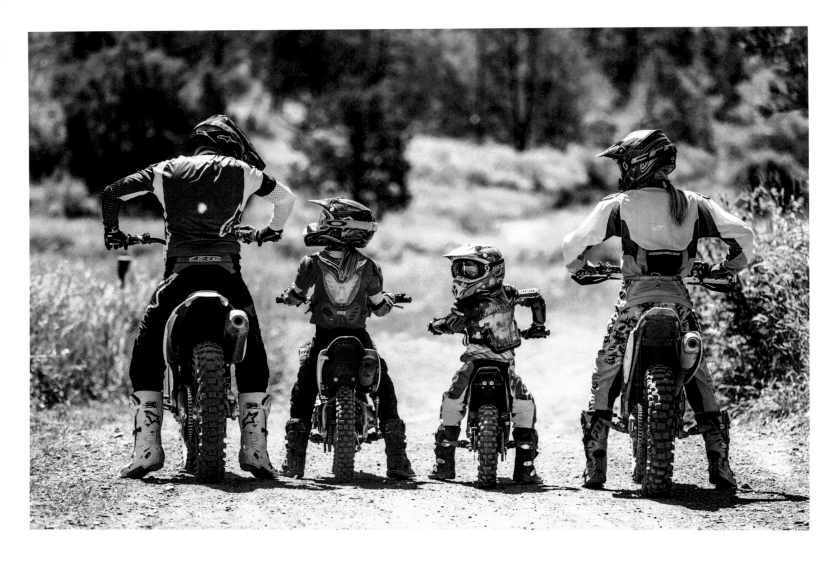

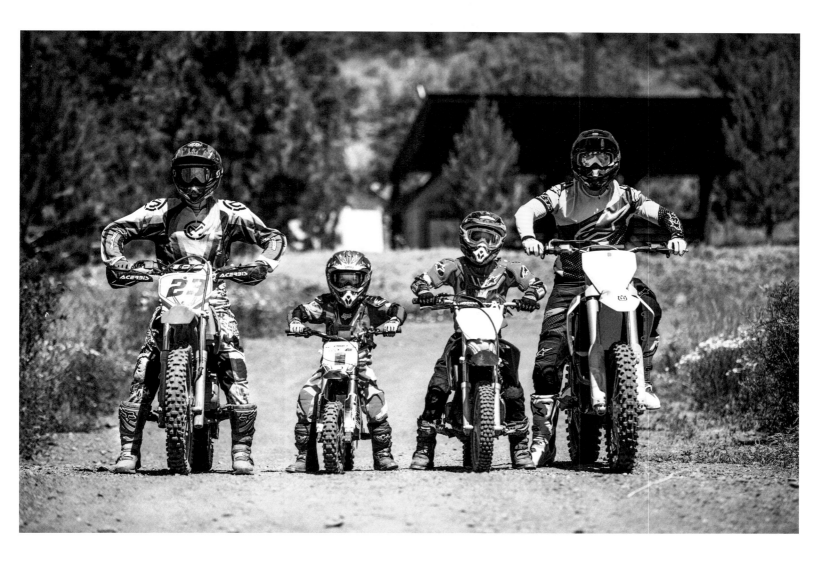

"My early years, obviously, were on dirt bikes. Being the father of two daughters, I wasn't sure if dirt bikes were in their future, so I was having an extremely prideful moment when we took these photos. The fact that Chani and the girls all like to ride is amazing. We ride every summer."

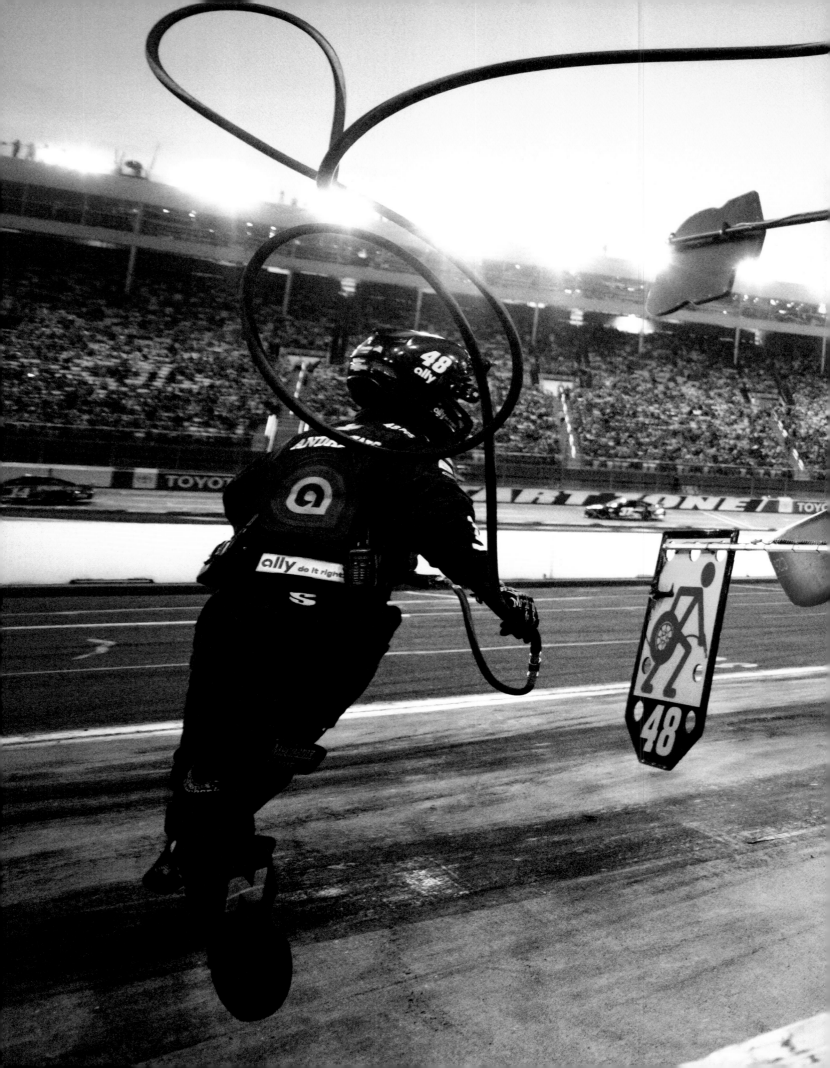

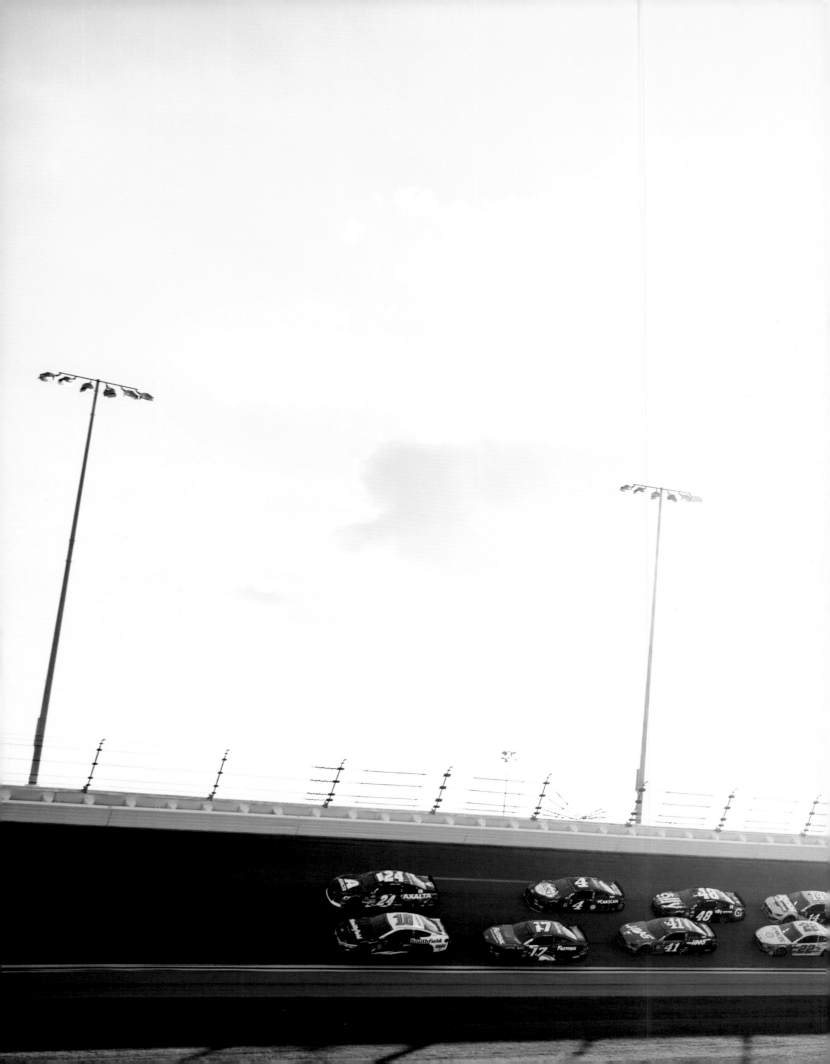

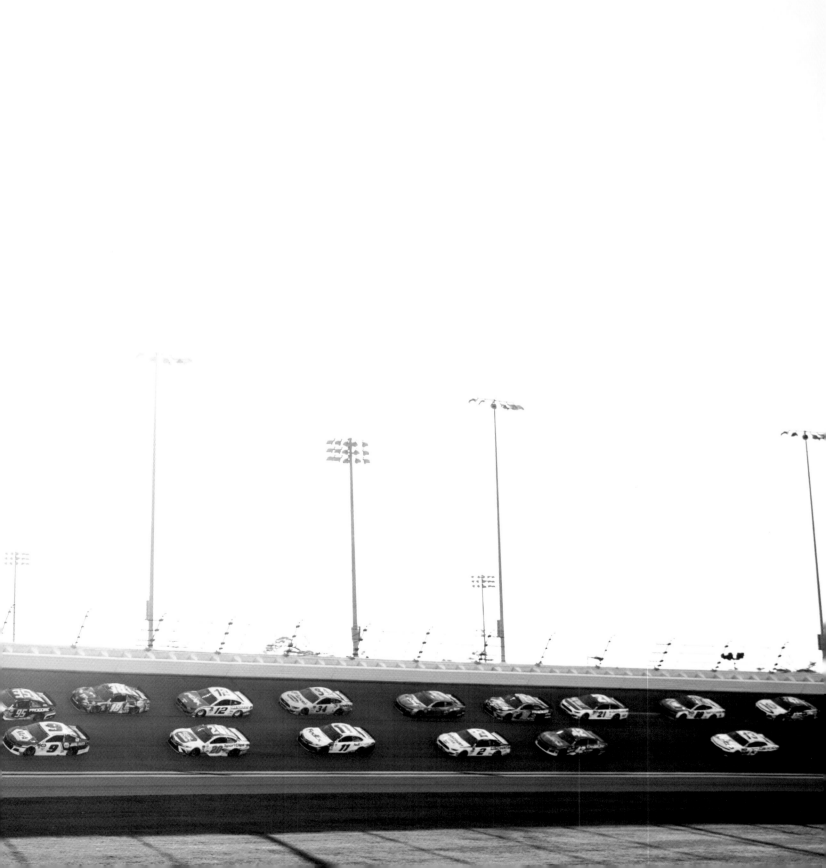

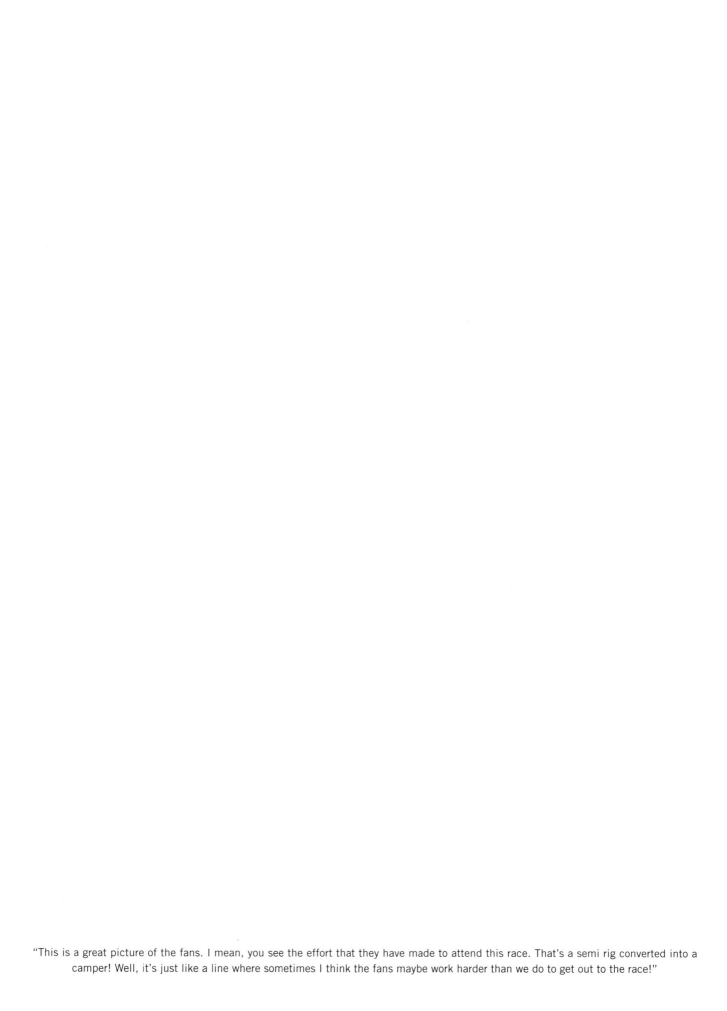

"This is a great picture of the fans. I mean, you see the effort that they have made to attend this race. That's a semi rig converted into a camper! Well, it's just like a line where sometimes I think the fans maybe work harder than we do to get out to the race!"

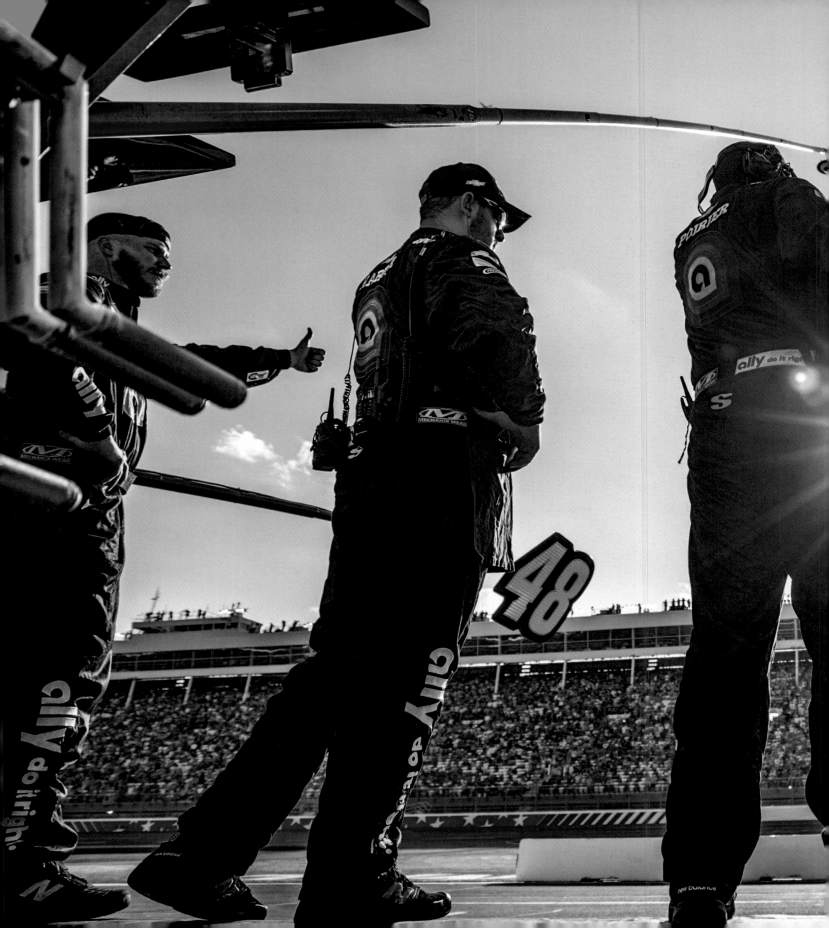

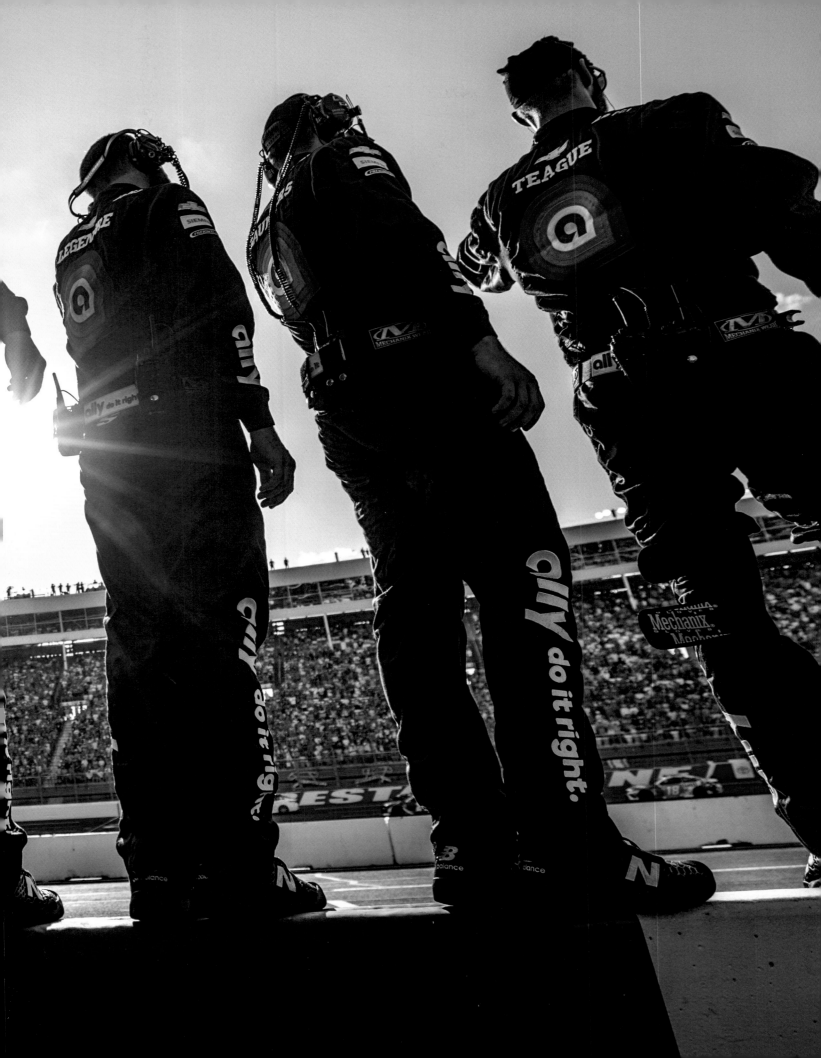

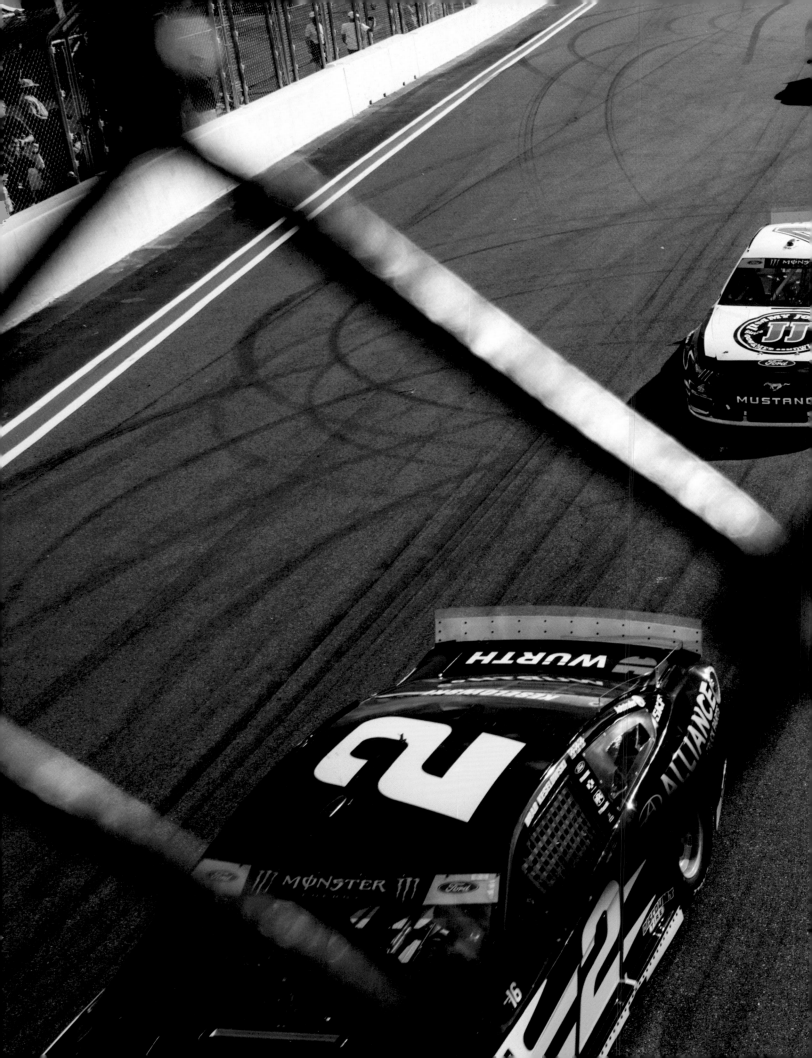

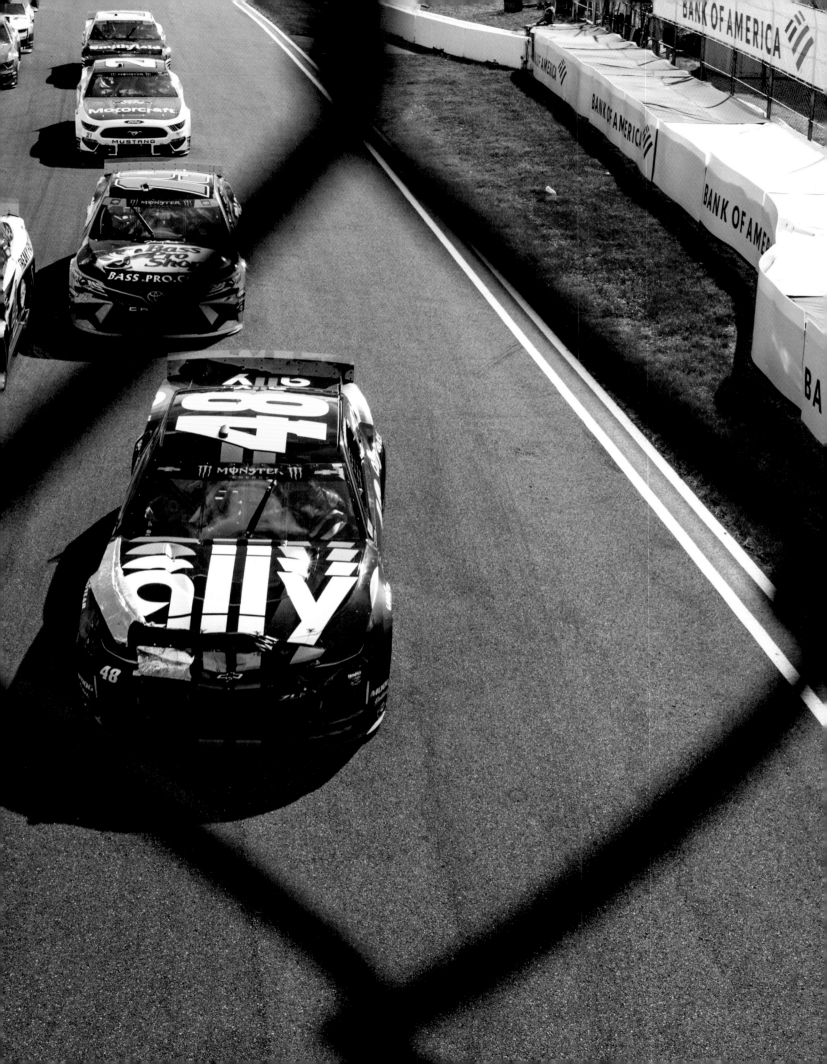

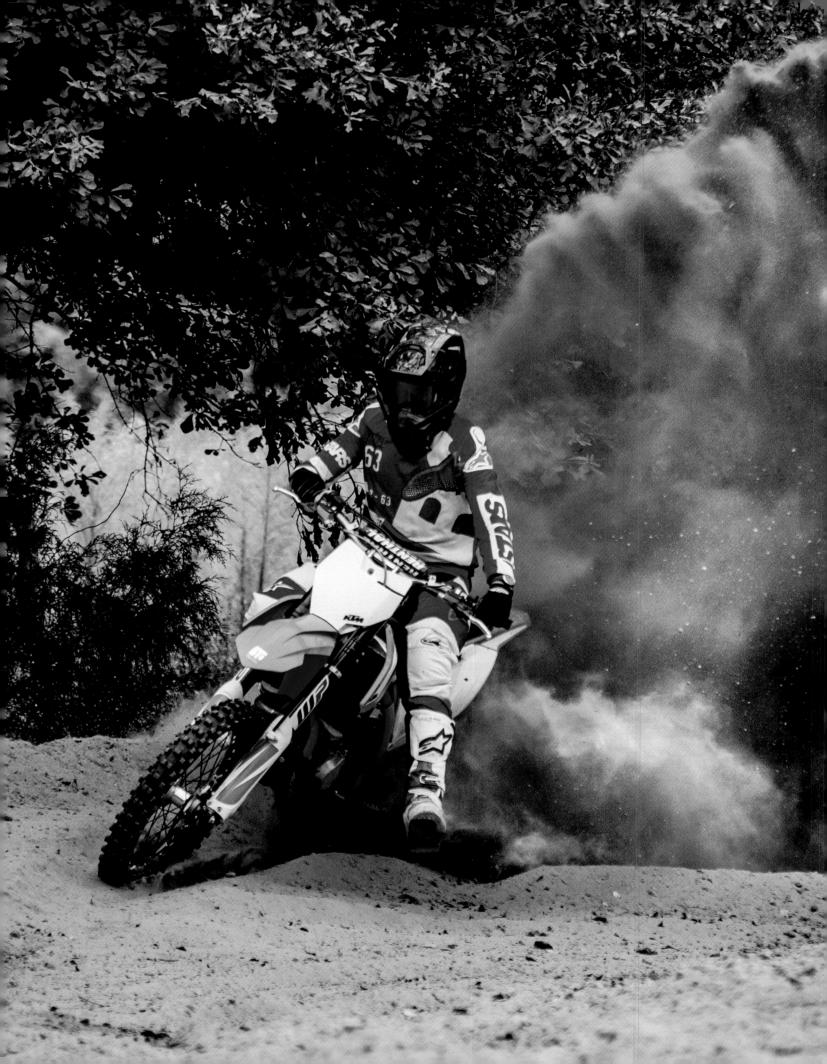

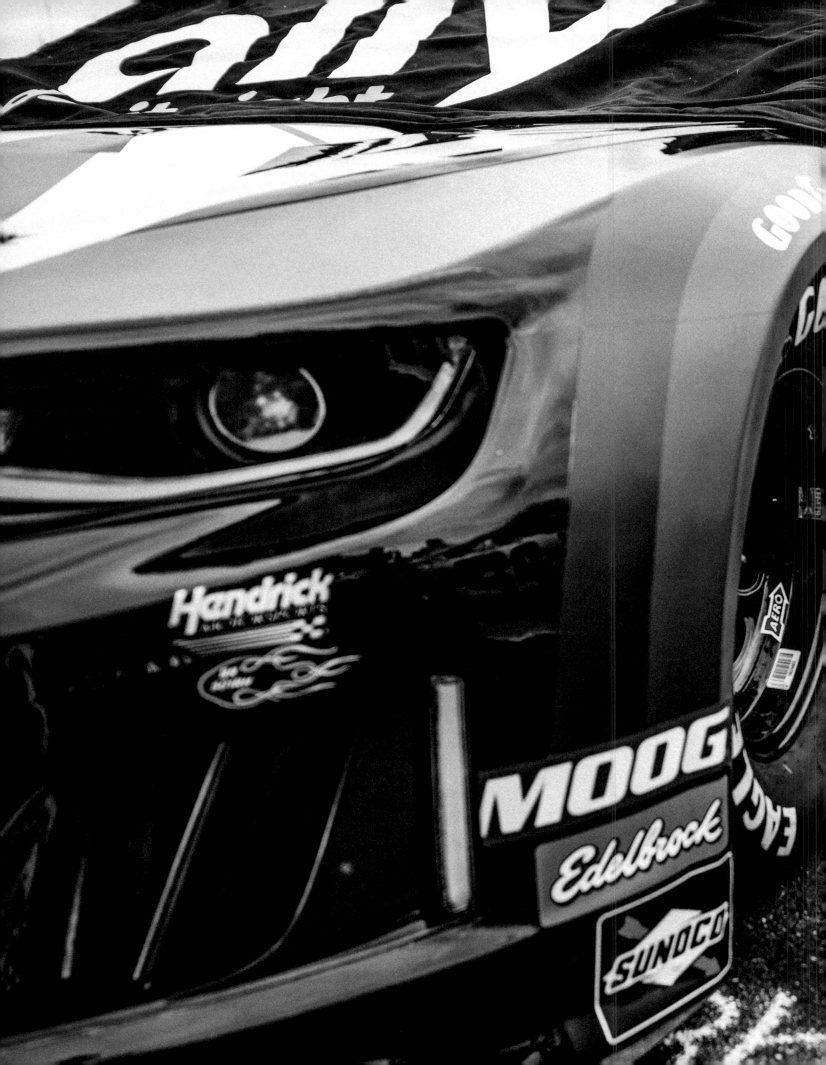

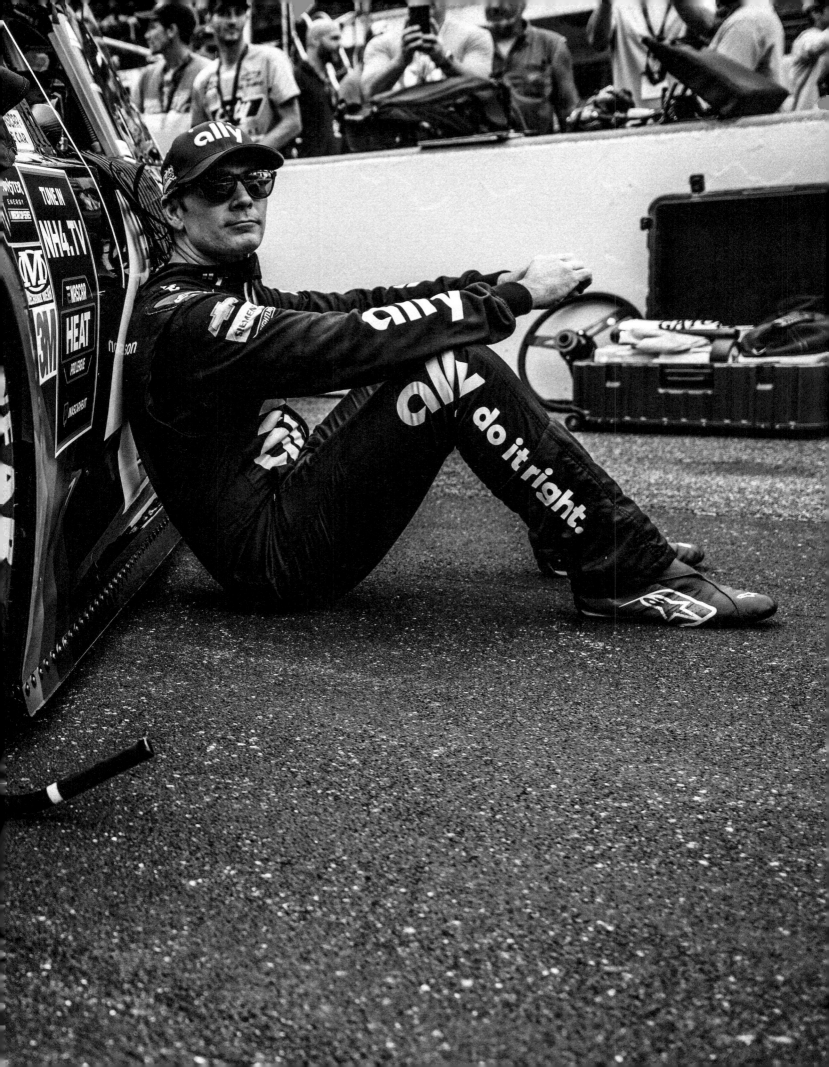

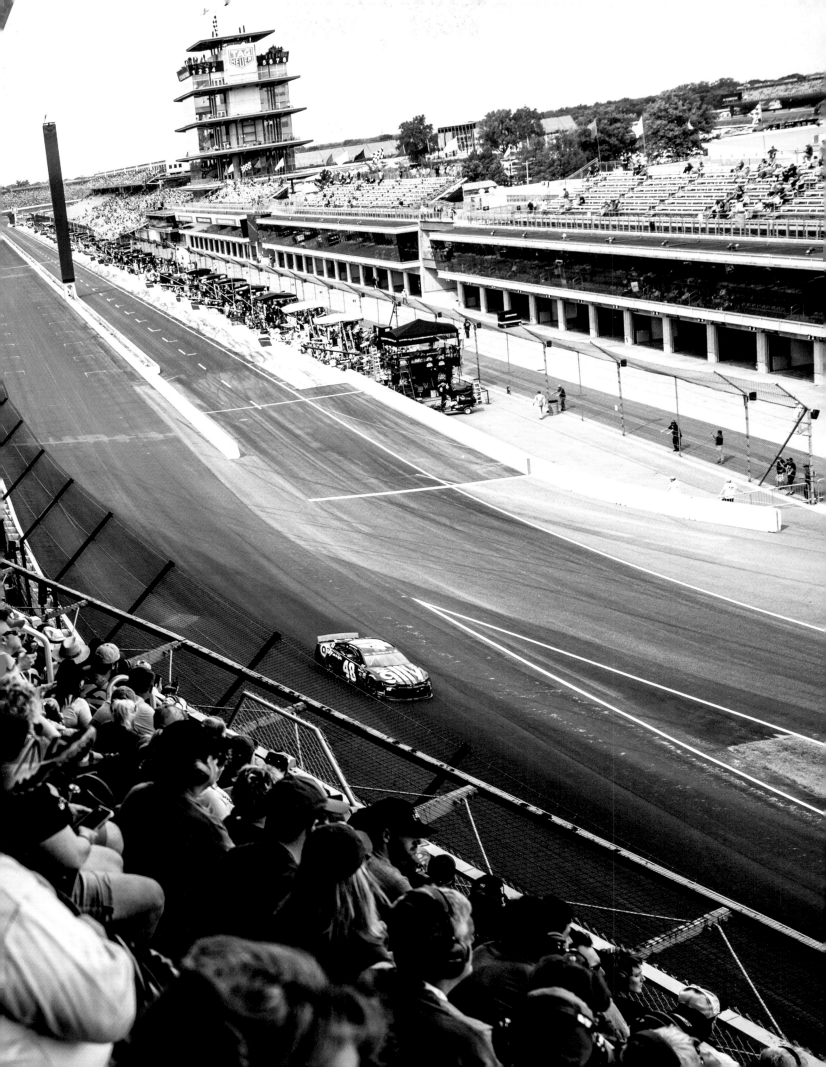

"The transporter is our locker room. We have countless meetings here. This is a pre-race meeting that includes a quick prayer. It's like you have this amazing team assembled. You all practiced your minds out, and also literally tried to think out everything you know. But then you're going for that other thing. You just need the winds to blow right, and you are hoping they will blow right. It's all strategy, but with a dose of hope for good luck."

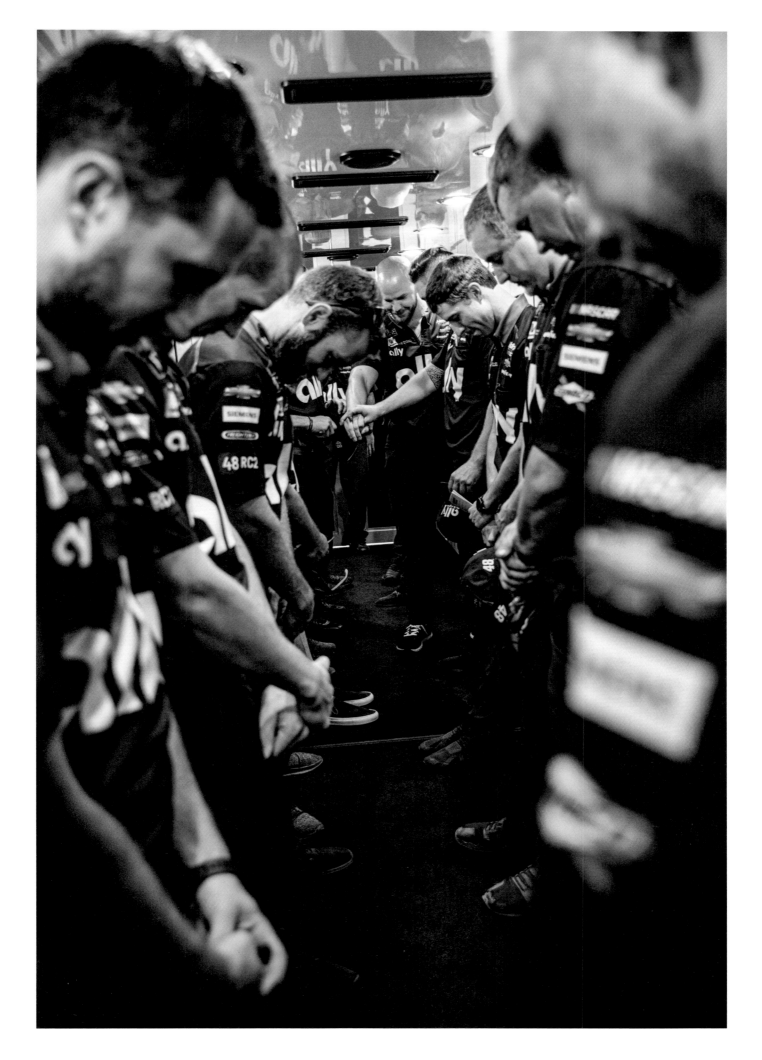

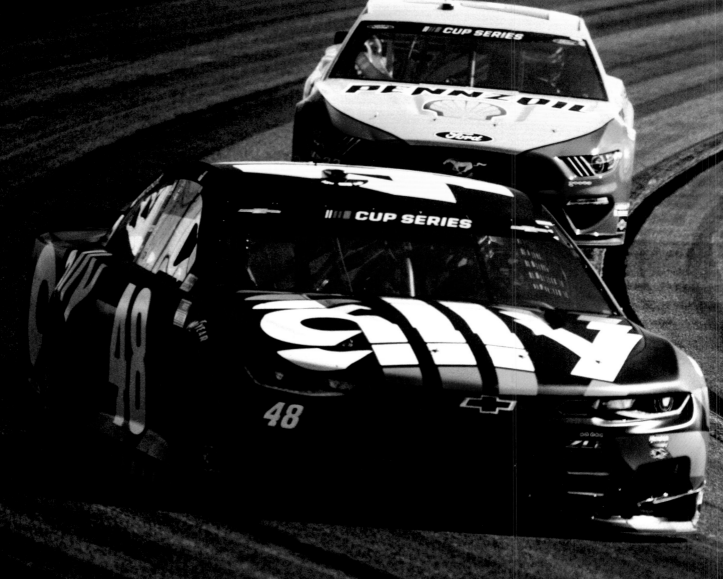

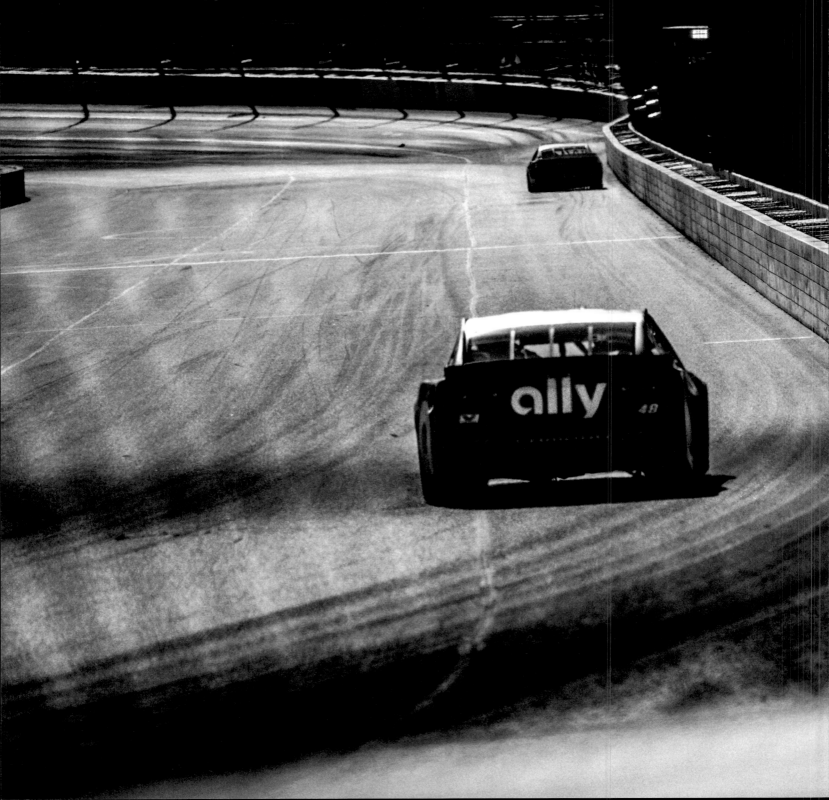

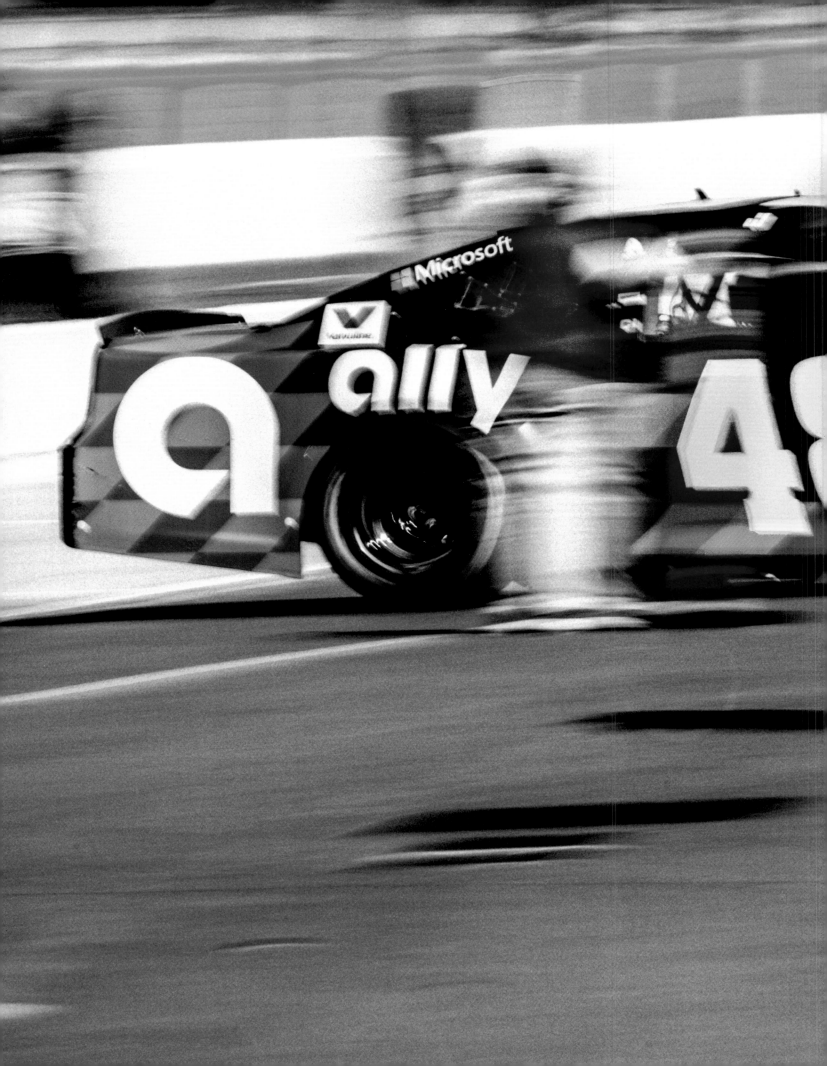

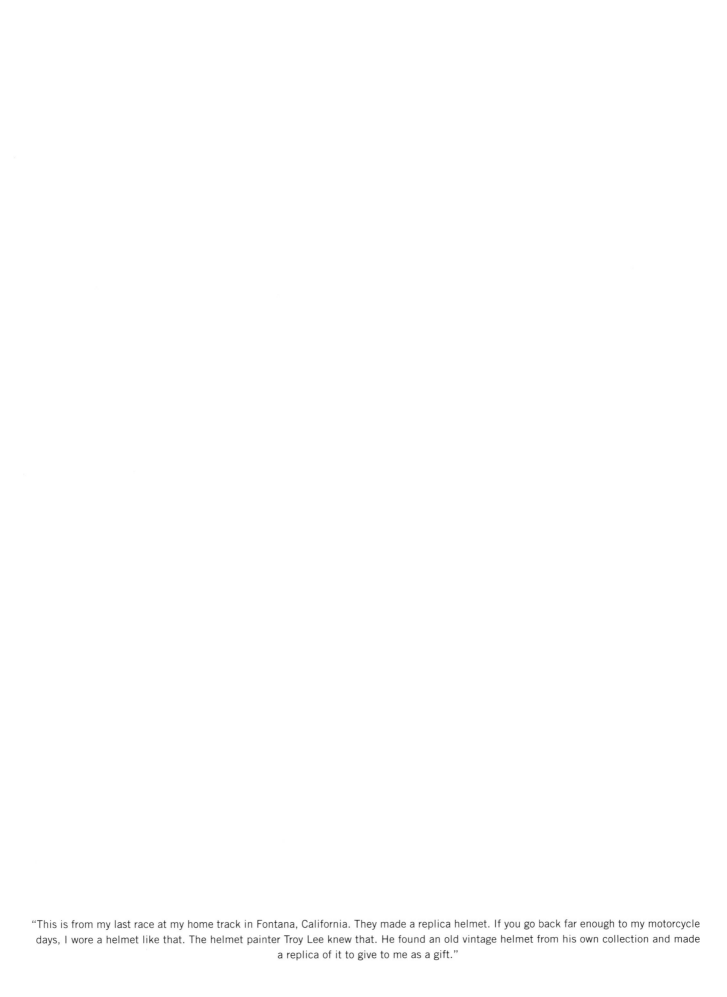

"This is from my last race at my home track in Fontana, California. They made a replica helmet. If you go back far enough to my motorcycle days, I wore a helmet like that. The helmet painter Troy Lee knew that. He found an old vintage helmet from his own collection and made a replica of it to give to me as a gift."

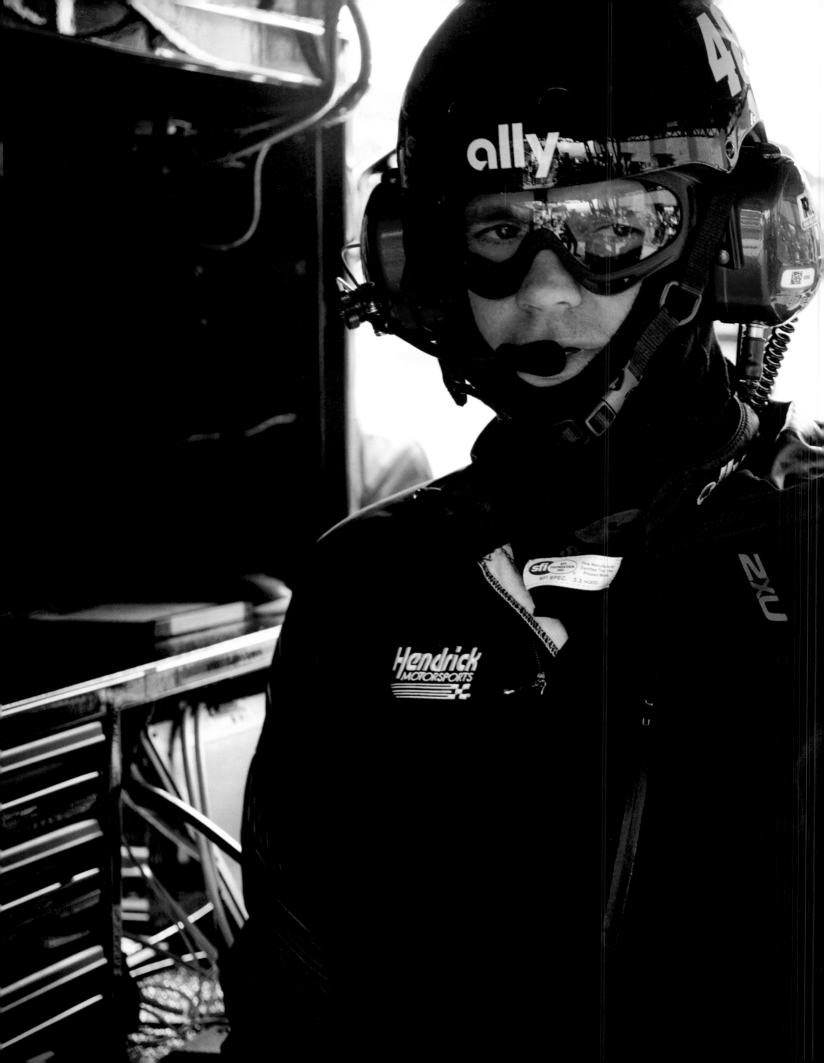

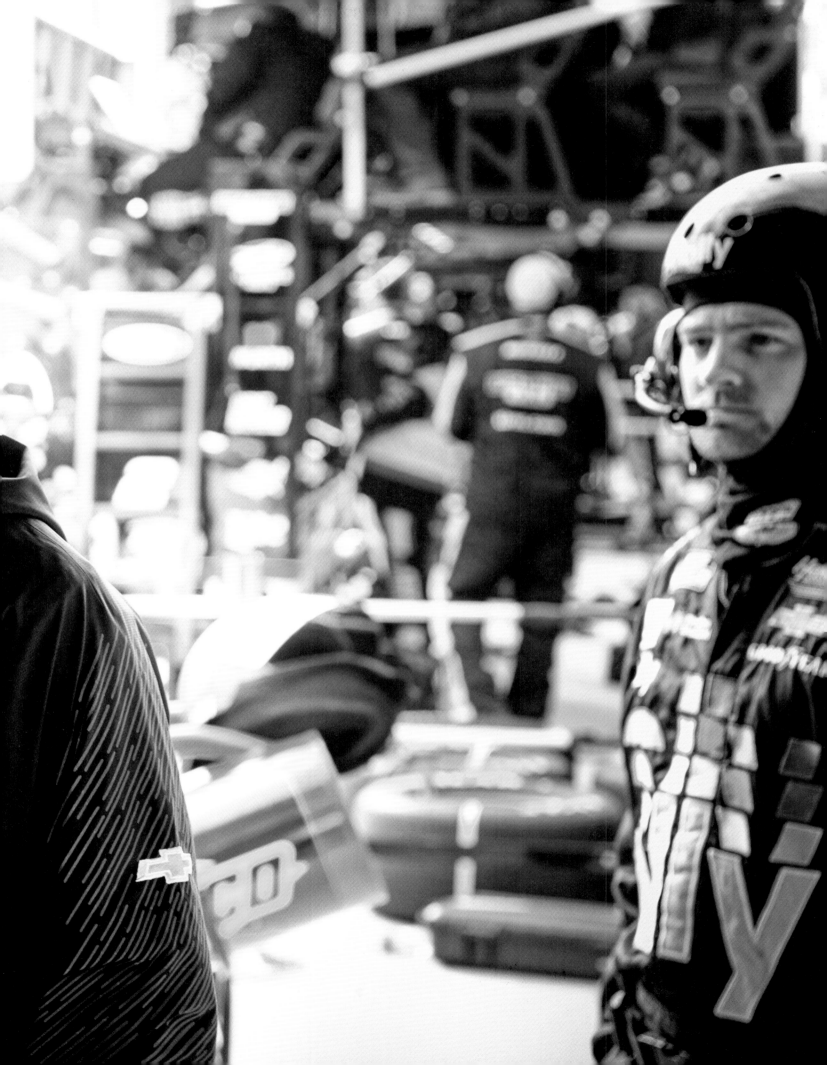

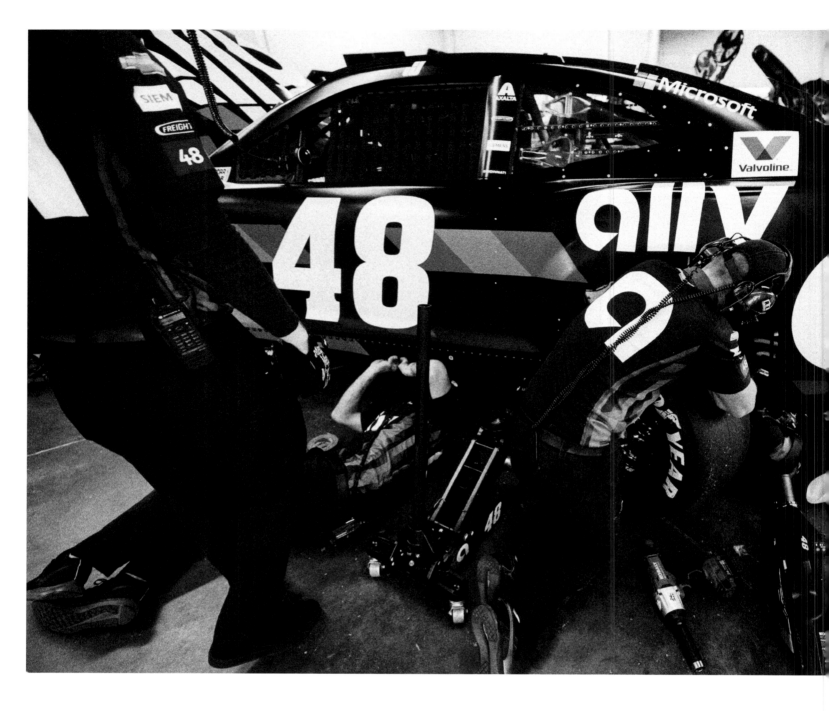

"Motorsports is a physics class blended with other disciplines. These crew members work within a thousand of an inch to hit perfection. That thousand of an inch is what matters. There are deep conversations about how to make sure our mouse trap is better than everyone else's."

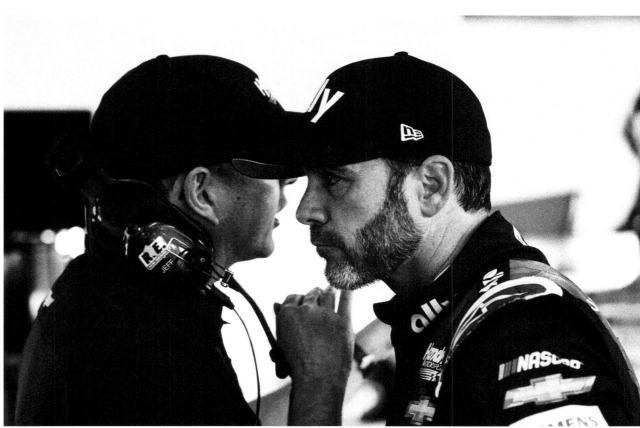

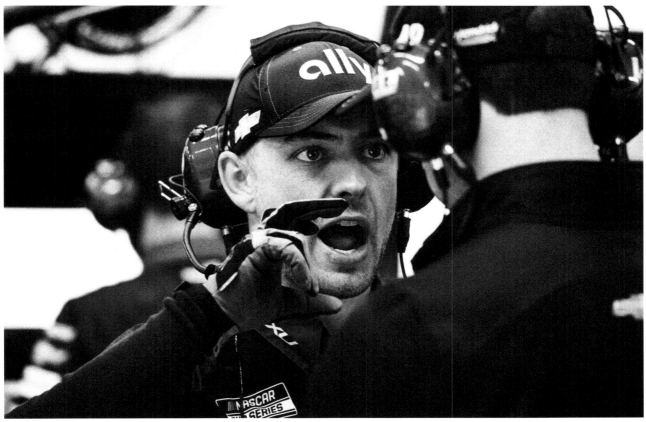

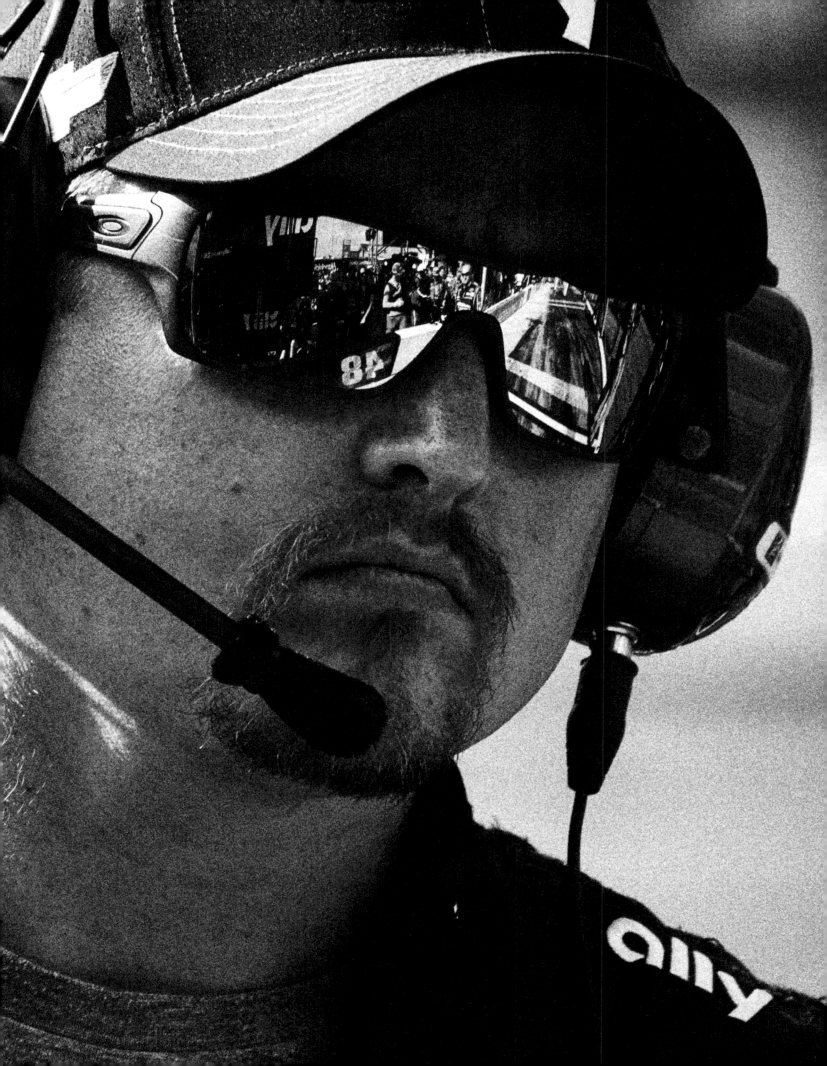

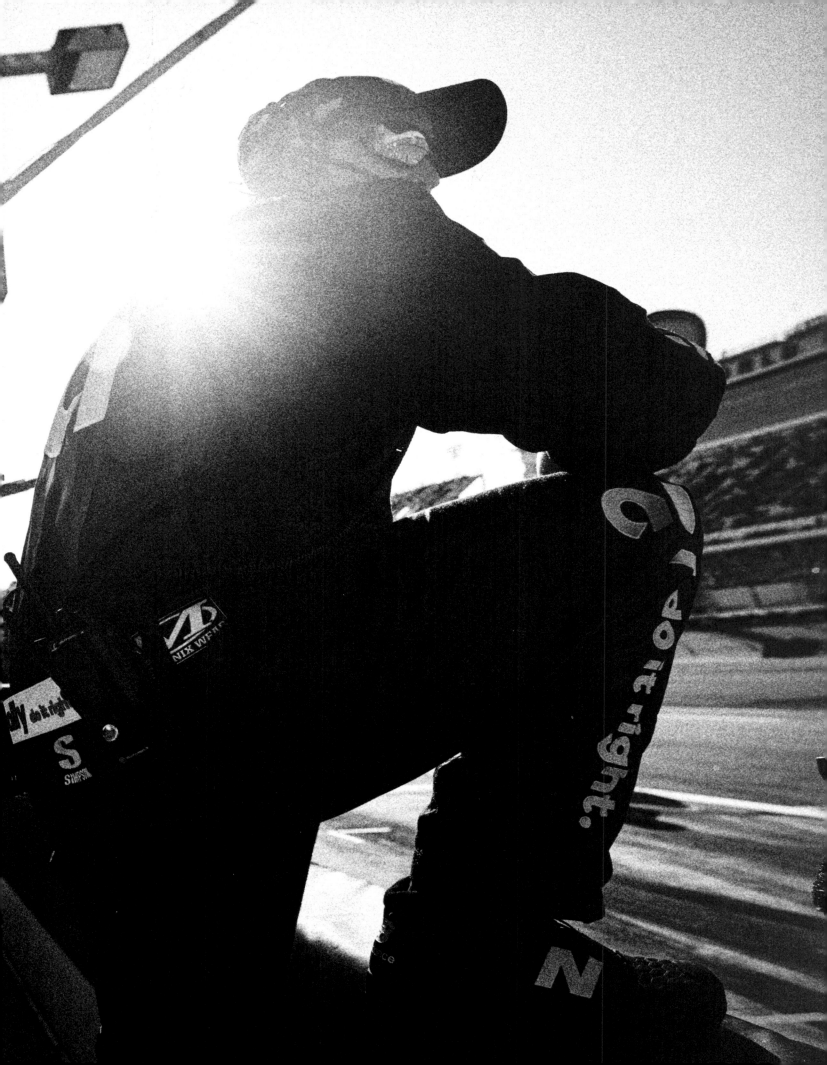

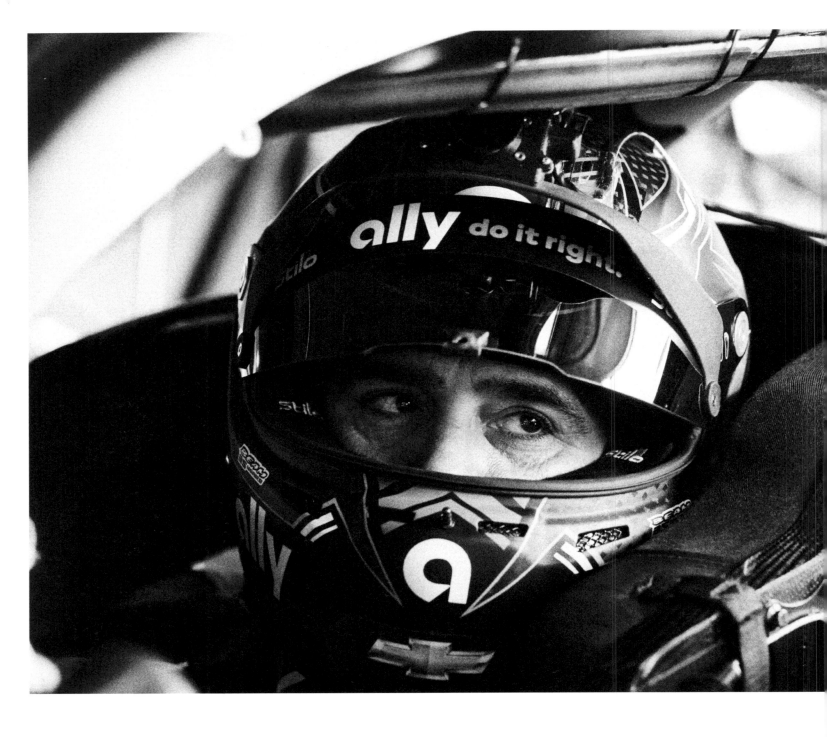

"When I look back on that last year in NASCAR, I think about Cliff, our crew chief, and Cesar, the No. 48 mechanic, not to mention Lance, our truck driver—all the guys on the team gave me so much during my time with Hendrick Motorsports. With Cliff as my lead engineer, I had won a few championships, and when he moved up to crew chief in 2019, we knew Cliff was the right guy for me, working hard to get me to victory lane and send me off the way we all wanted to go out. I was at the end of my NASCAR career but he was just getting going, and since my departure, Cliff has won the championship with Kyle Larson. I am so happy to have been able to give him that chance, to show the world all he is capable of."

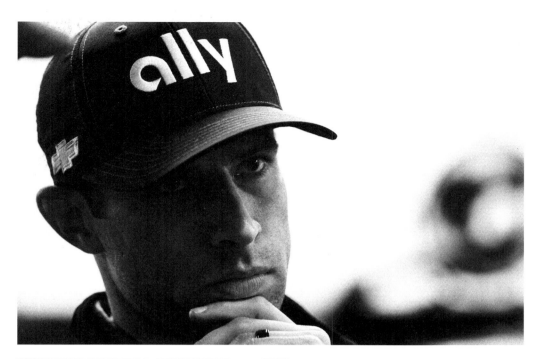

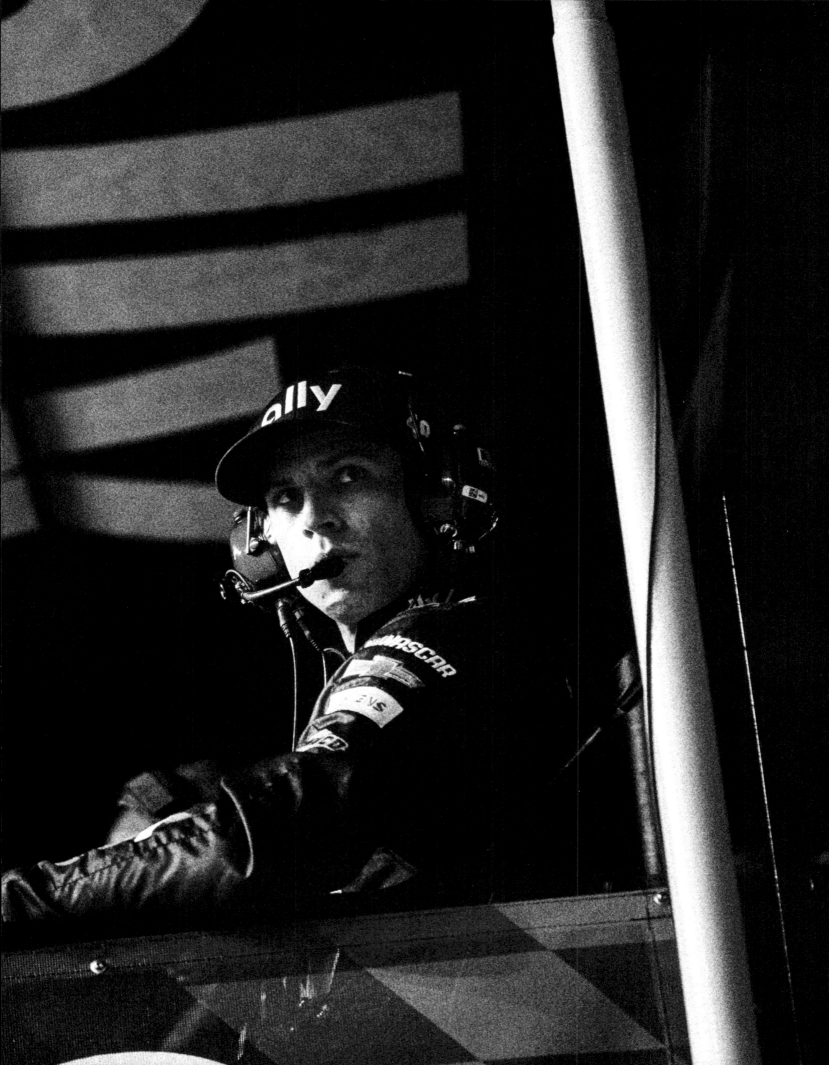

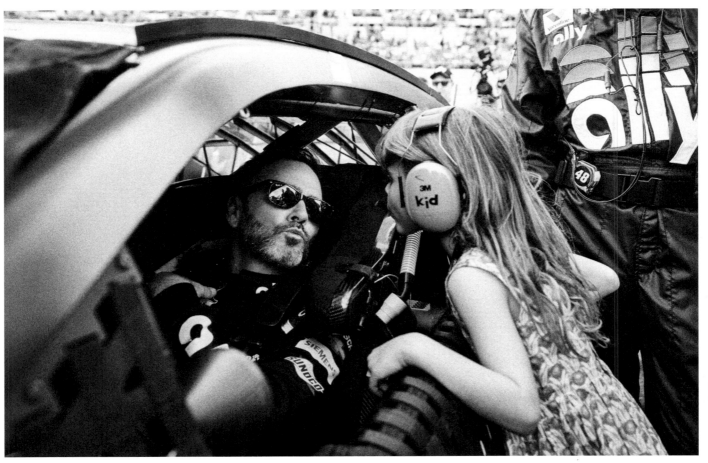

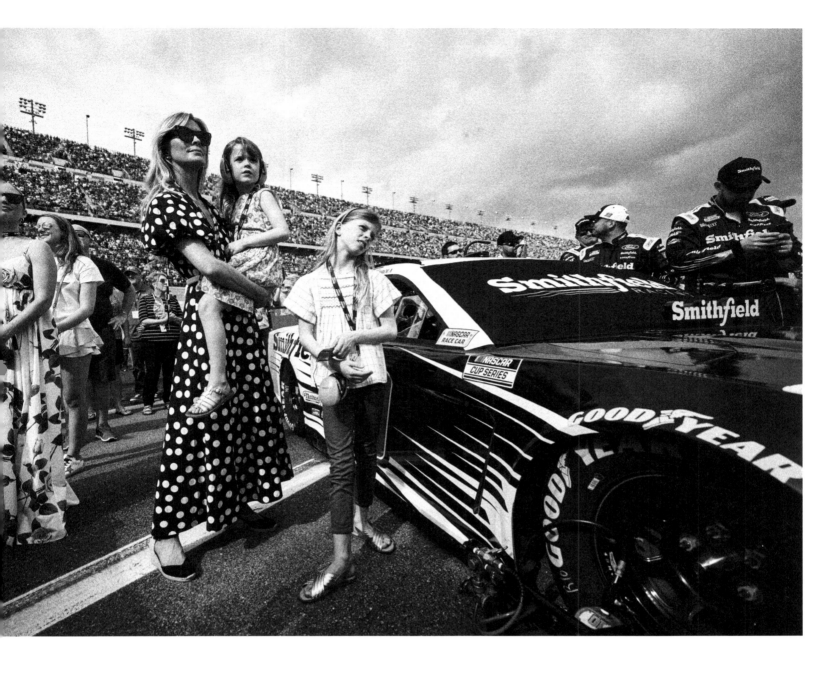

"This always feels like my last contact with earth before the race begins. There's just a feeling of family and of support. There was a cadence to each week. We would work through the week, and life is wild and crazy. For me, it was always a very calming moment on the grid with my family. We've prepared as a family to send dad off to work. That's the last calm moment before the work takes place."

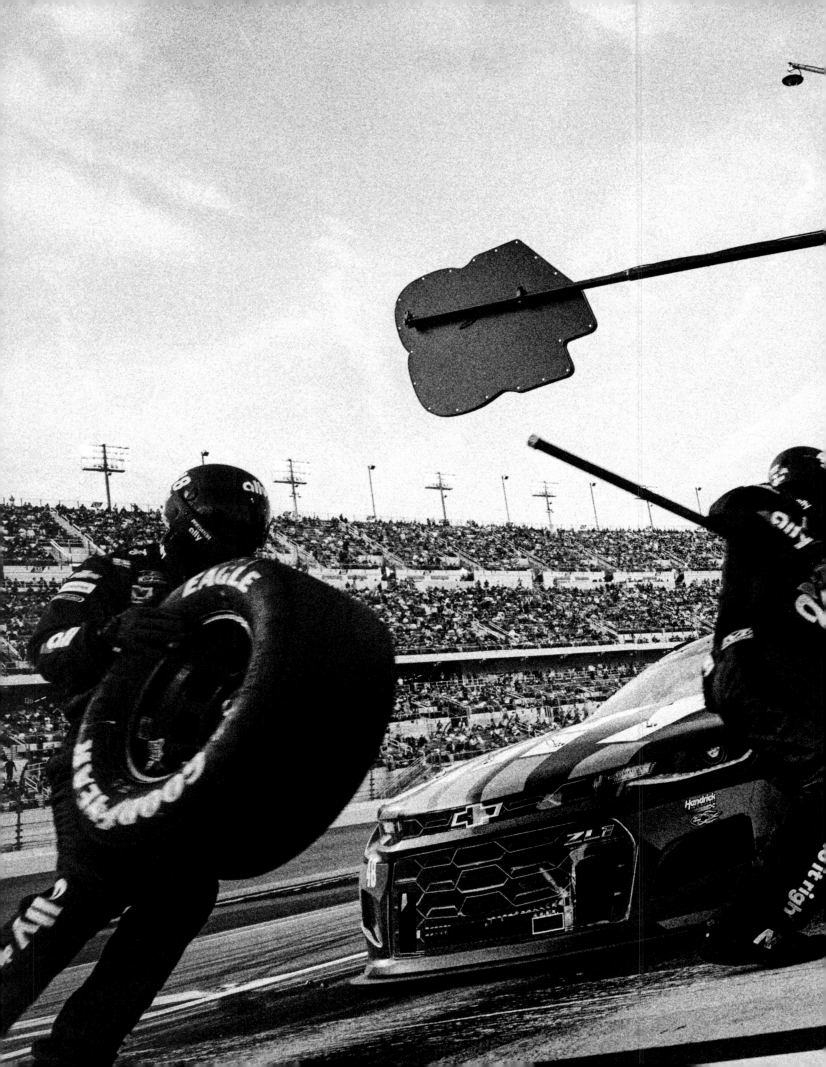

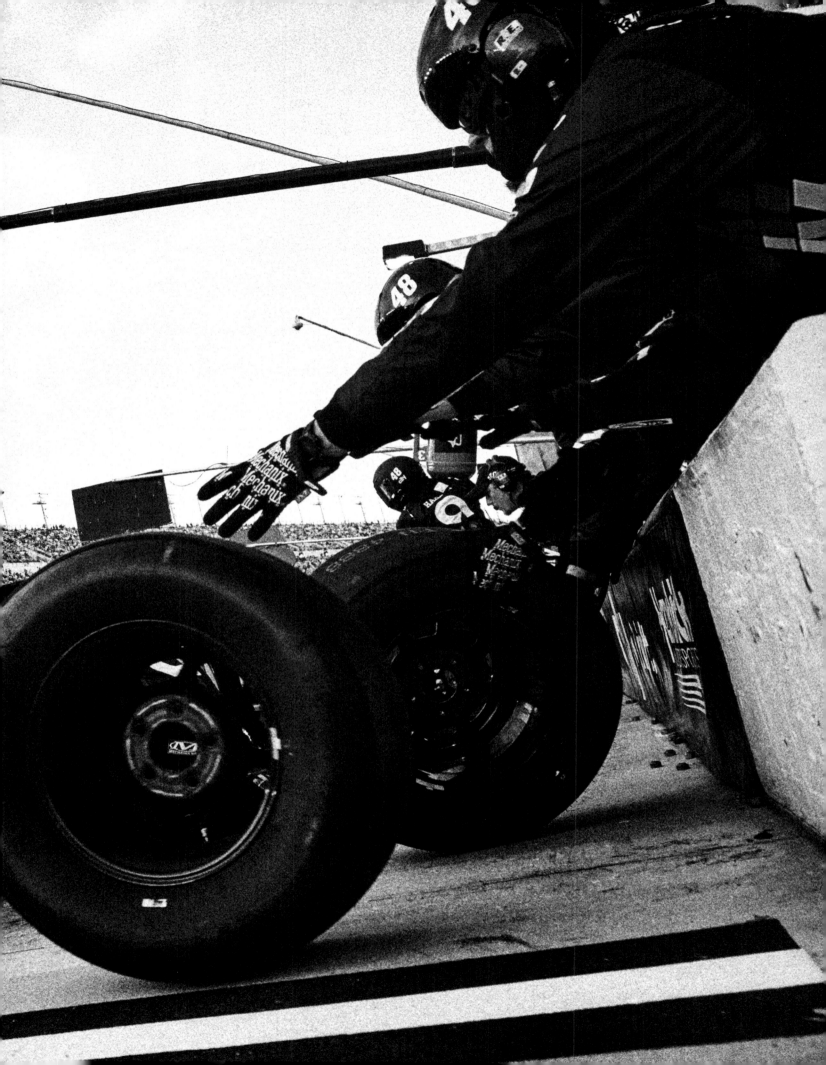

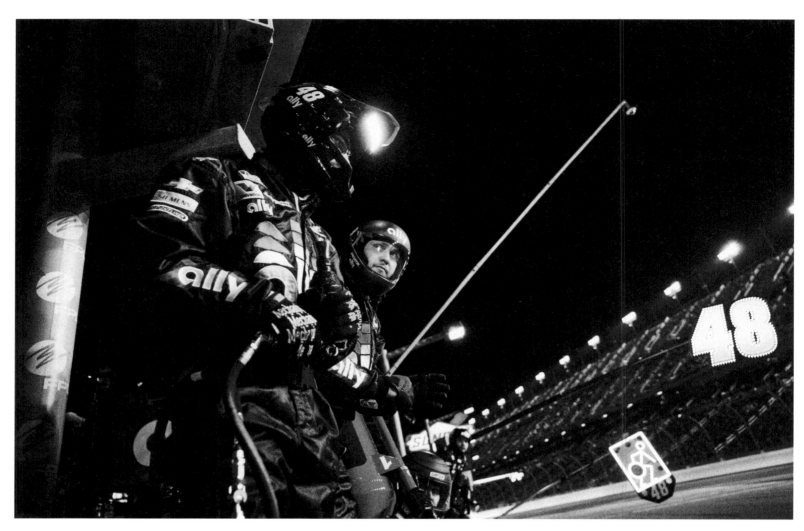

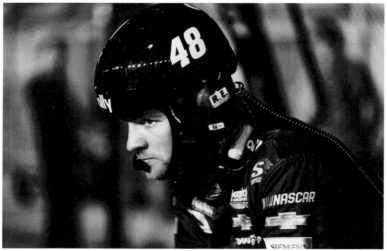

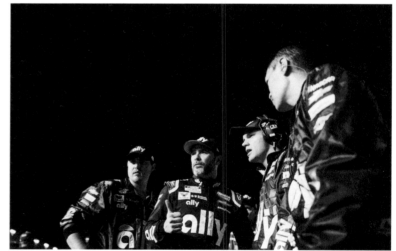

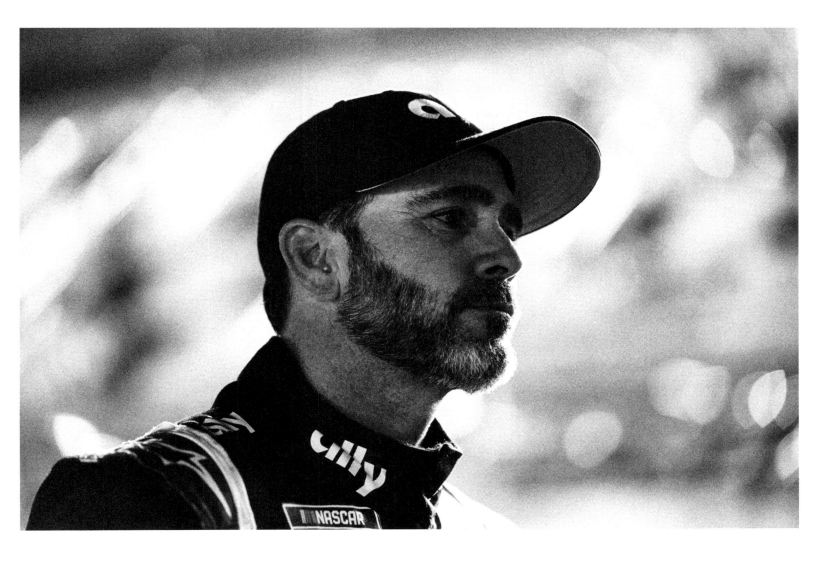

ABOVE, OPPOSITE AND FOLLOWING SPREAD: "This is in Daytona right before the COVID lockdown. I anticipated a farewell with fans everywhere. My final year was really not that. There were a couple of races at the beginning of the season, and then there were no more fans. If I only knew then that this would be the last of the large crowds for a long time!"

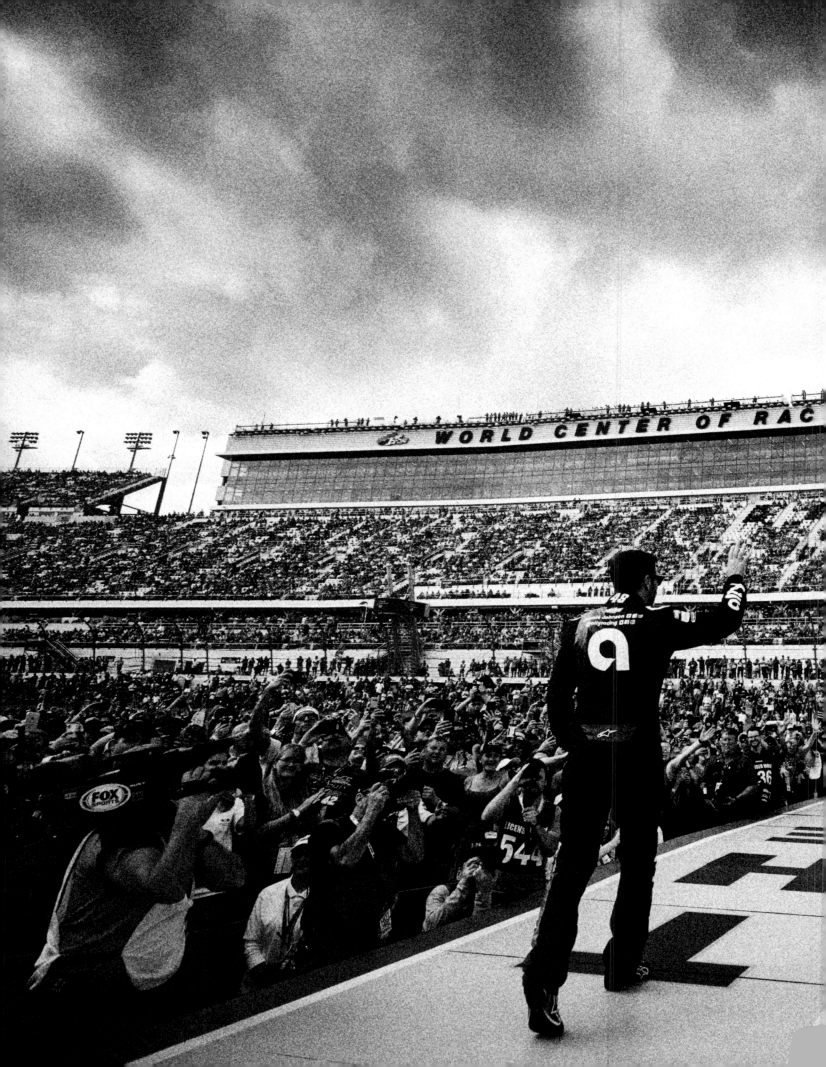

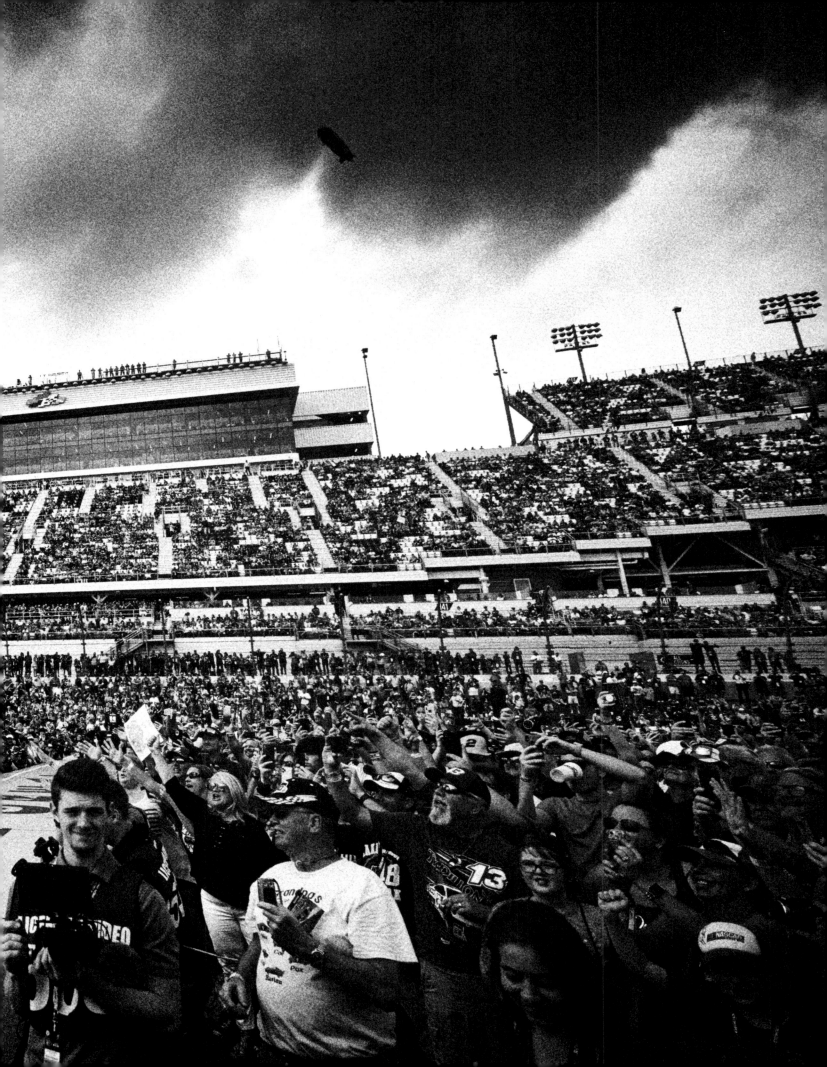

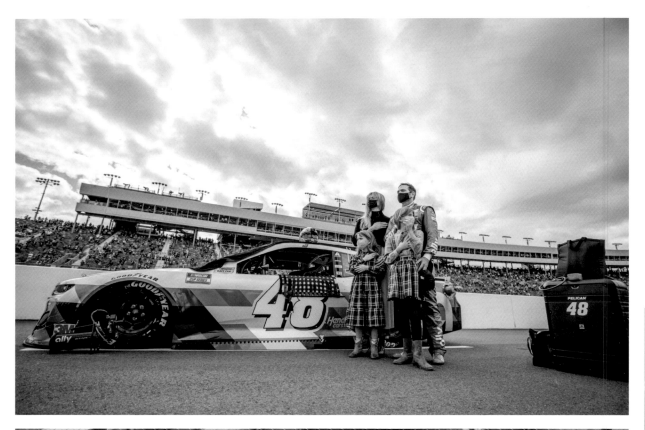

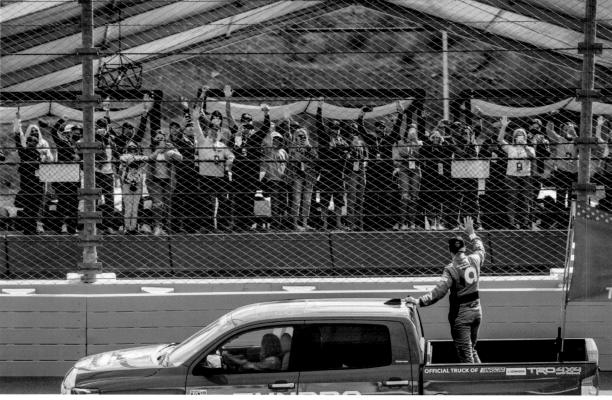

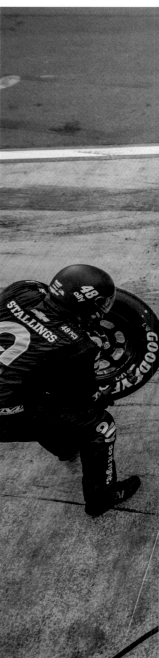

THIS SPREAD: "I'm still grateful to NASCAR for making special provisions to allow my family out on the grid on my last weekend, making it just a really special and emotional moment. Everything was complicated with pandemic protocols, but NASCAR helped us out, which meant so much to me after all those years. And then we had a great performance and finished fifth. **FOLLOWING SPREAD:** The final beer with my team was one of the great beers. If you go to the NASCAR Hall of Fame, you will see those empty beer cans in the trunk of the No. 48. I know. I went recently and checked, and they are definity there!"

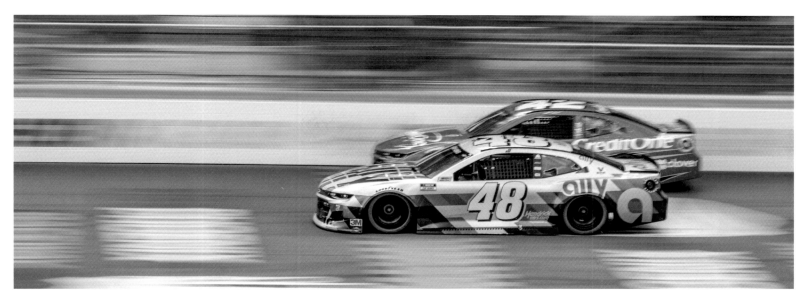

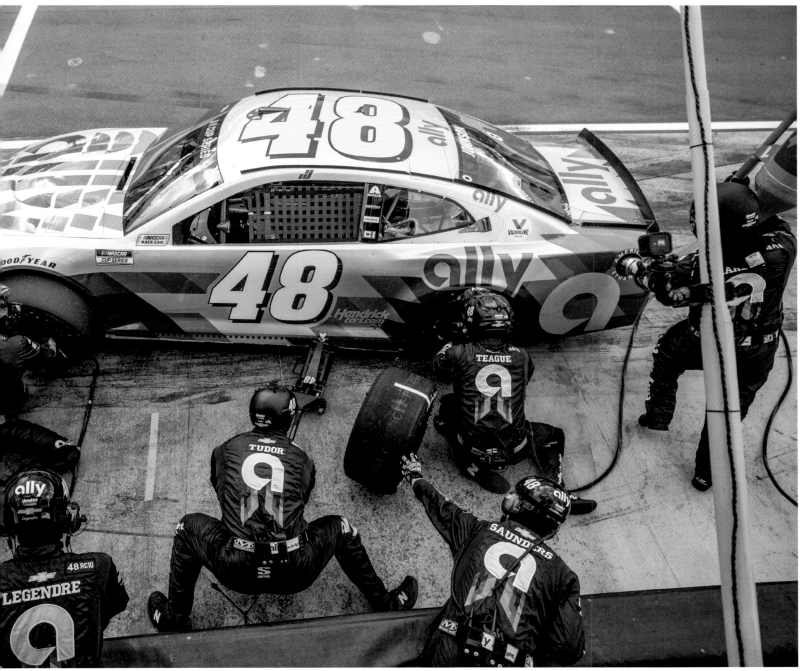

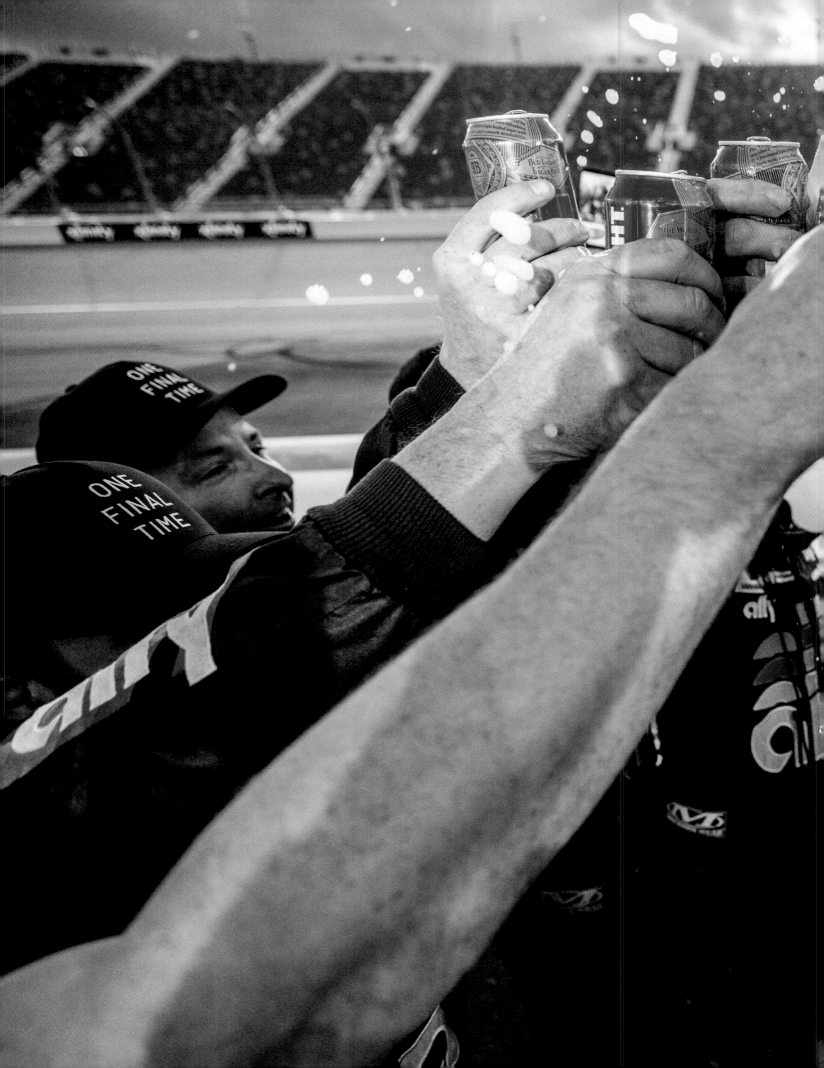

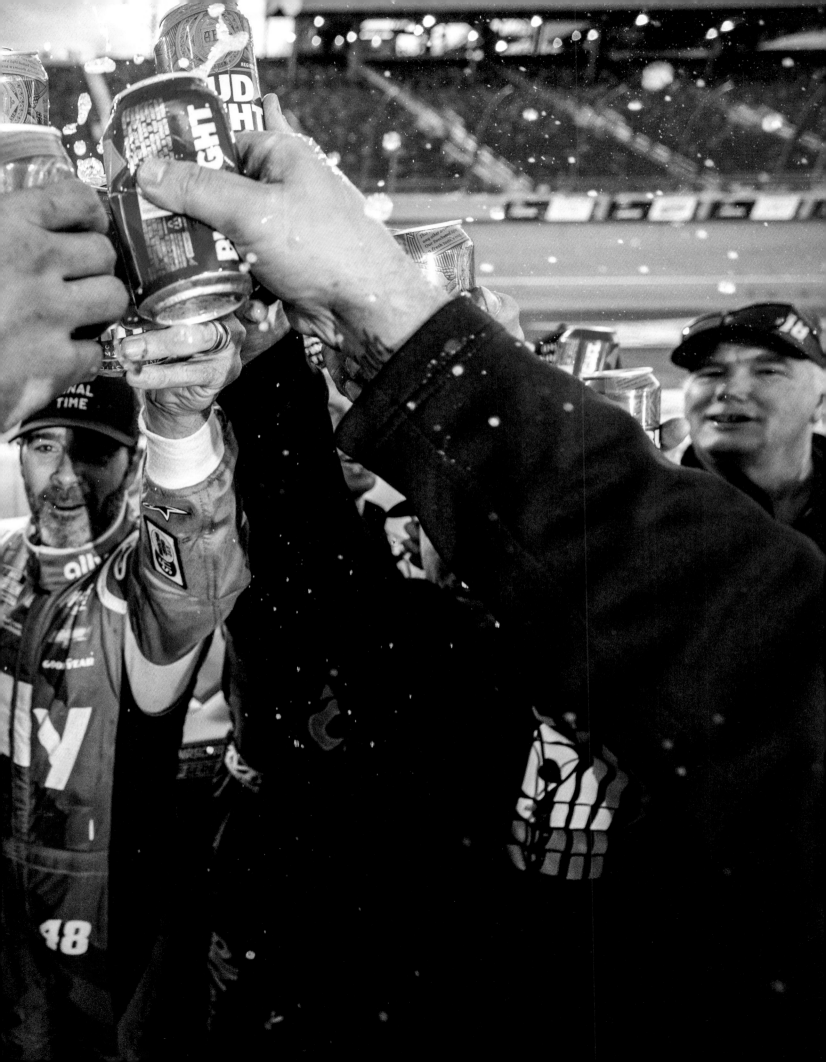

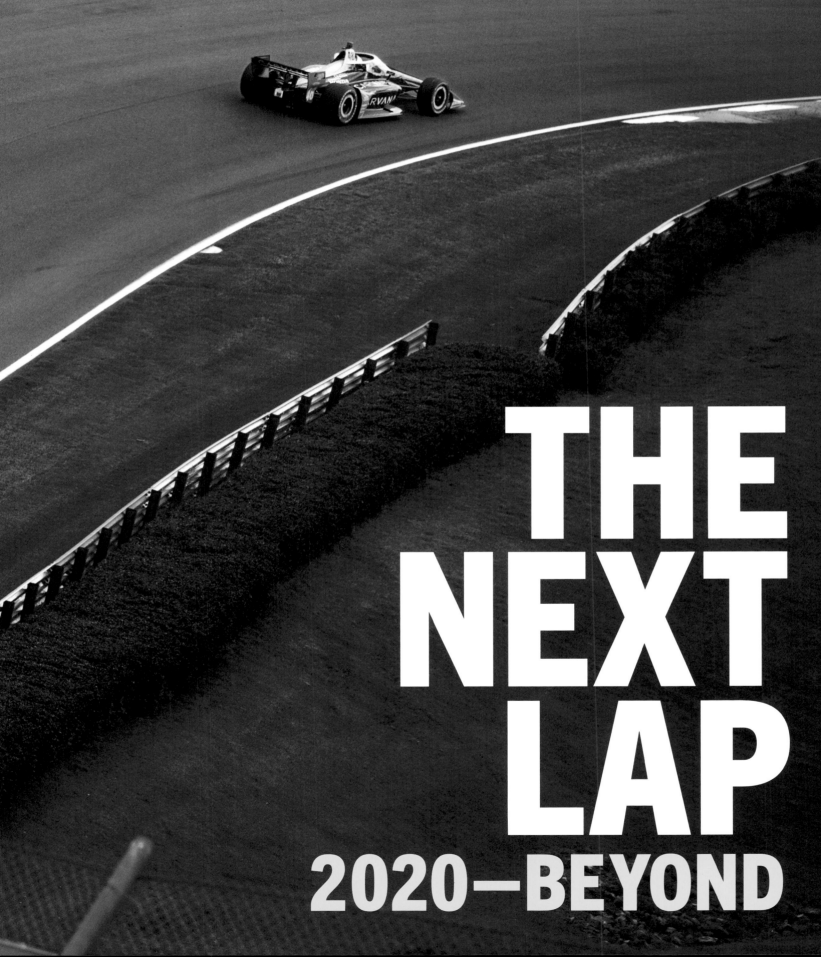

THE NEXT LAP
2020—BEYOND

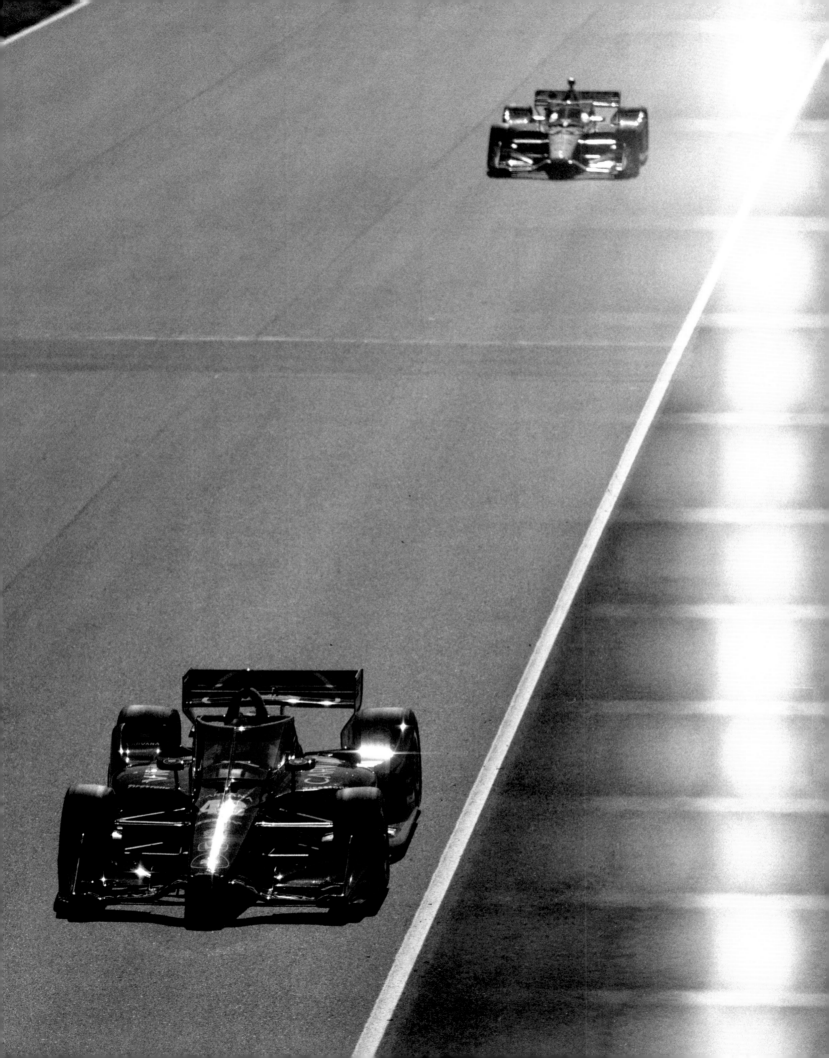

PREVIOUS SPREAD AND ABOVE: "Barber Motorsports Park in Alabama is the most physical track on which we compete. At the start of 2021, I got to go there to ramp up for the season. Chip Ganassi had just offered me the opportunity to drive the Carvana IndyCar, and this was one of my first times behind the wheel, feeling the grip on the track that came from a combination of the newness of the asphalt and the speed at which we were running. The forces on the body and the feedback through the steering wheel are the strongest in IndyCar racing. When I think back to these laps, I immediately flash to how exhausted I was after that test session."

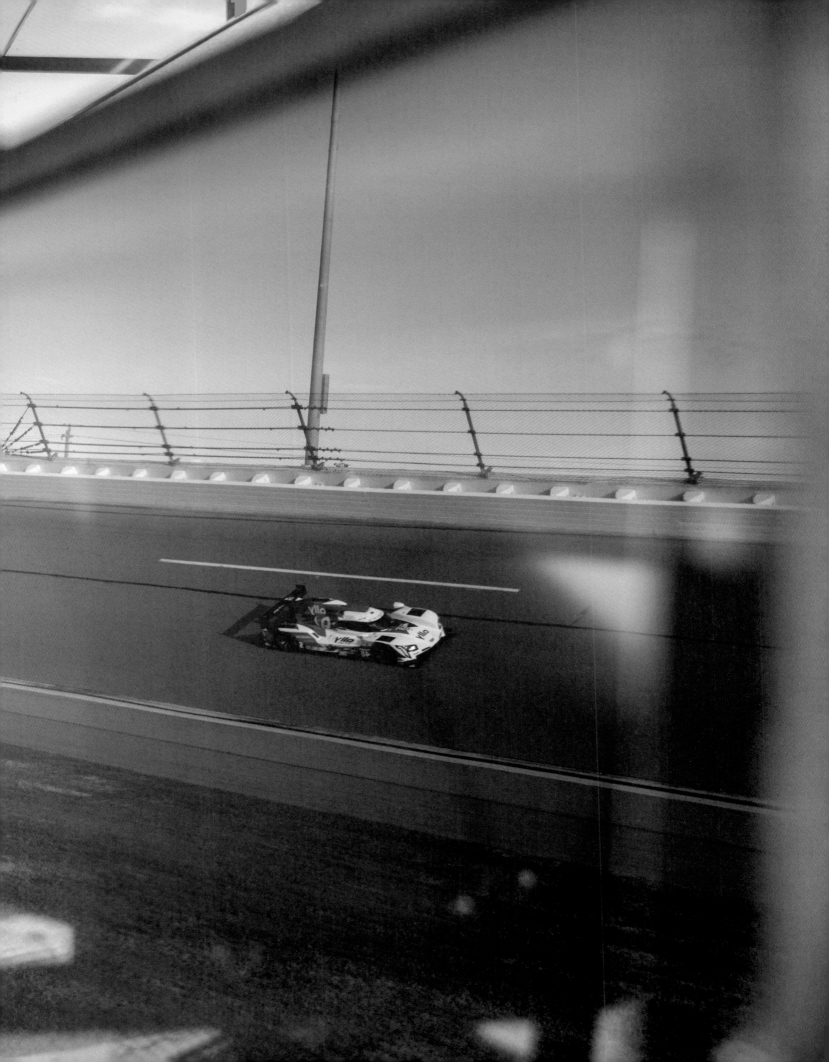

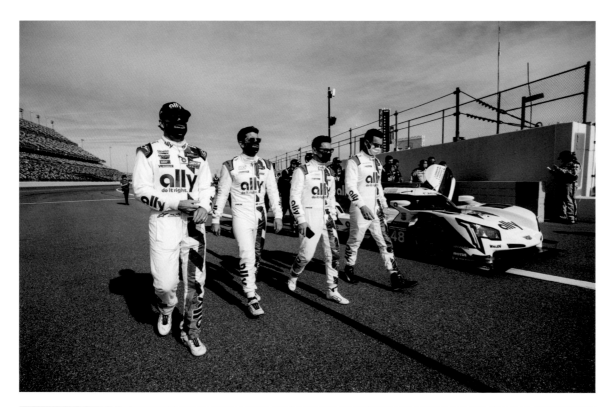

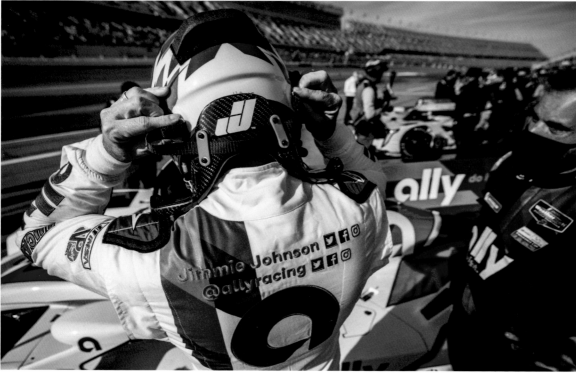

PREVIOUS SPREAD, OPPOSITE, AND BELOW: "This was my eighth attempt at winning a Rolex watch. That's what the winner receives. We ended up finishing second. So close! Of course, I'm going back again this year. I loved this event as a kid. I watched it on television. From early on, it was a goal of mine to race in IMSA. It's more of a relay race, and the baton is the car. You have a seating enclosure that you slip in for each driver. I am usually the largest driver, so the original seat is made for me, then a specific insert is created for each of the other drivers on the team."

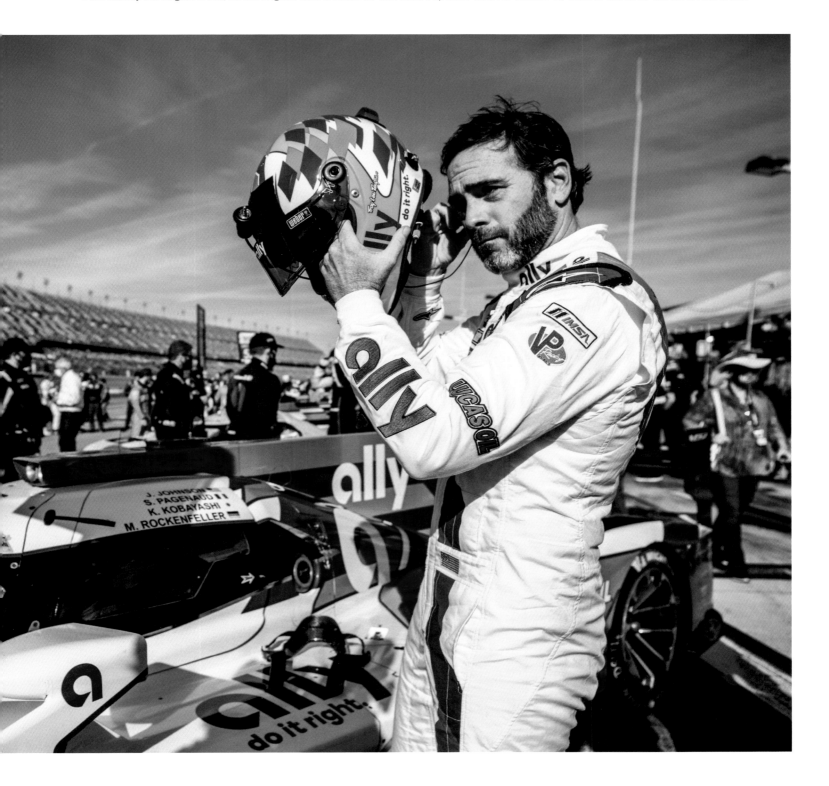

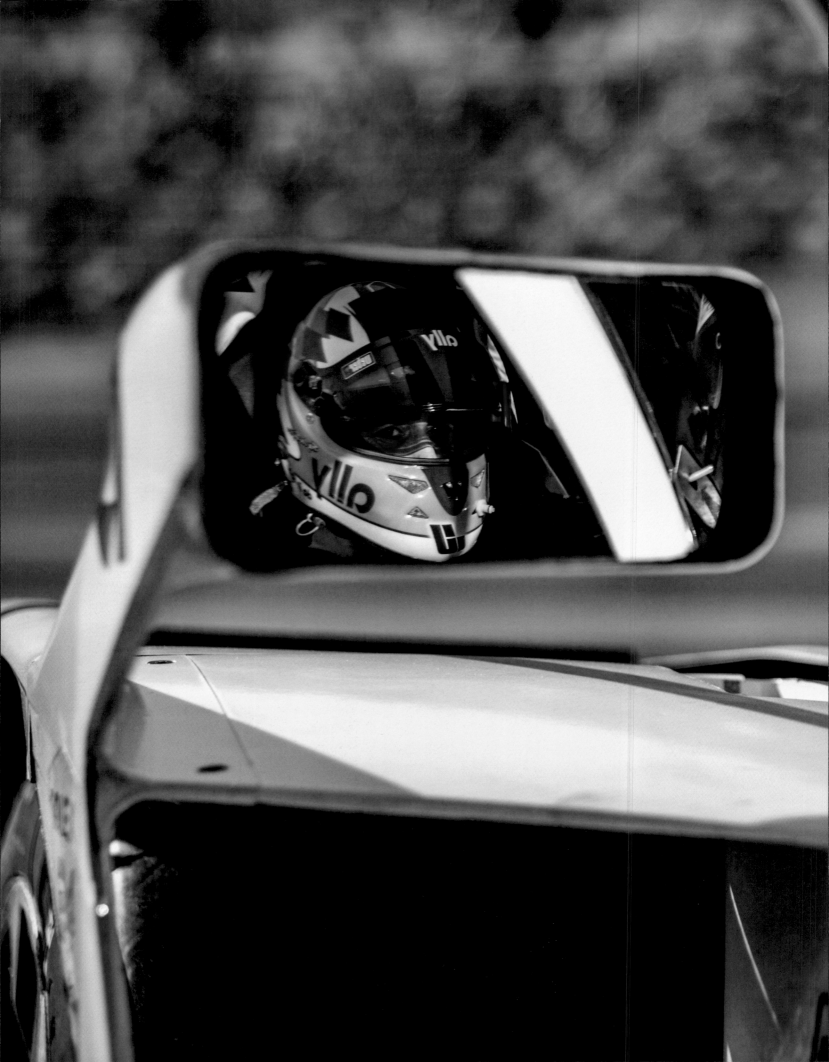

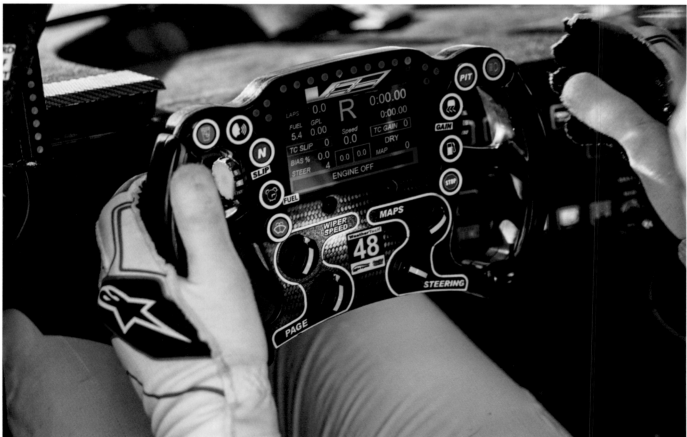

"You're trying to keep yourself in contention for 22 hours, and everybody talks about the race starting with two hours to go. So you have this high-performance vehicle that you need to drive at a very high level and also protect and take care of it. During the race, there are four other categories on track. So five classes in total and sixty cars on tracks are all going various speeds. The goal is to have a healthy race car with two hours to go. That's kind of the agreement all the drivers make."

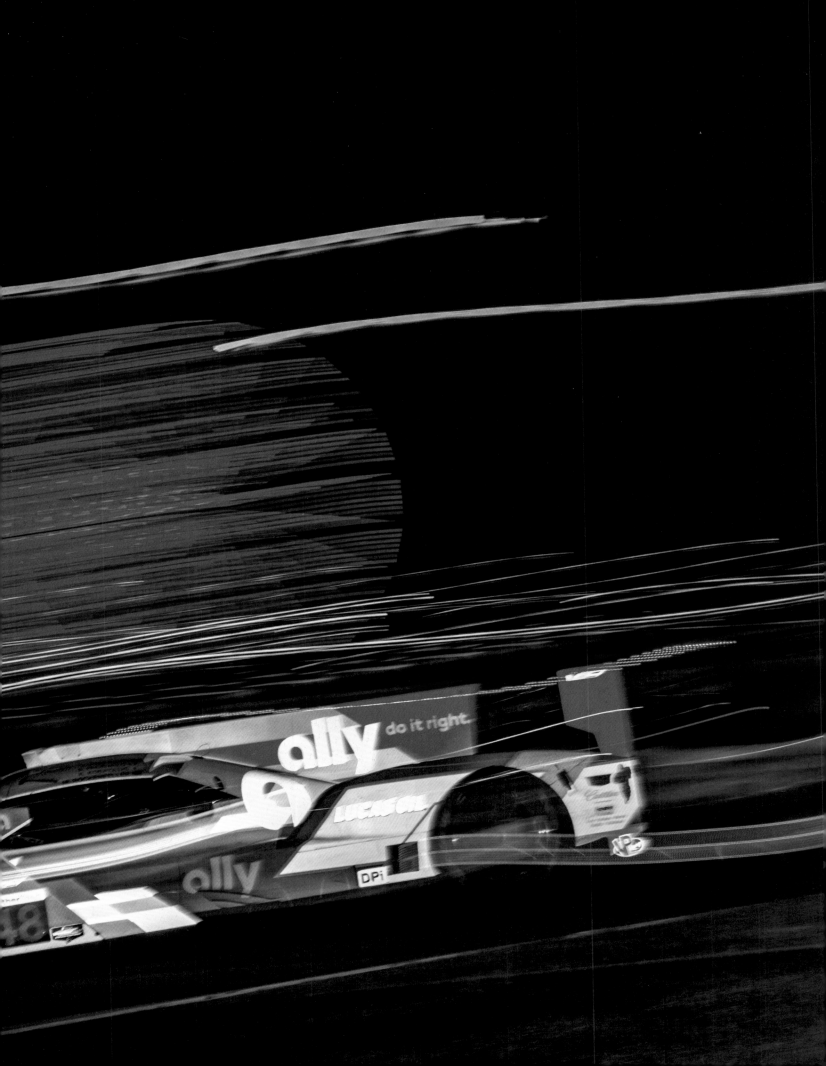

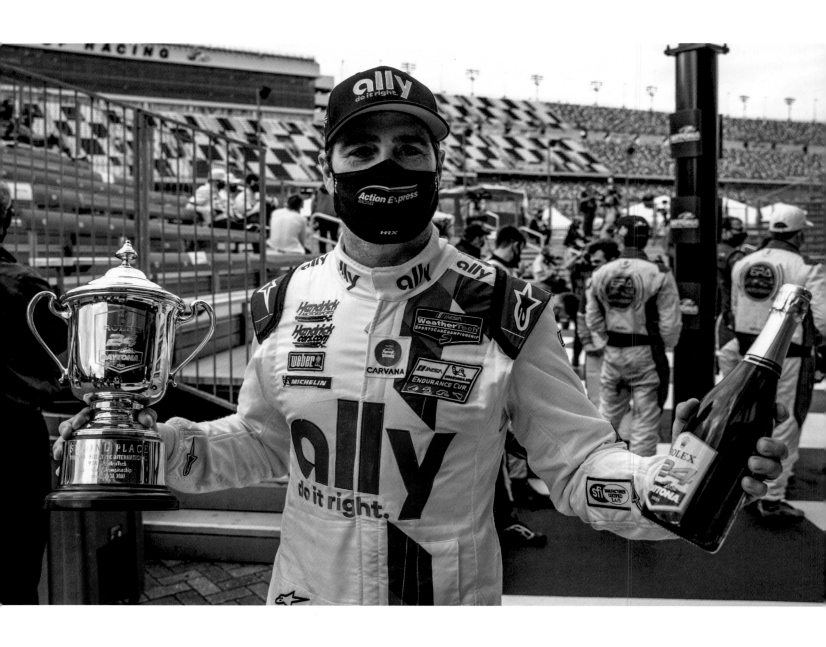

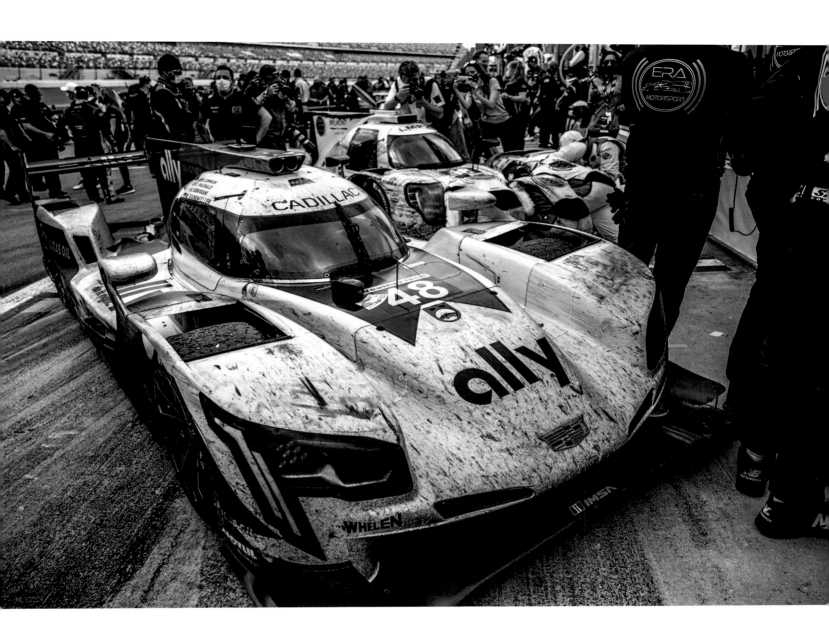

"At the 2021 Rolex 24 at Daytona, we finished second. After 24 hours of driving, we were just a few seconds back. I was sharing the car with Mike Rockenfeller, Kamui Kobayashi and Simon Pagenaud–three amazing drivers –and we came so close to winning in a car that is so technical, so fast, so exciting to drive. To end up on the podium after twenty four hours wasn't just cool, it was so much fun."

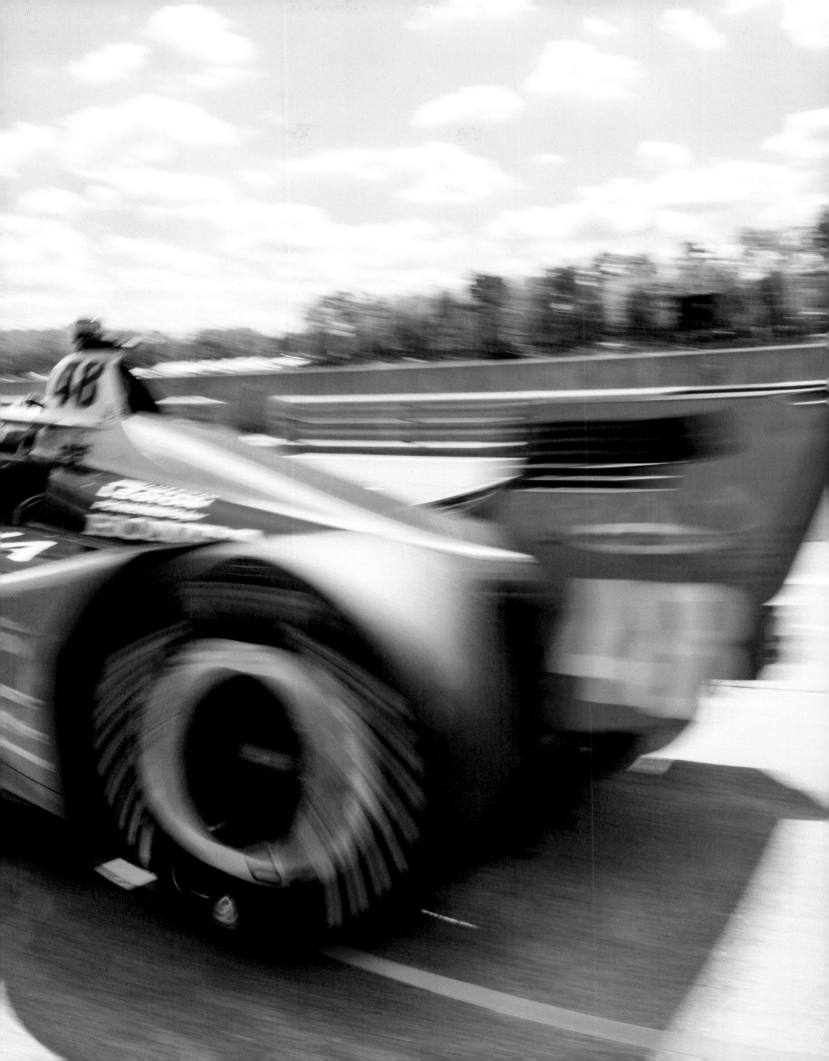

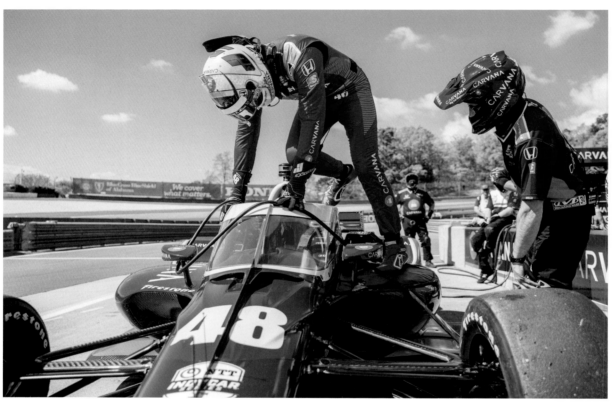

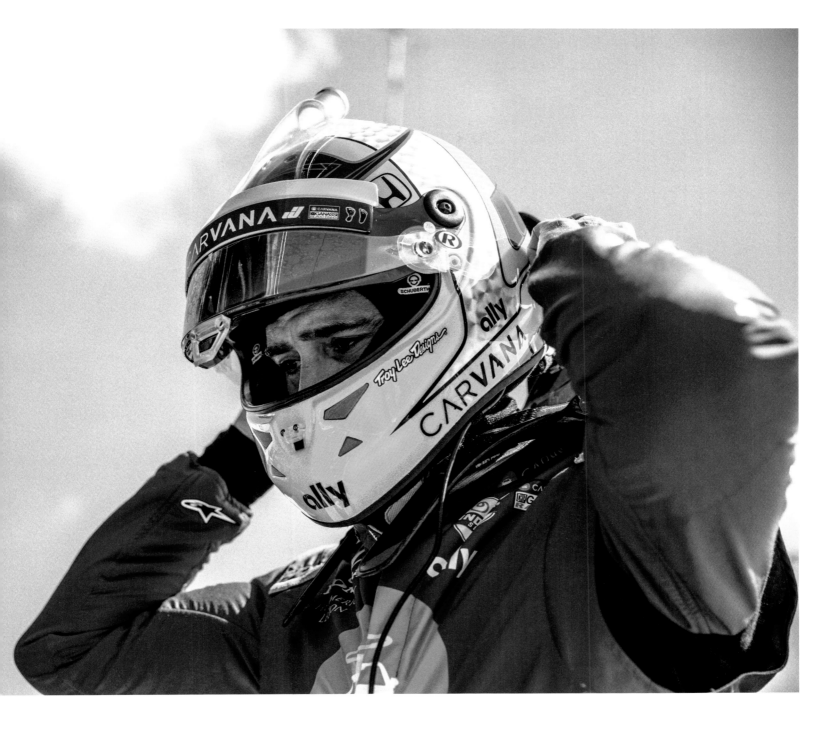

"It's something about the start of the year, with all the variations of IndyCar, which are even more variations than NASCAR. That's the thing about IndyCar. You have a road course, a circular course—an oval course and street racing. There are so many kinds of racing in IndyCar."

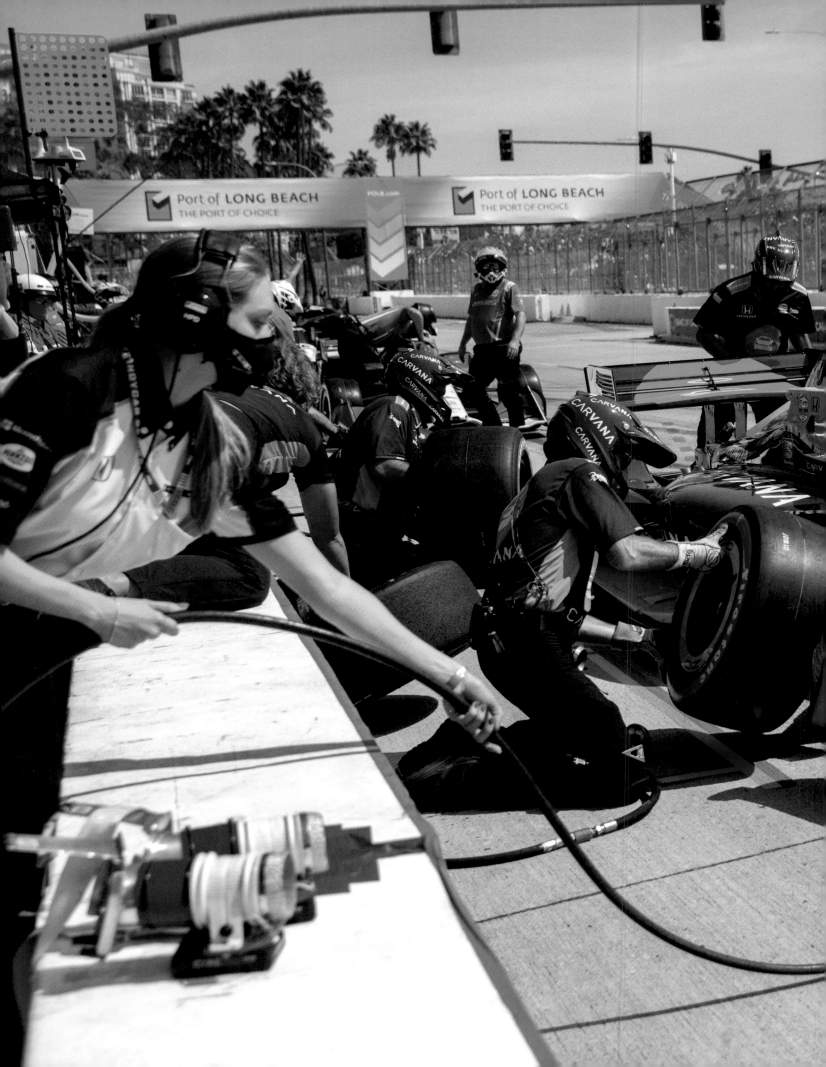

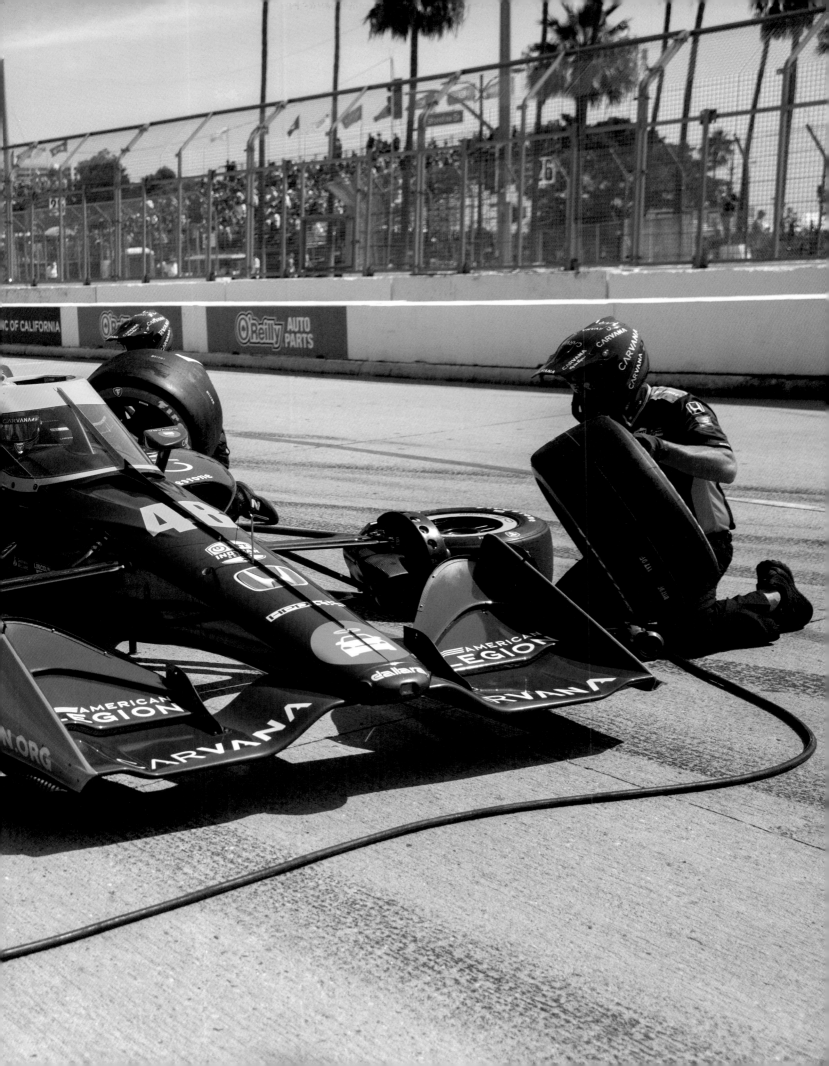

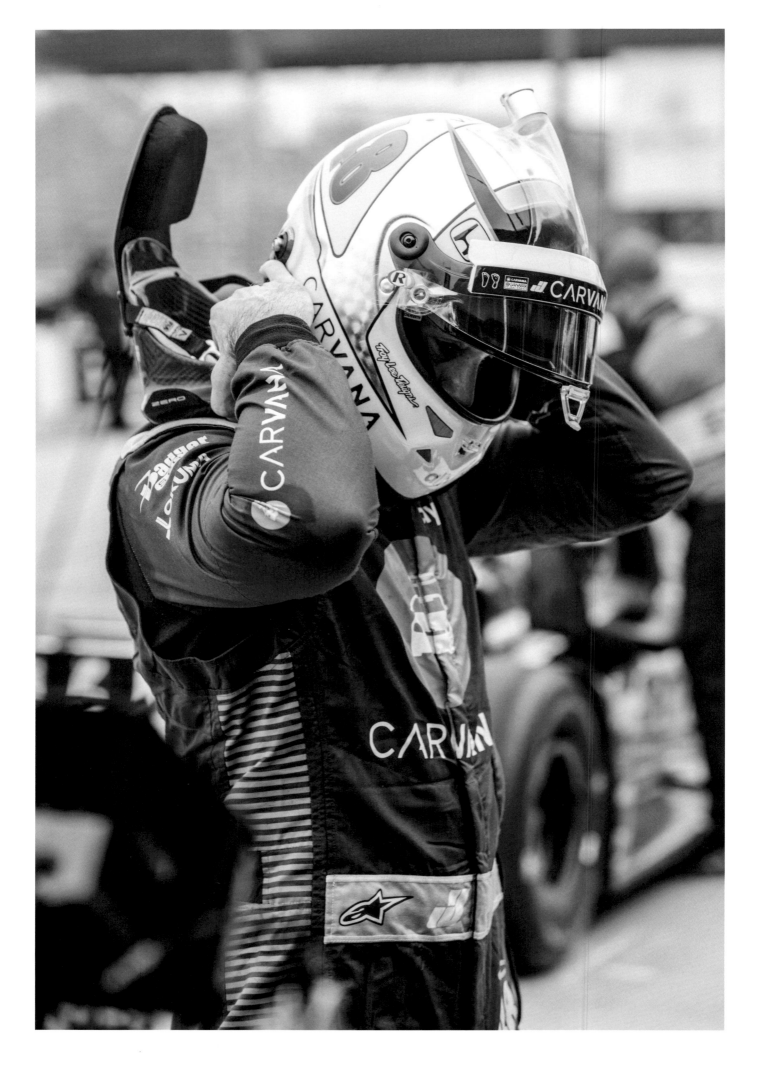

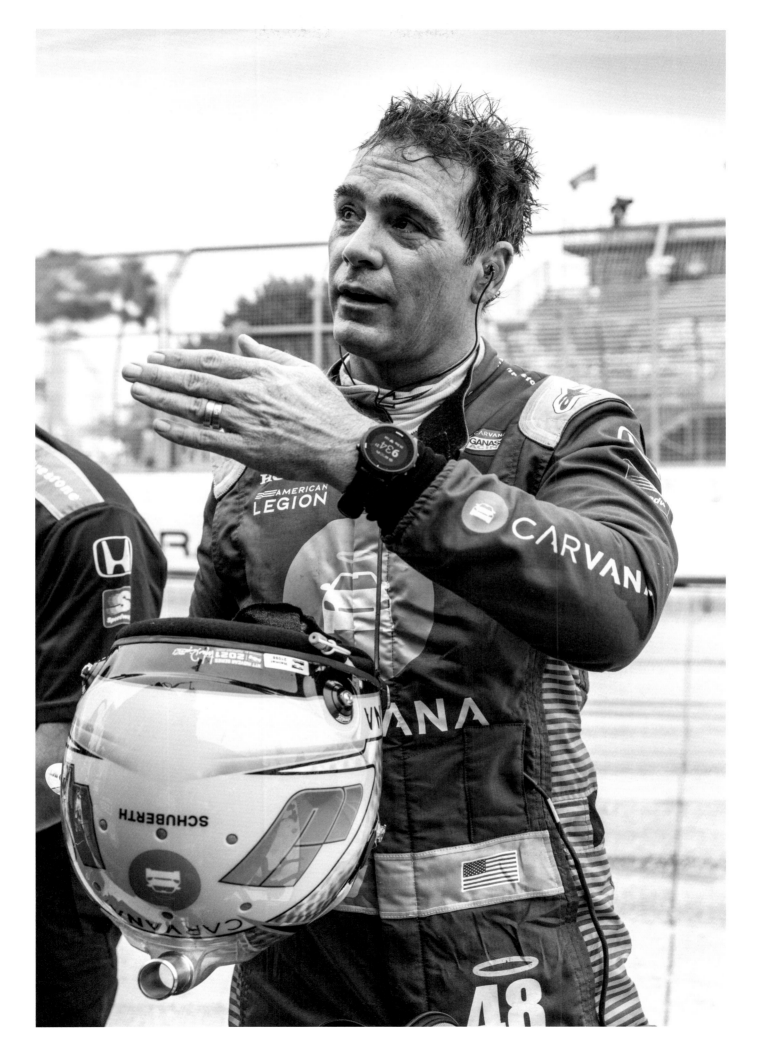

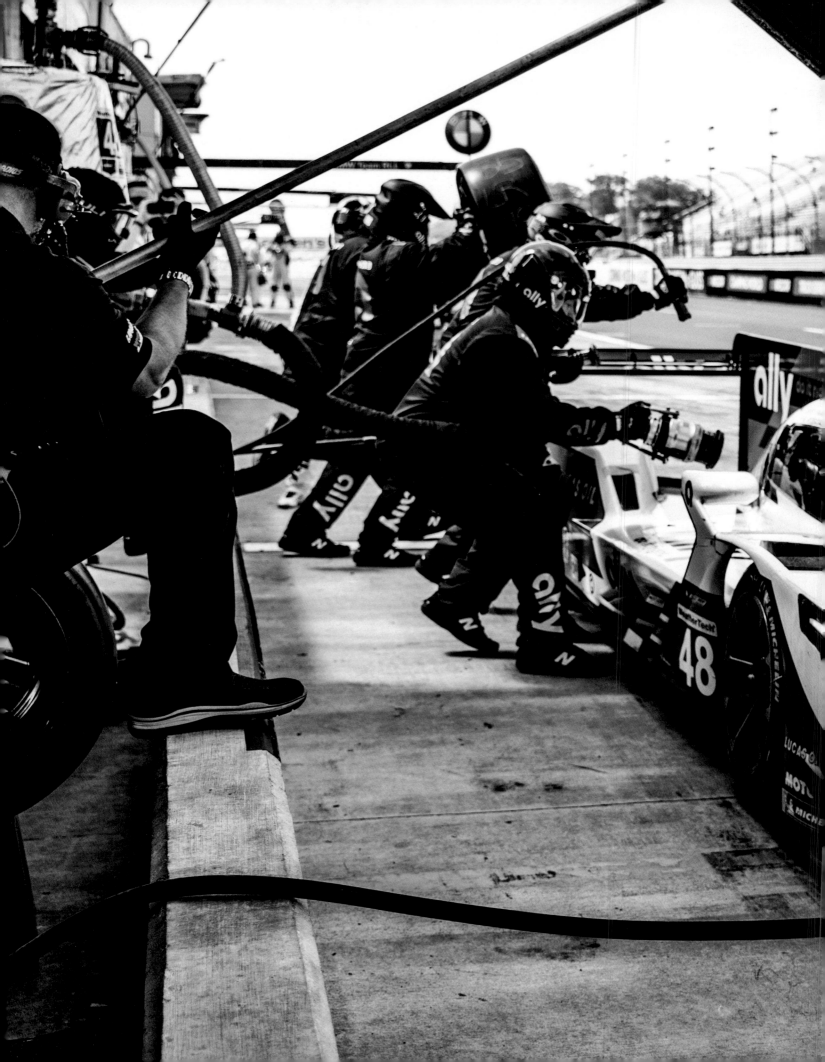

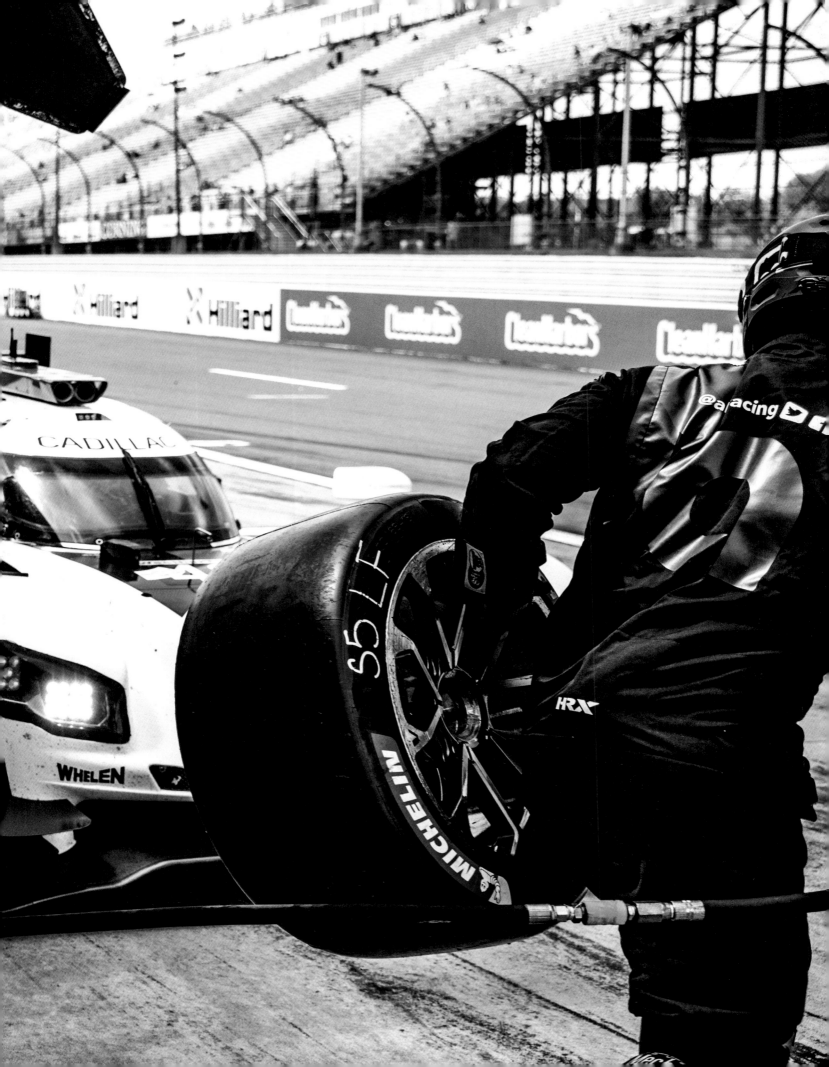

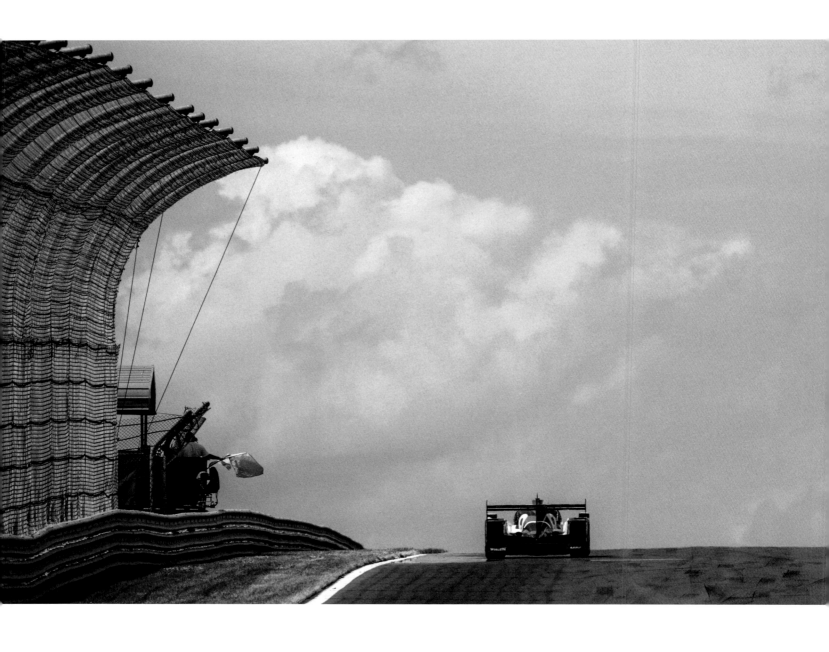

"There's something fun about how there's a history of racing and engines, and cars and bikes and planes. Like how automotive and other mechanical histories all align. There's something beautiful about how a race course is accidentally an awesome velodrome. On that ride, there was a bunch of fans who kept trying to get us to stop and have a beer. So, finally, the last time around, we stopped and had a beer with them. It was awesome!"

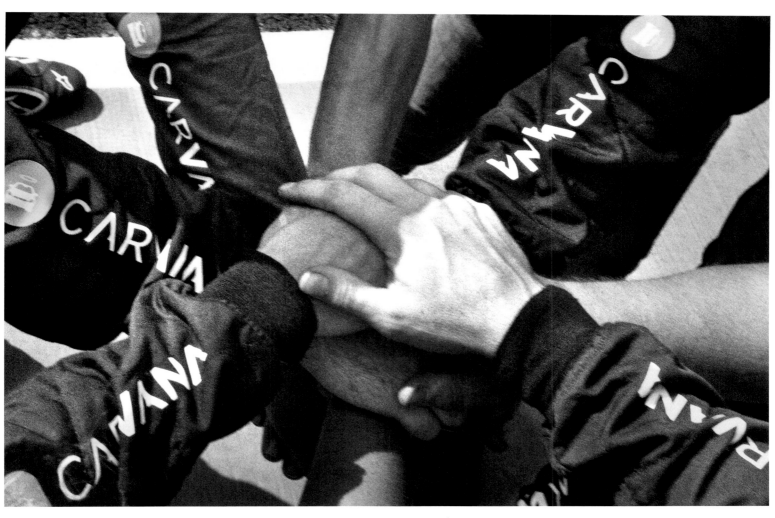

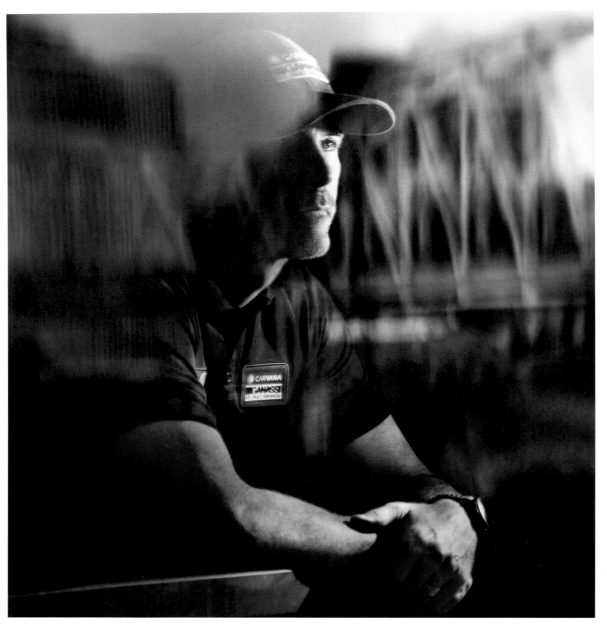

"This was a low point in the year. It was a point when my confidence was well above my talent level and I had three incidents in five sessions. It was definitely a low point, but Nashville was a great learning weekend for me. My confidence was high, and I got lazy with technique. I was kind of stuck inbetween my NASCAR technique and the IndyCar technique, and it bit me."

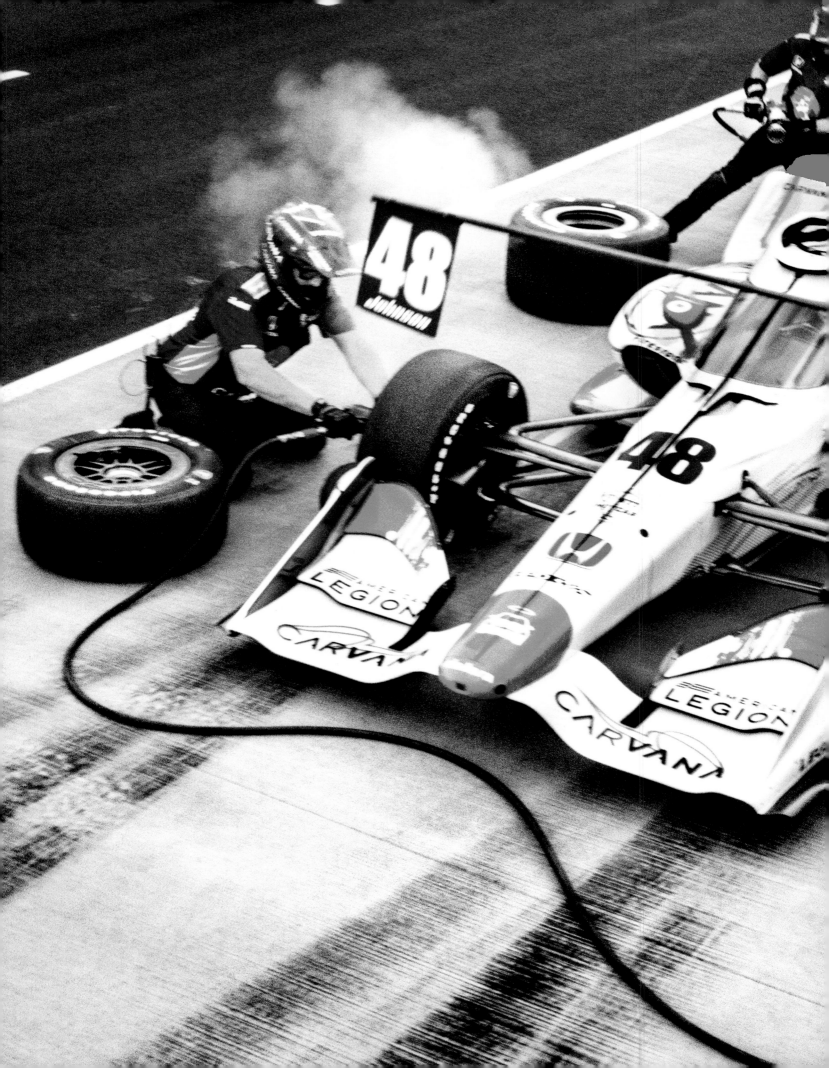

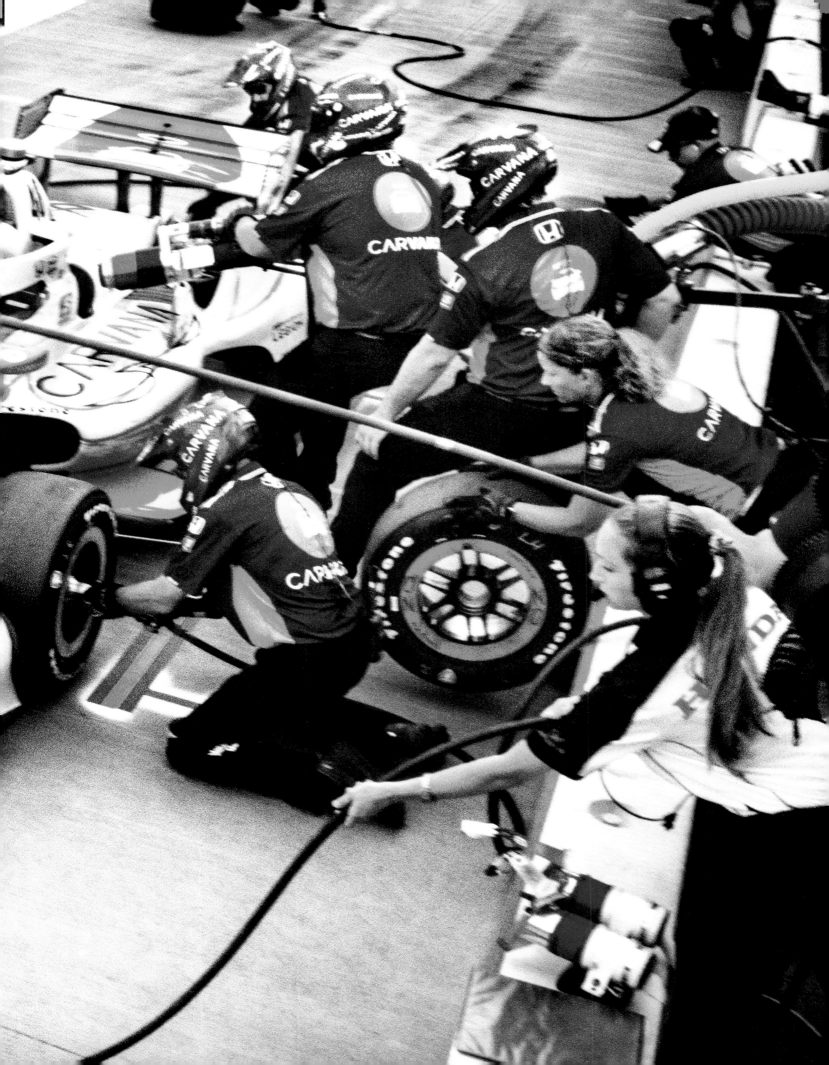

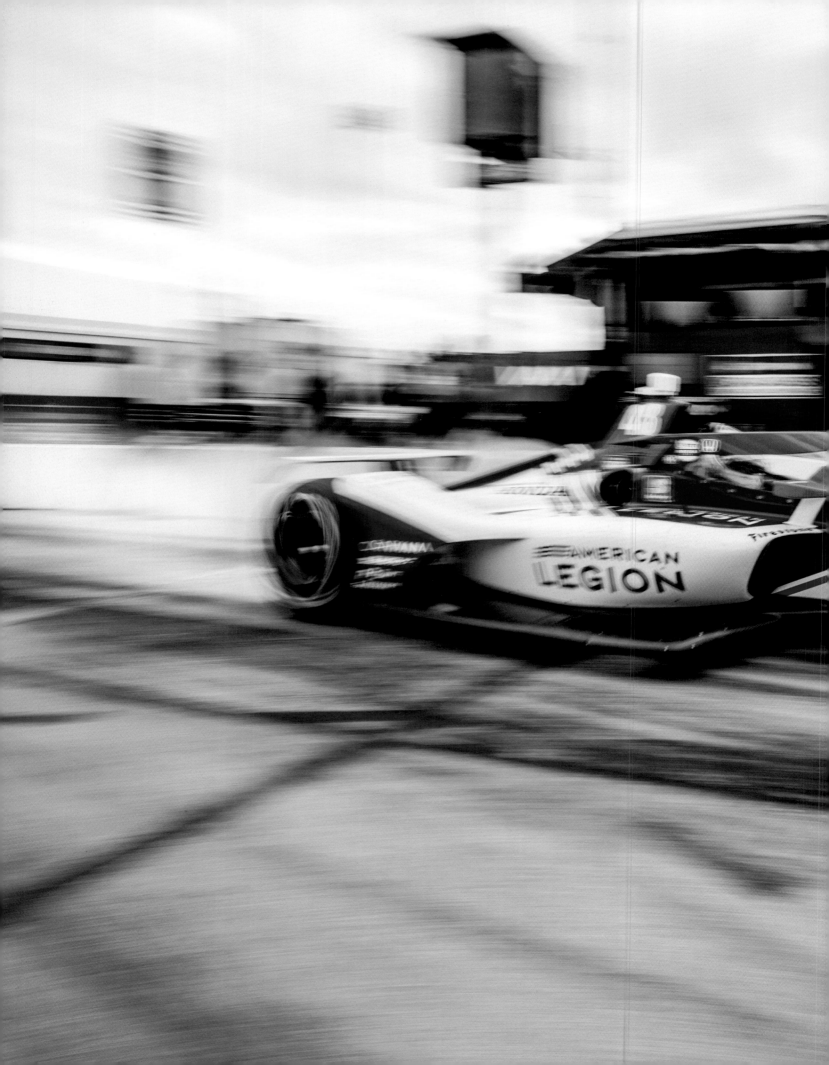

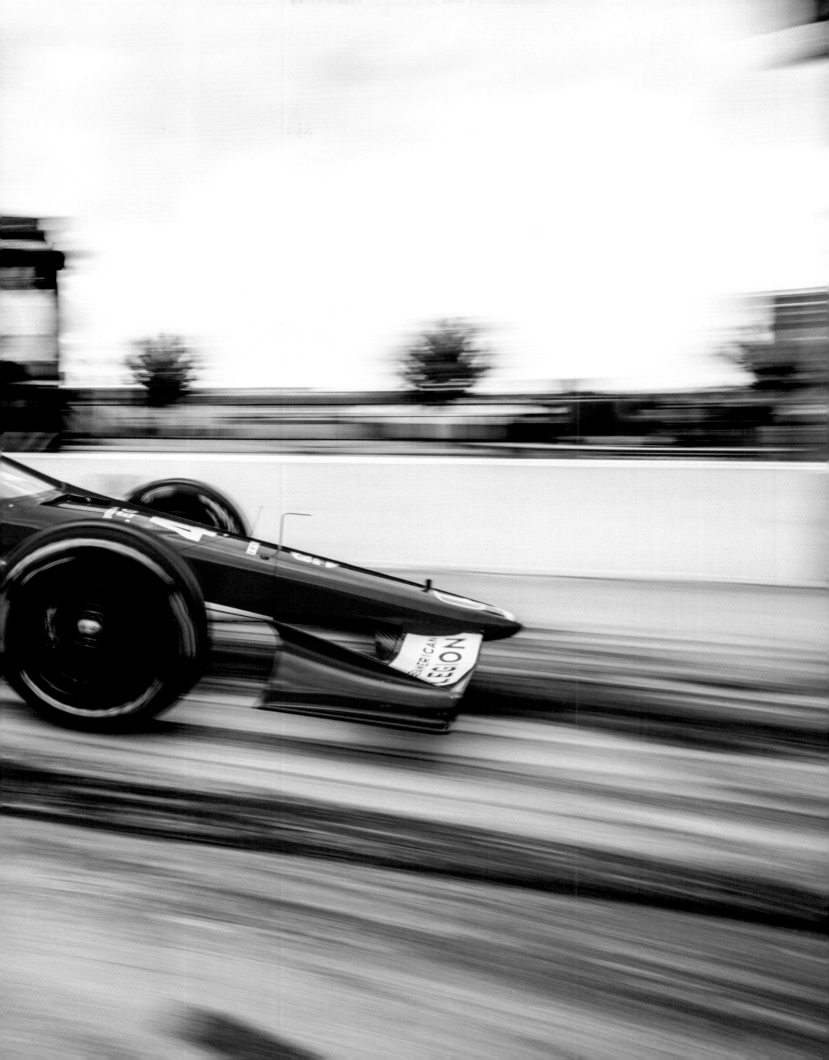

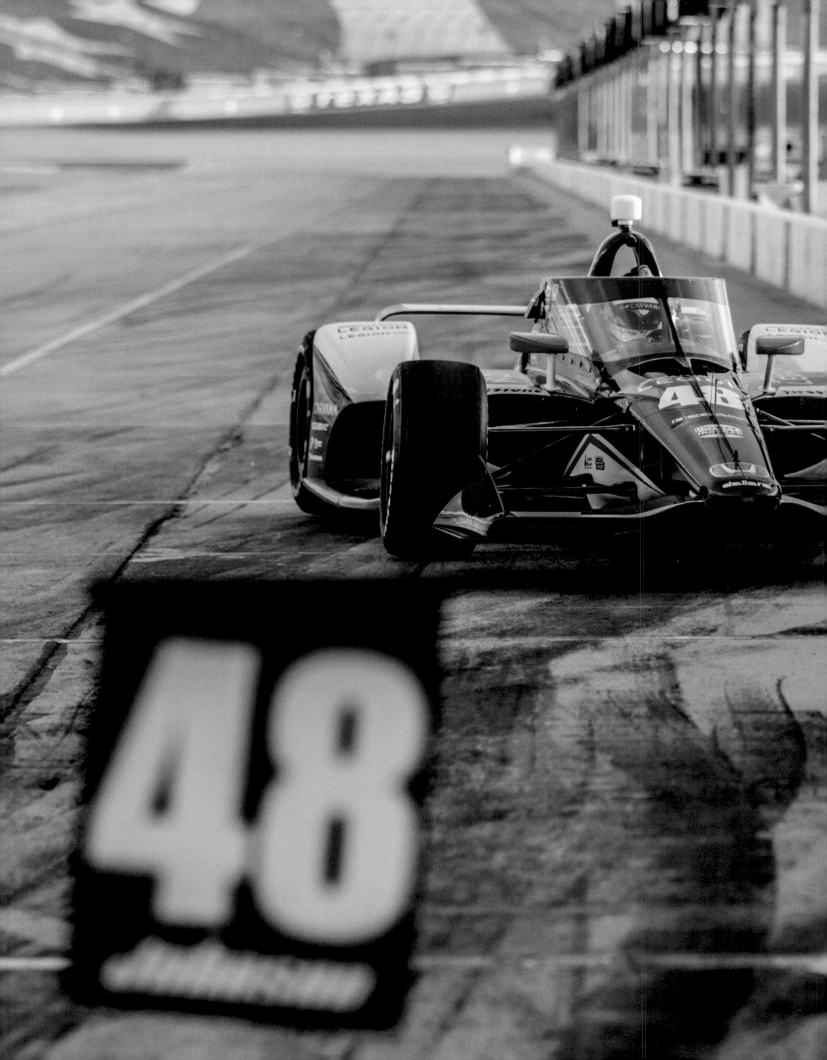

CAPTIONS AND PHOTOGRAPHY CREDITS

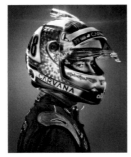

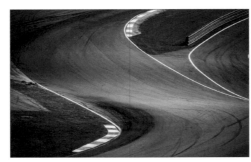

Carvana Chip Ganassi Racing Honda; Music City Grand Prix; Nashville, Tennessee; August 8, 2021; Photo by Pari Dukovic

Turn 1 and 2; Honda Grand Prix of Alabama; Barber, Alabama; April 18, 2021; Photo by Gabe L'Heureux

No. 48 IndyCar pit sign; Carvana Chip Ganassi Racing Honda; Music City Grand Prix; Nashville, Tennessee; August 8, 2021; Photo by Pari Dukovic

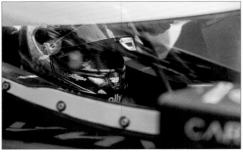

Jimmie Johnson aboard the No. 48; Carvana Chip Ganassi Racing Honda; Acura Grand Prix of Long Beach; Long Beach Street Circuit; Long Beach, California; September 26, 2021; Photo by Lorenzo Agius

Jimmie Johnson hoists his record seventh NASCAR Sprint Cup Championship Trophy; Homestead Miami Speedway; Ford EcoBoost 400; Homestead, Florida; November 20, 2016; Photo by Elizabeth Kreutz

Jimmie sitting in a McLaren Formula 1 car; McLaren Technology Center; Woking, England; November 21, 2018; Photo by Lyle Owerko

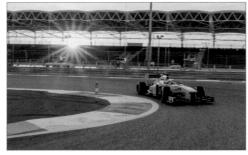

Jimmie turning his first laps in a McLaren Formula 1 car; Bahrain International Circuit; Sakhir, Bahrain; November 26, 2018; Photo by Bryan Knox

Top: A young Jimmie on his 60cc Yamaha; Southwest United States; circa late 1970s; Jimmie Johnson archive; **Bottom:** Jimmie, about 16 years old; early 1990s; Photo ©Trackside Photo

Jimmie's maiden NASCAR victory, which he still counts as his most treasured, coming at his home track; California Speedway; Fontana, California; NAPA Auto Parts 500; April 28, 2002; Photos: Jimmie Johnson Archive

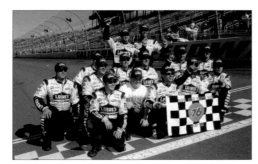

California Speedway; Fontana, California; NAPA Auto Parts 500; April 28, 2002; Photo by ©David Chobat Images

Top: Homestead-Miami Speedway; Homestead, Florida; Ford 400; November 22, 2009; **Bottom:** Homestead-Miami Speedway; Homestead, Florida; Ford 400; November 16, 2008; Photos by Sam Greenwood /©Getty Images

Jimmie wheels the No. 48 Carvana Chip Ganassi Racing Honda for the first time in competition on a street course; Firestone Grand Prix of St. Petersburg; Street of St. Petersburg; St. Petersburg, Florida; April 25, 2021; Photo by Gabe L'Heureux

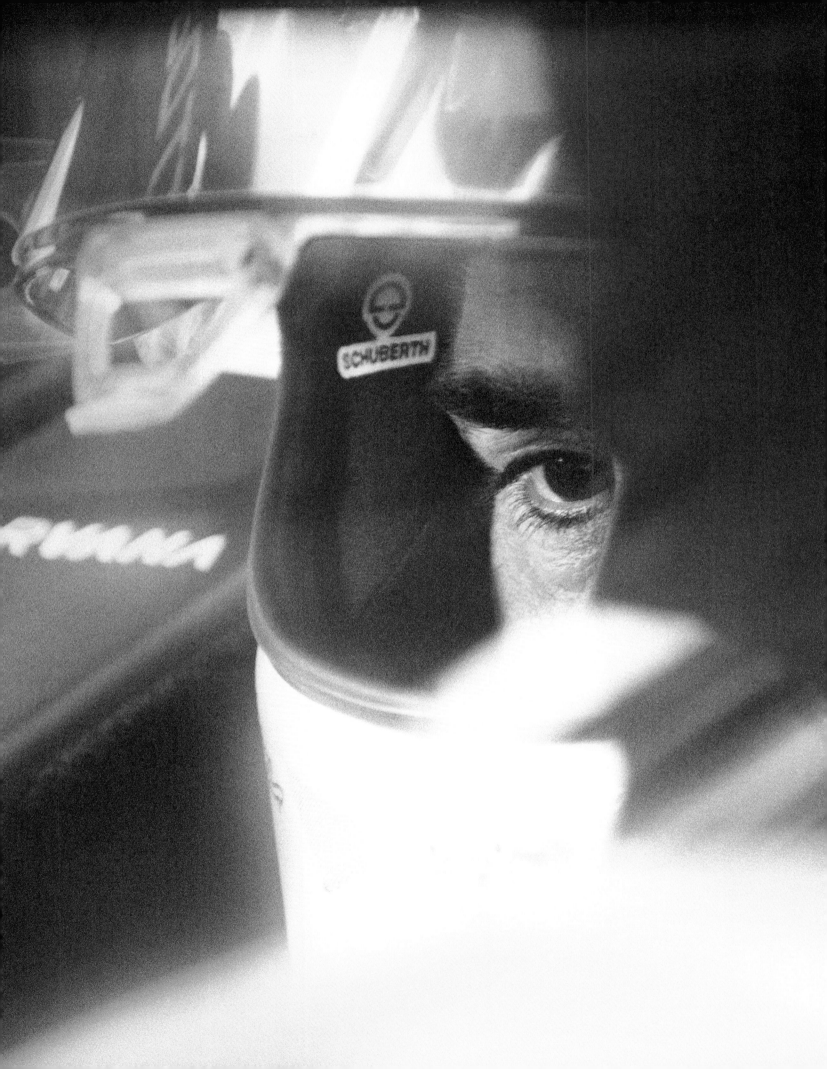

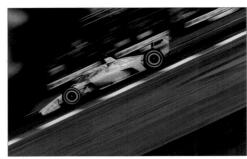

Jimmie drives the "Yellowjacket" No. 48 Carvana Chip Ganassi Racing Honda; Grand Prix of Portland; Portland International Raceway; Portland, Oregon; September 12, 2021; Photo by Joe Skibinski / ©IMS Photo Archive

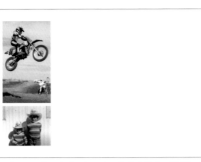

Top: A young Jimmie; Southwestern United States; 1980s; Jimmie Johnson archive; **Bottom:** A young Jimmie with his younger brother, Jarit; Los Coches Mobile Home Estates; El Cajon, California; early 1980s; Jimmie Johnson archive

Top: A young Jimmie with his father, Gary; Southwestern United States; Early 1980's; Jimmie Johnson archive. **Bottom:** A young Jimmie; Southwestern United States; early 1980s; Jimmie Johnson archive

The Johnson Family Racing Rig, complete with a Chevy Van and 3-wheelers on a sand dune; Southwestern United States; circa 1980s; Jimmie Johnson archive

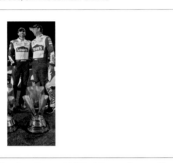

Jimmie and crew chief Chad Knaus after equalling NASCAR history with their seventh title; Homestead-Miami Speedway; Homestead, Florida; November 20, 2016; Photo by Elizabeth Kreutz

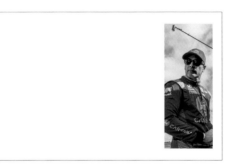

Jimmie; Carvana Chip Ganassi Racing Honda; Firestone Grand Prix of Monterey; WeatherTech Raceway Laguna Seca; Monterey, California; September 19, 2021; Photo by Walter Arce/ ©Dreamstime.com

Jimmie climbing aboard the No. 48 Carvana Chip Ganassi Racing Honda; Firestone Grand Prix of Monterey; WeatherTech Raceway Laguna Seca; Monterey, California; September 19, 2021; Photo by Walter Arce / ©Dreamstime.com

Jimmie, Chandra, Evie, and Lydia Johnson at the 2016 NASCAR Awards; The Wynn; Las Vegas, Nevada; December 2, 2016; Photo: ©NASCAR

Jimmie prepares to climb aboard the No. 48 Ally Cadillac; Sahlen's Six Hours of the Glen Watkins Glen International; Watkins Glen, New York; June 27, 2021; Photo by Gabe L'Heureux

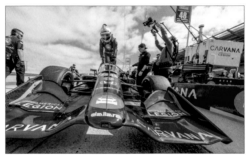

The No. 48 Ally Cadillac; Rolex 24 at Daytona; Daytona International Speedway; Daytona Beach, Florida; February 19, 2021; Photo by Gabe L'Heureux

The No. 48 Carvana Chip Ganassi Racing Honda Acura Grand Prix of Long Beach; Long Beach Street Circuit; Long Beach, California; September 26, 2021; Photos by Lorenzo Agius

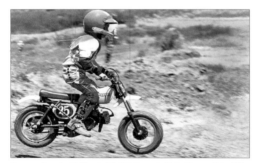

A young Jimmie; California Mini Motorcycle Club; Barona Oaks MX; San Diego, California; 1980; Jimmie Johnson archive

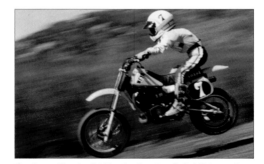

Jimmie on a Yamaha dirt bike; Southwestern United States; early 1980s; Jimmie Johnson archive

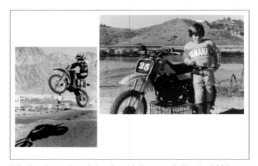

Left: Jimmie catches air in a Suzuki; Northern California; 1980s; **Right:** Posing next to a 60cc Yamaha; Barona Oaks MX; San Diego, California; 1980; Jimmie Johnson archive

Jimmie goes end-over in his Mickey Thompson Super-Lite Buggy before coming back to win; circa 1992; Jimmie Johnson archive

Jimmie and his Mickey Thompson Super-Lite Buggy; **Left:** San Francisco MTEG; 1993; Photo ©Trackside Photo; **Right:** Circa 1993; Jimmie Johnson archive

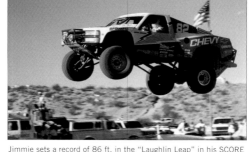

Jimmie sets a record of 86 ft. in the "Laughlin Leap" in his SCORE Off-Road Chevy Thunder truck; Laughlin, Nevada; 1995; Photo ©Trackside Photo

Left: Jimmie in his Chevy Thunder S-10s Truck; 1994; **Right:** Jimmie from his first Main Event win in the Mickey Thompson Stadium Off Road Series National Sport Truck Class; Sam Boyd Silverdome; Las Vegas, Nevada; October 1, 1994; Jimmie Johnson archive

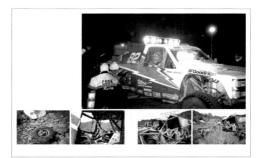

The infamous Baja 1000 crash; Ford TECATE Score Baja 1000; Baja Peninsula, Mexico; November 8–11, 1995; Jimmie Johnson archive

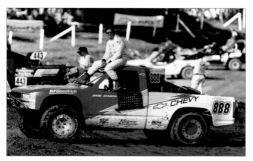

Jimmie Johnson sitting atop his Herzog Racing SODA Off-Road Chevrolet; Crandon Off-Road Series; Crandon International Raceway;Crandon,Wisconsin,1997; Jimmie Johnson archive.

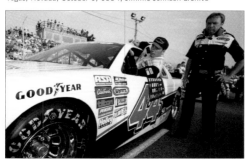

Jimmie climbs aboard his ASA No. 44 Herzog Racing Monte Carlo at the watchful eye of crew chief Howie Lettow; 1998; Jimmie Johnson archive

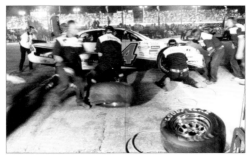

ASA No. 44 Herzog Racing Chevy Monte Carlo; 1998; Jimmie Johnson archive

Jimmie piloting the No. 48 Camaro ZL1 around the high banks in preparation for his first race with Ally sponsorship; Practice for the Daytona 500; Daytona International Speedway; Daytona Beach, Florida; February 2019; Photo by Gabe L'Heureux

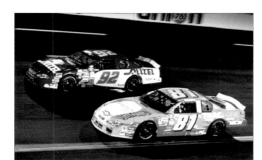

Jimmie (No. 92) racing his close friend Blaise Alexander (81) in the NASCAR Busch Series; AutoLite/Fram 200; Richmond International Raceway; Richmond, Virginia; September 8, 2000; Photo by ©David Chobat Images

The infamous NASCAR Busch Series crash at Watkins Glen in the No. 92; Alltel Herzog Racing Monte Carlo; Lysol 200; Watkins Glen International; Watkins Glen, New York; June 25, 2000; Photos by Bryan Mettler

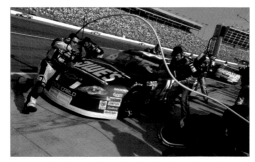

Jimmie waits at the attention of the No. 48 pit crew in his third-ever NASCAR Winston Cup race; NAPA 500; Atlanta Motor Speedway; Hampton, Georgia; November 18, 2001; Photo: Jimmie Johnson archive.

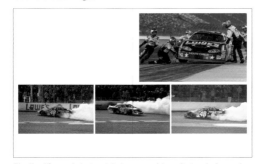

The No. 48 crew is featured during a mandatory pit stop during qualifying for a non-points Million-Dollar All-Star exhibition race known as "The Winston"; The Winston; Lowe's Motor Speedway; Concord, North Carolina; May 17, 2003; Photos: Jimmie Johnson archive.

Confetti flies over Jimmie's first Daytona 500 victory; Daytona 500; Daytona International Speedway; Daytona Beach, Florida; February 19, 2006; Photo by Terry Renna/©AP Photo

Daytona 500; Daytona International Speedway; Daytona Beach, Florida; February 19, 2006; Photo by Jonathan Ferrey /©Getty Images

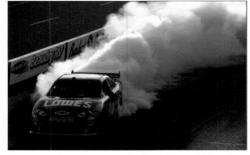

A celebratory victory burnout marking Jimmie's career high tenth win of the 2007 season; Checker Auto Parts 500; Phoenix International Raceway; Avondale, Arizona; November 11, 2007; Photo by Robert Laberge/©Getty Images

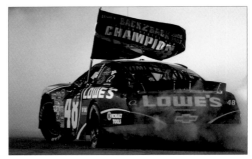

Jimmie burns it down celebrating his second straight Nextel Cup title; Ford 400; Homestead-Miami Speedway; Homestead, Florida; November 18, 2007; Photo by Robert Laberge /©Getty Images

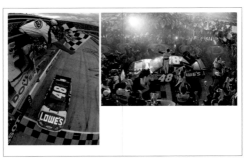

Left: AAA 400; Dover International Speedway; Dover, Delaware; September 27, 2009; Photo by Chris Trotman/©Getty Images; **Right:** Ford 400; Homestead-Miami Speedway; Homestead, Florida; November 22, 2009; Photo by Rusty Jarrett/©Getty Images

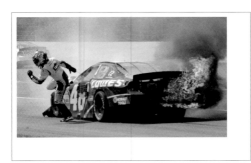

Jimmie escapes his burning Lowe's Chevy after a hard crash; Allstate Brickyard 400; Indianapolis Motor Speedway Speedway, Indiana; July 29, 2007; Photo by Scott Anderson/©AP Photo

Bank of America 500 Qualifying; Charlotte Motor Speedway; Concord, North Carolina; October 13, 2011; Photo by Missy McLamb

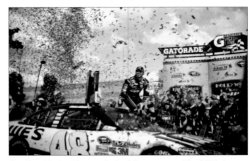

Jimmie celebrates his second win of the season and the 199th for Hendrick Motorsports; Hollywood Casino 400; Kansas Speedway; Kansas City, Kansas; October 9, 2011; Photo by Missy McLamb

Jimmie celebrates his second win of the season and the 199th for Hendrick Motorsports; Hollywood Casino 400; Kansas Speedway; Kansas City, Kansas; October 9, 2011; Photo by Missy McLamb

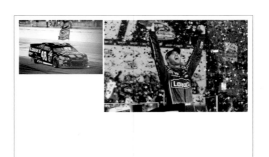

Jimmie celebrates his sixth cup title; Ford EcoBoost 400; Homestead-Miami Speedway; Homestead, Florida; November 17, 2013; **Left:** Photo by Jared C. Tilton/©Getty Images; **Right:** Photo ©Chris Ozer

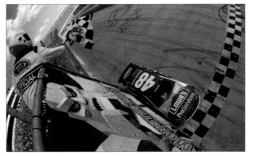

Jimmie makes history in Dover, becoming the fifth driver to win at least ten races at a single track; FedEx 400 Benefiting Autism Speaks; Dover International Speedway; Dover, Delaware; Photo by Chris Trotman/©Getty Images

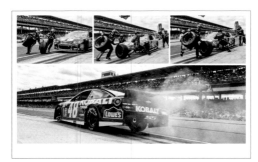

A pit stop sequence at Indy in the midst of a hard-fought second place finish; Crown Royal Presents the Samuel Deeds 400; Indianapolis Motor Speedway; Speedway, Indiana; July 28, 2013. Photos ©Chris Ozer

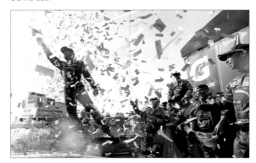

Jimmie's 77th career win, surpassing Dale Earnhardt, placing him seventh on the all-time wins list; Auto Club 400; Auto Club Speedway; Fontana, California; March 20, 2016; Photo by Jonathan Ferrey /©Getty Images

Lowe's employees, with the entire Hendrick Motorsports team, at their campus in Charlotte for a pep rally for the No. 48; Hendrick Motorsports; Charlotte, North Carolina; November 16, 2016; Photo by Elizabeth Kreutz

A young fan; Federated Auto Parts 400; Richmond, Virginia; September 7, 2013; Photo ©Chris Ozer

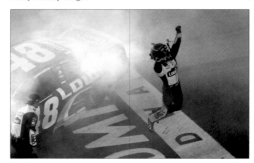

Jimmie leaps toward the sky moments after winning his record-tieing seventh championship; Ford EcoBoost 400; Homestead-Miami Speedway; Homestead, Florida; November 20, 2016; Photo by Sean Gardner/©Getty Images

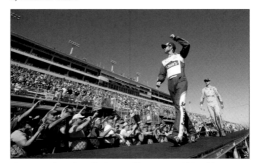

Jimmie and fans; Ford EcoBoost 400; Homestead-Miami Speedway; Homestead, Florida; November 20, 2016; Photo by Elizabeth Kreutz

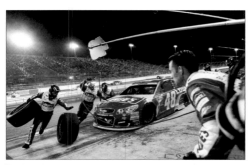

The Team Lowe's crew cranks out a fast stop; Ford EcoBoost 400; Homestead-Miami Speedway; Homestead, Florida; November 20, 2016; Photo by Elizabeth Kreutz

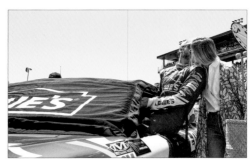

Jimmie kisses Chandra as he climbs aboard his Lowe's Chevy (he won his 83rd and final career points race just three events earlier); Toyota/SaveMart 350; Sonoma Raceway; Sonoma, California; June 25, 2017; Photo by Victor Cobian

Left: Austin Holland; **Right:** CJ Bailey Toyota/SaveMart 350; Sonoma Raceway; Sonoma, California; June 25, 2017; Photos by Victor Cobian

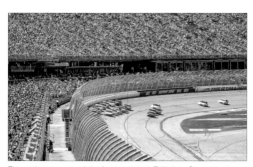

The pack roars around the frontstretch at Talladega Superspeedway; GEICO 500; Talladega Superspeedway; Talladega, Alabama; May 7, 2017; Photo by Andrew Moore

More than any other track on the NASCAR circuit, Talladega is known for its fans, their parties, and their partying spirit; GEICO 500; Talladega Superspeedway; Talladega, Alabama; May 7, 2017; Photos by Andrew Moore

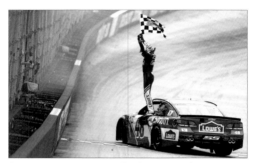

A day late, but no dollars short. Jimmie celebrates his second consecutive victory on a rain-delayed Monday; Food City 500; Bristol Motor Speedway; Bristol, Tennessee; April 24, 2017; Photo by Brian Lawdermilk/©Getty Images

Daytona 500; Daytona International Speedway; Daytona Beach, Florida; February 18, 2018; Photos by Jim Mangan

Daytona 500; Daytona International Speedway; Daytona Beach, Florida; February 18, 2018; Photo by Jim Mangan

Jimmie emerging from his record championship winning Chevrolet in Miami and embracing his family; Ford EcoBoost 400; Homestead-Miami Speedway; Homestead, Florida; November 20, 2016; Photo by Elizabeth Kreutz

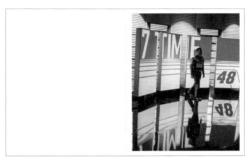

Jimmie walking out at the annual FOX Sports "Hangar Shoot" at a local airport hangar in Daytona Beach the week before the 2018 Daytona 500; Daytona 500; Daytona International Speedway; Daytona Beach, Florida; February 18, 2018; Photo by Jim Mangan

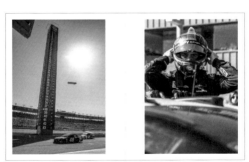

Auto Club 400; Auto Club Speedway; Fontana, California; March 17, 2019; Photos by Gabe L'Heureux

Flyover. Auto Club 400; Auto Club Speedway; Fontana, California; March 17, 2019; Photo by Gabe L'Heureux

Office blinds are parted to see the No. 48 Ally Camaro ZL1 blaze past for Jimmie's penultimate run at his home track; Auto Club 400; Auto Club Speedway; Fontana, California; March 17, 2019; Photo by Gabe L'Heureux

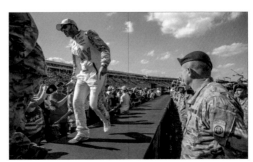

Jimmie high-fives the fans flanked and escorted by the service members being honored on Memorial Day weekend; Coca-Cola 600; Charlotte Motor Speedway; Concord, North Carolina; May 26, 2019; Photo by Gabe L'Heureux

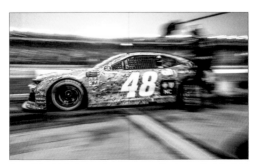

A special patriotic look, as is common practice for much of the field on Memorial Day weekend, Johnson rockets his digital camo No. 48 out of the pits; Coca-Cola 600; Charlotte Motor Speedway; Concord, North Carolina; May 26, 2019; Photo by Gabe L'Heureux

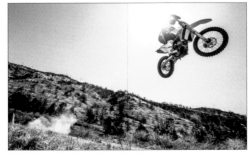

Jimmie catching air on a family dirt bike outing in Aspen; Aspen, Colorado; 2019; Photo by Gabe L'Heureux

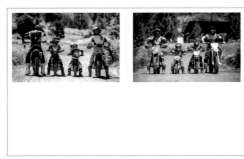

Jimmie, Chandra, Evie, and Lydia on a family dirt bike outing in Aspen; Aspen, Colorado; 2019; Photos by Gabe L'Heureux

Training for the Boston Marathon by running early before a Las Vegas Pre-Season NASCAR Test; Las Vegas, Nevada; January 2019; Photo by Adam Moran

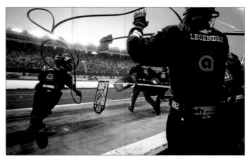

Coca-Cola 600; Charlotte Motor Speedway; Concord, North Carolina; May 26, 2019; Photo by Gabe L'Heureux

The third car in the outside train, Johnson minds his time around sixth place; Daytona 500; Daytona International Speedway; Daytona Beach, Florida; February 17, 2019; Photo by Gabe L'Heureux

Coca-Cola 600; Charlotte Motor Speedway; Concord, North Carolina: May 26, 2019; Photo by Gabe L'Heureux

Spotter's stand; Coca-Cola 600; Charlotte Motor Speedway; Concord, North Carolina; May 26, 2019; Photo by Gabe L'Heureux

As is tradition up and down pit road, the Ally crew saluted its driver during the pace laps at Charlotte; Coca-Cola 600; Charlotte Motor Speedway; Concord, North Carolina; May 26, 2019; Photo by Gabe L'Heureux

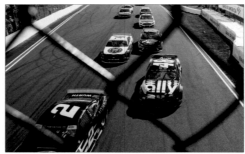

Johnson dives under the crossover bridge at the Charlotte ROVAL; Bank of America ROVAL 400; Charlotte Motor Speedway ROVAL;Concord, North Carolina; September 29, 2019; Photo by Gabe L'Heureux

Jimmie rooster-tailing it; Creekside Motocross; Alexis, North Carolina; 2019; Photo by Gabe L'Heureux

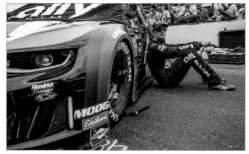

Jimmie rests against his steed before one of the year's marquee events at the "Racing Capital of the World"; Big Machine Vodka 400 at the Brickyard; Indianapolis Motor Speedway; Speedway, Indiana; September 8, 2019; Photo by Gabe L'Heureux

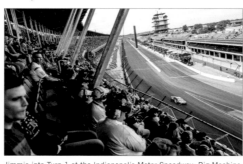

Jimmie into Turn 1 at the Indianapolis Motor Speedway; Big Machine Vodka 400 at the Brickyard; Indianapolis Motor Speedway; Speedway, Indiana; September 8, 2019; Photo by Gabe L'Heureux

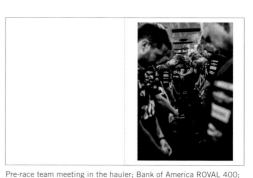

Pre-race team meeting in the hauler; Bank of America ROVAL 400; Charlotte Motor Speedway ROVAL; Concord, North Carolina; September 29, 2019; Photo by Gabe L'Heureux

Jimmie skirts his Ally Chevy around the thin yellow line in the desert; Fan Shield 500; Phoenix Raceway; Avondale, Arizona; March 8, 2020; Photo by Gabe L'Heureux

Fan Shield 500; Phoenix Raceway; Avondale, Arizona; March 8, 2020; Photo by Gabe L'Heureux

Jimmie pulls the Ally Camaro into the garage for adjustments during practice; Fan Shield 500; Phoenix Raceway; Avondale, Arizona; March 8, 2020; Photo by Gabe L'Heureux

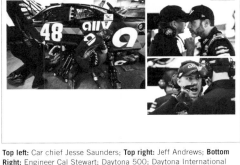

Nowhere but NASCAR will you see diehards rolling up in a recliner. But as with any sport, fan support comes in many languages; final Auto Club 400 weekend; Auto Club Speedway; Fontana, California; March 1, 2020; Photos by Peggy Sirota

Final Auto Club 400 weekend; Auto Club Speedway; Fontana, California; March 1, 2020; Photo by Peggy Sirota

Final Auto Club 400 weekend; Auto Club Speedway; Fontana, California; March 1, 2020; Photo by Peggy Sirota

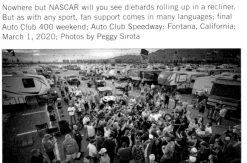
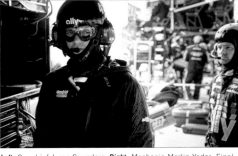
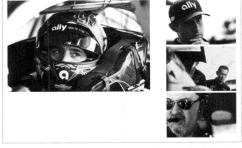

Hometown fans are the best fans; final Auto Club 400 weekend; Auto Club Speedway; Fontana, California; March 1, 2020; Photo by Peggy Sirota

Left: Car chief Jesse Saunders; **Right:** Mechanic Marlin Yoder; Final Auto Club 400 weekend; Auto Club Speedway; Fontana, California; March 1, 2020; Photo by Peggy Sirota

Top left: Car chief Jesse Saunders; **Top right:** Jeff Andrews; **Bottom Right:** Engineer Cal Stewart; Daytona 500; Daytona International Speedway; Daytona Beach, Florida; February 17, 2020; Photos by Sebastian Kim

Mechanic Thomas Heslink; Daytona 500; Daytona International Speedway; Daytona Beach, Florida; February 17, 2020; Photo by Sebastian Kim

Pit wall; Daytona 500; Daytona International Speedway; Daytona Beach, Florida; February 17, 2020; Photo by Sebastian Kim

Top Right: Crew Chief Cliff Daniels; **Middle Right:** Interior Mechanic Cesar Villenueva; **Bottom right:** Truck Driver Lance Scott; Daytona 500; Daytona International Speedway; Daytona Beach, Florida; February 17, 2020; Photos by Sebastian Kim

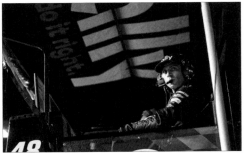

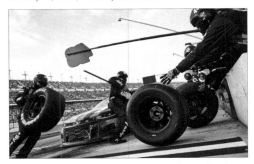

Crew Chief Cliff Daniels atop the box; Daytona 500; Daytona International Speedway; Daytona Beach, Florida; February 17, 2020; Photo by Sebastian Kim

The Johnsons enjoy Jimmie's final run in the Daytona 500, a race he won twice; Daytona 500; Daytona International Speedway; Daytona Beach, Florida; February 17, 2020; Photos by Sebastian Kim

Daytona 500; Daytona International Speedway; Daytona Beach, Florida; February 17, 2020; Photo by Sebastian Kim

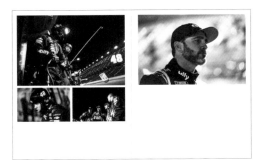
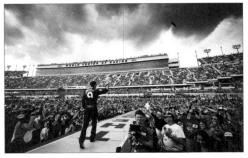
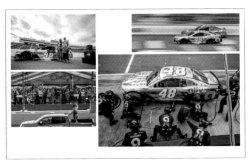

Daytona 500; Daytona International Speedway; Daytona Beach, Florida; February 17, 2020; Photos by Sebastian Kim

One final walk out on NASCAR's biggest stage; Daytona 500; Daytona International Speedway; Daytona Beach, Florida; February 17, 2020; Photo by Sebastian Kim

One Final Time in its truest form: Seven Time's final NASCAR race; 2020 Season Finale 500; Phoenix Raceway; Avondale, Arizona; November 8, 2020; Photos by Gabe L'Heureux

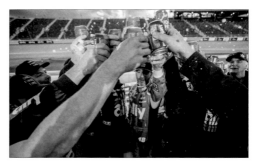
A champion's toast stock-car style; 2020 Season Finale 500; Phoenix Raceway; Avondale, Arizona; November 8, 2020; Photo by Gabe L'Heureux

Jimmie rolling through the hills of Alabama at 160+ mph in his first IndyCar race weekend; Honda Indy Grand Prix of Alabama; Barber Motorsports Park; Birmingham, Alabama; April 18, 2021; Photo by Gabe L'Heureux

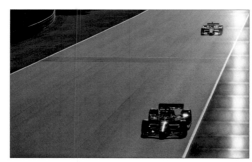
First Ganassi IndyCar Test; Barber Motorsports Park; Birmingham, Alabama; November 2, 2020; Photo by Gabe L'Heureux

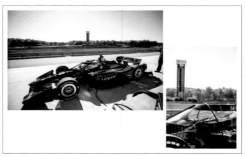
First Ganassi IndyCar Test; Barber Motorsports Park; Birmingham, Alabama; November 2, 2020; Photo by Gabe L'Heureux

The No. 48 Ally Cadillac DPi; Rolex 24; Daytona International Speedway; Daytona Beach, Florida; January 30–31, 2021; Photo by Gabe L'Heureux

Jimmie alongside teammates Mike Rockenfeller, Kamui Kobayashi, and Simon Pagenaud; Rolex 24; Daytona International Speedway; Daytona Beach, Florida; January 30–31, 2021; Photos by Gabe L'Heureux

Rolex 24; Daytona International Speedway; Daytona Beach, Florida; January 30–31, 2021; Photo by Gabe L'Heureux

Rolex 24; Daytona International Speedway; Daytona Beach, Florida; January 30–31, 2021; Photo by Gabe L'Heureux

Nightfall at Daytona; Rolex 24; Daytona International Speedway; Daytona Beach, Florida; January 30–31, 2021; Photo by Gabe L'Heureux

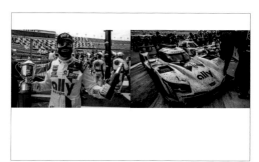
Rolex 24; Daytona International Speedway; Daytona Beach, Florida; January 30–31, 2021; Photo by Gabe L'Heureux

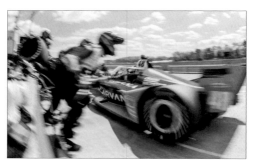
Barber Motorsports Park; Birmingham, Alabama; April 17, 2001; Photo by Gabe L'Heureux

Jimmie climbing aboard the No. 48 Carvana Chip Ganassi Racing Dallara Honda; Barber Motorsports Park; Birmingham, Alabama; April 17, 2001; Photo by Gabe L'Heureux

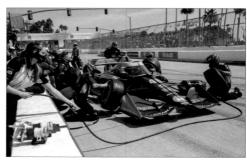
The Carvana Chip Ganassi Racing crew works on the No. 48 Honda during practice for the season finale; Acura Grand Prix of Long Beach; Long Beach Street Circuit; Long Beach, California; September 26, 2021; Photo by Lorenzo Agius

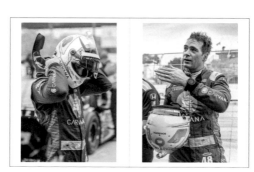
Acura Grand Prix of Long Beach; Long Beach Street Circuit; Long Beach, California; September 26, 2021; Photos by Lorenzo Agius

Acura Grand Prix of Long Beach; Long Beach Street Circuit; Long Beach, California; September 26, 2021; Photo by Lorenzo Agius

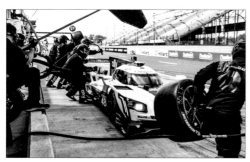

Johnson pits the Ally Cadillac during the summer leg of the IMSA Endurance Championship; Sahlen's Six Hours of the Glen; Watkins Glen International; Watkins Glen, New York; June 27, 2021; Photo by Gabe L'Heureux

From left to right, a difference of about 160 mph can be seen at the top of the esses at Watkins Glen; Sahlen's Six Hours of the Glen; Watkins Glen International; Watkins Glen, New York; June 27, 2021; Photos by Gabe L'Heureux

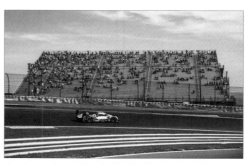

Jimmie roars through Turn 1 at Watkins Glen; Sahlen's Six Hours of the Glen; Watkins Glen International; Watkins Glen, New York; June 27, 2021; Photo by Gabe L'Heureux

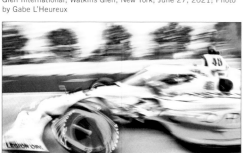

Music City Grand Prix; Nashville, Tennessee; August 8, 2021; Photo by Pari Dukovic

Music City Grand Prix; Nashville, Tennessee; August 8, 2021; Photos by Pari Dukovic

Music City Grand Prix; Nashville, Tennessee; August 8, 2021; Photos by Pari Dukovic

Music City Grand Prix; Nashville, Tennessee; August 8, 2021; Photo by Pari Dukovic

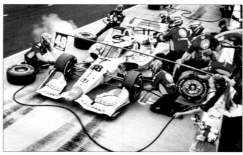

Music City Grand Prix; Nashville, Tennessee; August 8, 2021; Photo by Pari Dukovic

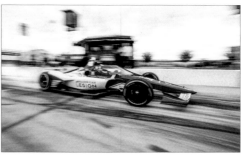

Testing an IndyCar on an oval; Texas Motor Speedway; Fort Worth, Texas; August 30, 2021; Photo by Gabe L'Heureux

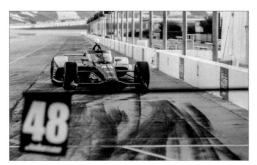

Texas Motor Speedway; Fort Worth, Texas; August 30, 2021; Photo by Gabe L'Heureux

Texas Motor Speedway; Fort Worth, Texas; August 30, 2021; Photo by Gabe L'Heureux

Music City Grand Prix; Nashville, Tennessee; August 8, 2021; Photo by Pari Dukovic

"In 2020, when my final NASCAR season started up, pandemic protocols meant that I was in charge of my own gear, including washing and drying my race suits. I took this picture looking out my backyard, after our first race back, post-lockdown"; Photo by Jimmie Johnson

The Esses; IMSA Petit Le Mans endurance race; Road Atlanta; Atlanta, Georgia; Nov 13, 2021; Photo by Gabe L'Heureux

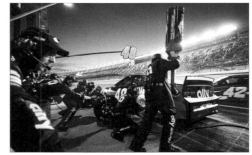

Daytona 500; Daytona International Speedway; Daytona Beach, Florida; February 17, 2020; Photo by Sebastian Kim

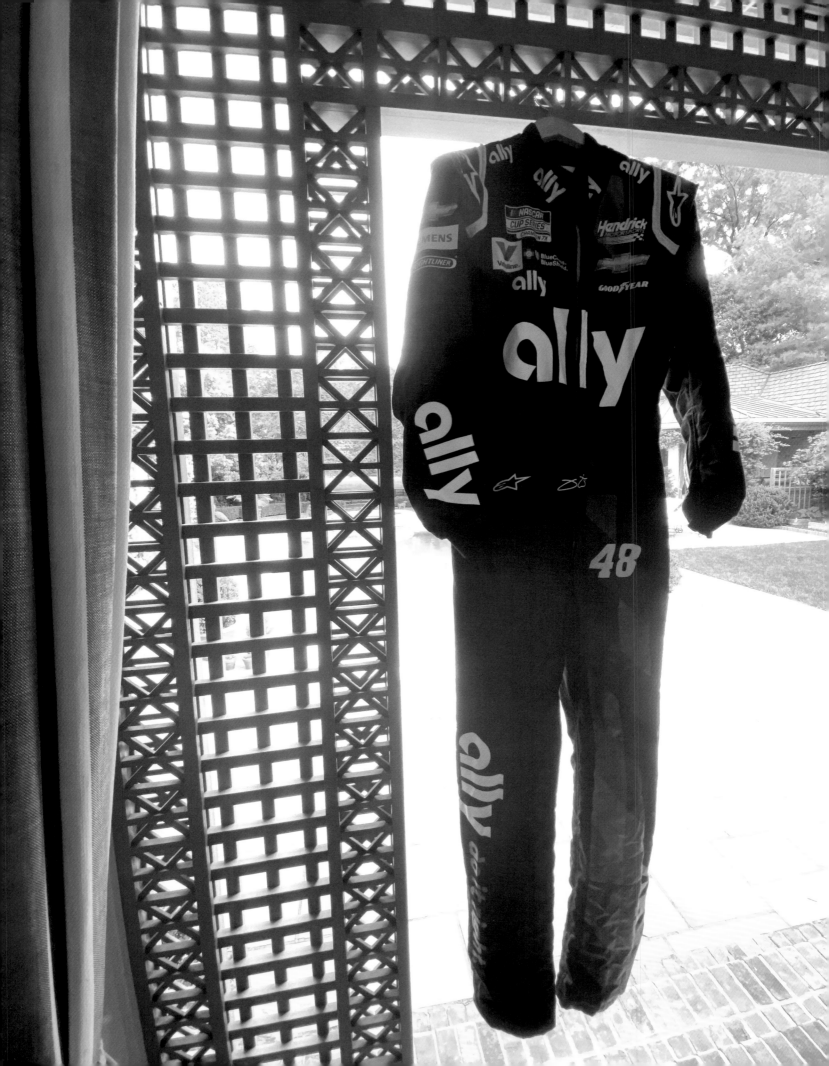

ACKNOWLEDGMENTS

None of this would have been possible without the love and support of my parents, Gary and Cathy, and my brothers, Jarit and Jessie. Although we lived by the simplest of means, my brothers and I always had toys to race. We were the priority. Mom and dad, you sacrificed so much to make my dreams come true. I am forever grateful. Mr. and Mrs. Hendrick, you were my second parents. You changed my life and will always be family to me. Words can't express my gratitude. Ricky was a great friend who was more like a brother. I will always miss him.

Rick Johnson, you have always been there for me, and you got me over that first triple jump! You have mentored me for decades and introduced me to the folks at Chevrolet. For all this, I thank you. To Jeff Bennet, thank you for giving me my true start in one of your buggies. Herb Fishel, you are the man that made this whole thing happen. As head of GM Motorsports, you spotted me from the stands and changed my life. And thank you to Jon Nelson and everyone at Nelson & Nelson Racing. Thank you to Bill, Stan, Randy, and the entire Herzog family. You brought me into your family and took such wonderful care of me and my career.

Gratitude to Charlie Schleevie, my amazing off-road crew chief. And to Howard Lettow, who showed me the bridge from off road to asphalt. You were the professor; those were my college years.

To my mentor, Jeff Gordon, how crazy to be handpicked by my childhood hero! Thank you for believing in me. You created my job and from that, our friendship. Gratitude to Chad Knaus. You are like a brother. We did this together. Alan Miller, I am so thankful for your wisdom and guidance.

Michael Jordan, it's been amazing to get to know you and become your friend. Thank you for writing such a beautiful foreword. And thank you for that text when I hit number 6! John Lewensten, who has literally been there since the beginning, I am so grateful for your commitment to me and my family, and for shepherding this project.

Chip Ganassi, I am so happy to be getting to know you. You are someone I have always respected. You gave this old guy a shot! You take chances that others don't.

To everyone at Hendrick Motorsports, you were team members and remain my family. Thank you all so much. Thanks also to the team at Chip Ganassi Racing. What an amazing welcome to such a successful operation. And thank you to everyone at Action Express Racing.

I am beyond grateful to the France Family and everyone at NASCAR. Thank you to the extraordinary team at IndyCar. And thank you to everyone at Lowe's, Ally, and Carvana for always being in my corner.

To my family at JJ Racing, thank you for all you do to keep me moving forward every day. I am grateful to John Lewensten, Chel and Earl Barban, Kristine Curley, Lauren Edwards, Kelly Hudson, Deanna Pryor, Sean Reapp, Amy Walsh Stock, and John Vignona. Thank you to Sam Ulrich for putting all the pieces together.

Sam Shahid and Mathew Kraus, thank you for your brilliant vision and for bringing these pages to life. Robert Sullivan, I appreciate your attention to every detail and for telling my story so thoughtfully. A huge thank you to Ivan Shaw for helping to make this passion project a reality. His vision, dedication, and creativity helped meld thousands of special moments into a story. Chandra and I can't thank you enough for leading this project and, more importantly, for your friendship.

To my friends and competitors: I am so thankful to have you in my life. You have shared this journey and for that I am grateful.

At Rizzoli: I give many thanks to Anthony Petrillose, Charles Meiers, Gisela Aguilar, Maria Pia Gramaglia, and Olivia Russin. To the extraordinary photographers, without which, there would be no book, thank you; Lorenzo Agius, Pari Dukovic, Sebastian Kim, Bryan Knox, Elizabeth Kreutz, Gabe L'Heureux, Jim Mangan, Missy McLamb, Andrew Moore, Adam Moran, Lyle Owerko, and Peggy Sirota.

And lastly, my profound thanks to the fans. We have had such an amazing journey together. You have been so loyal and shown such dedication, I can't express in words my gratitude. None of this would have been possible without you. You are so important to motorsport. I can't wait to share the next lap with you.

—Jimmie Johnson

First published in the United States of America in 2022 by
Rizzoli International Publications Inc.
300 Park Avenue South
New York, NY 10010
www.rizzoliusa.com

© 2022 Jimmie Johnson Racing ll, Inc.

Publisher: Charles Miers
Associate Publisher: Anthony Petrillose
Editor: Gisela Aguilar
Production Manager: Alyn Evans
Design Coordinator: Olivia Russin

Produced by Ivan Shaw
Designed by Sam Shahid and Matthew Kraus

Distributed in the U.S. Trade by Random House, New York.

Printed in Italy

2022 2023 2024 2025 2026 / 10 9 8 7 6 5 4 3 2

ISBN: 978-0-8478-7201-5
Library of Congress Control Number: 2022902502

Visit us online:
Facebook.com/RizzoliNewYork
Twitter: @Rizzoli_Books
Instagram.com/RizzoliBooks
Pinterest.com/RizzoliBooks
YouTube.com/user/RizzoliNY
Issuu.com/Rizzoli